THE COMPLETE IDIOT'S GUIDE® TO

Drawing People

Illustrated

by Brenda Hoddinott

ALPHA

A member of Penguin Group (USA) Inc.

This book is dedicated to my parents, Pamela and Granville Hoddinott. Thank you for a lifetime of love and encouragement.

International Standard Book Number: 1-59257-223-5
Library of Congress Catalog Card Number: 2004105301

06 05 8 7 6 5 4 3 2

Interpretation of the printing code: The rightmost number of the first series of numbers is the year of the book's printing; the rightmost number of the second series of numbers is the number of the book's printing. For example, a printing code of 04-1 shows that the first printing occurred in 2004.

Printed in the United States of America

Note: This publication contains the opinions and ideas of its author. It is intended to provide helpful and informative material on the subject matter covered. It is sold with the understanding that the author and publisher are not engaged in rendering professional services in the book. If the reader requires personal assistance or advice, a competent professional should be consulted.

The author and publisher specifically disclaim any responsibility for any liability, loss, or risk, personal or otherwise, which is incurred as a consequence, directly or indirectly, of the use and application of any of the contents of this book.

Most Alpha books are available at special quantity discounts for bulk purchases for sales promotions, premiums, fund-raising, or educational use. Special books, or book excerpts, can also be created to fit specific needs.

For details, write: Special Markets, Alpha Books, 375 Hudson Street, New York, NY 10014.

Publisher: *Marie Butler-Knight*
Product Manager: *Phil Kitchel*
Senior Managing Editor: *Jennifer Chisholm*
Senior Acquisitions Editor: *Mike Sanders*
Development Editor: *Lynn Northrup*
Production Editor: *Megan Douglass*
Copy Editor: *Keith Cline*
Cover/Book Designer: *Trina Wurst*
Indexer: *Heather McNeil*
Layout/Proofreading: *Becky Harmon, Donna Martin*

Contents at a Glance

Contents

Foreword

With a degree in art from the University of Florida, 26 years as an advertising art director and creative director in New York and Miami, 2 years as a lecturer in art at the University of Miami, and 18 years as a full-time portrait artist, I think it's safe to say I know a good book about drawing when I see one. This is not only a good book about drawing people, it's a good book about drawing, period. Brenda Hoddinott has a clean, precise drawing style and smooth, easy writing that is perfect for teaching. The way she draws eyes—the hardest and most critical part of drawing the human face—is worth the price of the book alone.

When I went through my middle-age crisis, I found myself hanging around bars (especially those with large hors d'oeuvres tables), trying to meet girls. "Hi there, I'm Dan. Come here often?" didn't work for squat for me, so I had to find something else. Something unique. Something that would make *them* come to *me*. Then one night I stumbled on the neatest pick-up trick in the world. I mean *the world!* While doodling on a napkin with a fine-point pen, I began drawing a beautiful girl sitting across the bar from me. First, I drew just her eyes. Then, thinking, "Hmm, that ain't too shabby," I drew her nose and mouth. Then the outline of her face, then her hair. "Sonofagun, it actually *looks* like her!" I thought. Of course, she was aware of what I was doing, and when I was finished, she came around the bar to see what I had done. Bingooo! One thing led to another and I left there with a pretty girl on my arm. For the next two years I never went without a date on Saturday night, and I rarely had to pay for my own drinks in any bar or restaurant. (I learned to stay away from places with cloth napkins.) It all came to a halt one night when I drew a napkin portrait of a tall, drop-dead gorgeous girl with huge blue eyes. She said it was the most romantic thing she'd ever seen. (Didn't they all?) We've been married now for 26 years. And she still has the napkin drawing. Now, obviously not everyone is into hanging around bars, but just for the sheer joy of it, *learn to draw people!* It doesn't necessarily have to lead to anything … but one never knows, right? You never know what delicious trouble you can get into.

I have to say that I've never met Brenda Hoddinott in person, but I've known her for several years as one of my friends on an Internet discussion group of artists called "Paint-1." But just the same, I'm very familiar with her skills as an artist who's especially good at drawing people. And I gotta tell ya—she's good. Very, very good. The old saw, "Those who can, do … those who can't, teach" is definitely not true when it comes to Brenda. She's not only a good artist, she's also a good teacher. Stay with her on this journey into the art of drawing people and I promise you'll become a better artist. She's even managed to show me a few things. Of course, I'd never tell her that. After all, I can't have her getting all uppity on me, now can I?

—Daniel Shouse

Daniel Shouse is a professional portrait artist and Member of Merit, Portrait Society of Atlanta.

Introduction

The secret to learning how to draw people is to take the information within these pages and apply it to practicing the skills of drawing. In other words, you learn by doing. However, I don't just *tell* you how to draw. I *show* you! To emphasize this point, take a quick look at the more than 450 illustrations I have packed into the pages of this book.

Each skill presented in *The Complete Idiot's Guide to Drawing People Illustrated* is designed to help you improve your artistic eye. As your basic drawing abilities become stronger, your expressive individuality and creativity will automatically become part of your artistic repertoire.

As you strengthen your techniques, continue to search for and embrace opportunities to expand and develop new skills. Choose only drawing subjects that appeal to you. Take joy in your good drawings, and learn from those that turn out not so good. Keep an open mind and maintain an ongoing commitment to trying new techniques and different media. Last but not least, look upon every creative endeavor as an opportunity for fun and enjoyment!

How to Use This Book

The exercises and skills in this book start off super simple and progressively become more challenging as you reach the final chapters. You can work your way through this book in several different ways. The ideal approach is to begin at the beginning and slowly work through the entire book in sequence, doing each exercise along the way. Each new skill you learn prepares you for the next one. If an exercise is too difficult, go back and try it again (and again if you need to) until you're happy with the results. By the time you reach the end of the book, you'll be ready to jump into drawing people on your own!

Or you may prefer to simply browse through this book in no particular order. Enjoy the more than 450 illustrations and try your hand at the various exercises that appeal to you. Other than a few potential challenges with terminology (this is why you have a glossary in the back of the book), and possibly some projects beyond your current skill level, this approach can work well. If you begin to feel totally overwhelmed and frustrated, you can always go back and read the book from the beginning!

Part 1, "Beginning with the Basics," introduces you to "warm fuzzies" and gently immerses you into the art of drawing people. You take several steps into discovering your own abilities and the artist within. I walk you through the processes of shopping for drawing supplies and setting up a space in which to draw. By then you'll be ready to have some fun exercising your brain, drawing lines, figuring out how to set up a drawing, and taking a little journey into the third dimension!

Part 2, "Translating Light and Shadows into Shading," gives you oodles of exercises that take you from seeing as an artist to putting your vision on paper with shading. Shading allows you to apply the magic of three-dimensional reality to your drawings. No matter how much I try to make this technical stuff interesting with tons of fun illustrations (and believe me, I've tried!), it just simply isn't as much fun as drawing what you love. However, without an understanding of the important technical stuff, your drawings just don't turn out the way you want, and you may end up feeling frustrated or even artistically apathetic. Hang in there! Eventually, the boring stuff becomes instinctual.

Part 3, "Exploring the Human Head," shows you how to draw a human face that is proportionately correct. You take a little journey in time and watch a person's face develop, mature, and age from birth throughout an entire lifetime. You have an opportunity to add simple techniques for drawing eyes, noses, mouths, and ears to your skills repertoire. Be prepared to giggle your way through tons of hairy, fuzzy, fancy, and fun hair fashions and a whole chapter of zany cartoons demonstrating a bunch of really cool facial expressions.

Part 4, "Examining Figures," introduces you to drawing correctly proportioned and expressive human figures of various shapes, sizes, and ages. Tons of illustrations take you step by step through drawing individual parts of bodies and then putting them together to become entire figures. I show you several approaches to sketching some gestures, movements, actions, and poses of people of various ages. Finally, you learn how to draw the textures, patterns, and folds of fabric and clothing.

Part 5, "Enjoying Eclectic Facets of Drawing People," explores various ways of adding creative expression to drawings of people to bring them into the realm of dynamic works of art. I share several great ideas for turning photos into natural-looking drawings. I show you how to create different drawings from one photo and how to transform numerous photos into one artwork. You find out how to efficiently use a viewfinder frame and a grid. I also discuss various ways to add emotion and mood to your artworks with artistic tools such as contrast and body language.

I also include two helpful appendixes: a glossary of drawing terms and a resource section of books, websites, and places to shop for art supplies.

Extras

Throughout this book, you discover oodles of snippets of information designed to make your drawing experiences more enjoyable.

Info Tidbit _____
These boxes contain drawing-related anecdotes and interesting information.

Art Alert! _____
We all learn from mistakes! Look here for valuable tips that can save you potential frustration by encouraging you to learn from my mistakes.

Helpful Hint _____
Check these boxes for helpful information that shows you an easier or faster way to do something or that explains a special technique for improving a specific skill.

Warm Fuzzy _____
Feeling discouraged? These boxes offer affirmations and words of encouragement to help you become more comfortable with drawing.

Acknowledgments

Warmest thanks to the entire Alpha-Penguin family, whose extraordinary expertise transformed my original vision into a book that I'm very proud of. I would like to especially acknowledge the phenomenal contributions of Lynn Northrup and Mike Sanders, who were absolute joys to work with. Special thanks are also extended to Megan Douglass, Keith Cline, and the entire production team.

A humungous bouquet of warm fuzzies is sent to my best friend, Rob, for editing, modeling, and always providing me with an infinite supply of giggles.

Special thanks to my friends and colleagues who shared their unique talents to help make this book a reality: literary agent Jessica Faust, business manager John McKeage, photographer Bruce Poole, legal advisor John Church, website managers Sherri Flemings, Philip Bigelow, Dean Slaunwhite, and Jeff Baur, computer guru (a.k.a. Chief Geek) Mark Palmer, and all the staff at Mike's for keeping me fed!

Big hugs to my family for their infinite patience, love, and support: parents, Pamela and Granville Hoddinott; children, Heidi and Ben Thomson; grandson, Brandon Thomson-Porter; sister, Karen Unicomb; brother, Peter Hoddinott; sister-in-law, Francine Clement; nephews, Colin and Adam; niece, Amy; and the critters: Shadow, Chewy, Buddy, Panda, Chum, and Fluff.

My sincere gratitude to other friends and family who loaned me their faces and body parts for the drawings in this book: Karin and Kathleen McCleave, Claudette Germaine, Benny Fong, Jason Brown, Chris Church, Jaclyn Poole, Joel Allan, Phil Power, Anne Sawney, Mike Lemoine, and the late Gordon Forbes (forever in our hearts).

Last, but not least, warm fuzzies are extended to all my wonderful Paint-L friends, and to each and every one of my former students who taught me how to teach.

Trademarks

All terms mentioned in this book that are known to be or are suspected of being trademarks or service marks have been appropriately capitalized. Alpha Books and Penguin Group (USA) Inc. cannot attest to the accuracy of this information. Use of a term in this book should not be regarded as affecting the validity of any trademark or service mark.

In This Part

Beginning with the Basics

In this part, you are gently immersed into the creative realm of drawing human beings. You gain new insights into the word *talent*, and accept that you do in fact have the ability to draw.

We go shopping for art supplies. Actually, *you* go shopping for your own supplies. I do, however, help you make your shopping list! I also present you with diverse options for planning, designing, and implementing a personal drawing space within your home.

I provide you with an insightful peek into the workings of your mind and vision, and you can have some fun with an optical-illusion exercise. From there, I guide you through the processes of planning your drawings, and give you a basic understanding of how to create the illusion of depth on a flat piece of paper. Lots of simple drawing projects introduce you to several basic skills you need for drawing human figures.

In This Chapter

- ◆ Developing an understanding of drawing
- ◆ The joys of an artistic practice
- ◆ How drawing enriches your life
- ◆ Developing an individual style
- ◆ Ten simple steps to drawing a "warm fuzzy"

Inspiration from Warm Fuzzies

Today is a great day to begin your artistic journey. Drawing is an enjoyable, inexpensive, and productive activity, accessible to everybody with some vision and able to hold a pencil. It's never too late to invite the artist inside you to surface (or resurface), and claim ownership of the joys of making art!

As little kids, we all drew people, the most natural of all subjects. Sadly, at some point in the growing up process, many potential artists become intimidated by drawing humans. But in fact, drawing people is no different than drawing anything else.

In this chapter—and throughout this book—I demystify popular myths about talent and drawing people. I share a few of my early drawings of people so that you can see my artistic beginnings. You also explore a few of the many perks of inviting the pleasures of drawing into your life.

I then guide you gently through 10 easy steps to create a simple drawing of a warm fuzzy, in which you discover several basic skills used for drawing people. By the way, I also refer to encouragements or affirmations, either given or received, as warm fuzzies. They represent something unique to everyone and live wherever kindheartedness dwells. This chapter is chock full of warm fuzzies for you, so be prepared!

Understanding Drawing and Talent

Drawing, of course, is the application of an art medium to a surface so as to produce an image, which visually defines an artist's choice of drawing subjects from his or her own unique perspectives. The act of drawing people hasn't changed since prehistoric humans drew on the walls of caves. The ability to draw shouldn't be considered an inborn talent. Strong drawing skills come to those who put forth the committed effort required to learn. This is why I firmly believe that everyone can learn how to draw!

I often feel uncomfortable when well-meaning friends tell me I am talented. Their assumption is that I am doing something innately extraordinary. In fact, I have worked hard to get to my current level of technical competence. Therefore, I consider the ability to draw as an accomplishment rather than a talent. I consider talent to be a process of self-discovery, throughout which you acknowledge and embrace your ability to become exceptional. With a personal commitment, patience, and dedication, you can develop your talent for drawing.

In the next illustration, you see two fun faces I drew when I was a young adolescent.

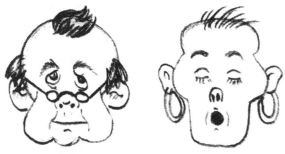

As an adolescent, I drew people's faces with simple lines.

Warm Fuzzy

You need three invaluable ingredients in order to improve your drawing skills—practice, practice, and more practice! If you practice drawing anybody and anything, whenever and however you wish, your skills will automatically improve.

Through self-directed learning, you become your own art teacher. You can set up a flexible and convenient schedule, and work at any pace you wish. Your only challenge is making a commitment. I taught myself how to draw, and so can you.

Exploring the Artist Within You

Drawing connects you to the people and world around you in unique ways. Your drawings of people represent more than the physical outward appearance of human beings. They illustrate the personal significance of people through your eyes, heart, and mind. Your individuality moves you to illustrate faces and figures in ways that have never been seen before.

Seeing Your World from a New Perspective

As the adage goes, "A picture is worth a thousand words." Your drawings are original poetry, written in pictures instead of words.

Whether you are learning drawing skills for the very first time, or honing your current abilities, learning to see is the very foundation of drawing. The key is to train your eyes to see people's faces and bodies from artistic perspectives—to see shapes, forms, and values in addition to their actual personalities.

I was a teenager before I discovered that shading gave my drawings a three-dimensional quality. In the next drawing, you can examine my early shading techniques.

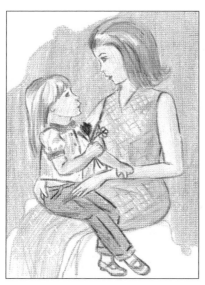

By the time I reached my teens, I was adding shading to my portraits.

Warm Fuzzy

You cannot fail at drawing. Be patient with yourself. You are successful in simply being an artist. Your artistic vision and drawing skills will expand over time.

Enriching Your Life with Drawing

Many aspects of your life can be enhanced with an ongoing dedication to drawing people. Consider a few of the benefits of being an artist:

◆ You find yourself exploring the people in your life from the exciting new perspective of finding drawing subjects. If one of your hobbies is people watching, you can discover lots of opportunities to explore drawing humans.

◆ Drawing is a productive activity with the physical reward of a finished piece of artwork. Your art can even decorate your home with a personal touch.

◆ Giving some thought to who and what you enjoy most in your life determines your favorite drawing subjects. This self-enlightenment is a perk of the language of art.

◆ Portraits speak without words by translating your personal perceptions into the non-narrative language of art. Through the eyes of those you draw, you take feelings from your life experiences and transfer them into pictorial expressions.

◆ Your drawings become a visual diary of your artistic journey. You are recording your present life for future reflection.

◆ Drawing is relaxing, mentally challenging, and emotionally stimulating.

Drawing can become a pleasurable and important aspect of your life. With patience and commitment, your skills will constantly improve. Take a deep breath, relax, and plan to thoroughly enjoy each step of your art-making journey!

Developing Your Unique Style

Making marks on a surface is the core of drawing. Different mark-making techniques lend themselves to various styles of drawing. Every artist seems to have a unique approach. Some love big, bold, "loose" drawings. Others like tiny drawings with lots of intricate details.

The natural development of your drawing style may be influenced by any or all of the following:

◆ Your personal philosophies and life experiences

◆ Your knowledge of the history of art

- ◆ Your goals and expectations of the drawing experience
- ◆ Your approaches to implementing the styles you prefer
- ◆ The drawing media you choose
- ◆ Your preference of smooth or rough drawing surfaces
- ◆ The way you hold your pencils

Keep your mind open as you explore different styles of drawing. Enjoy trying various methods of drawing, and take note of which approaches you prefer. Your individual style is automatically unfolding each time you draw. There's no right or wrong way to draw, but rather a respect for and acceptance of diversity.

By the time I reached high school, I was drawing every chance I could find. In the next illustration, you can see the realistic elements of my current drawing style beginning to emerge.

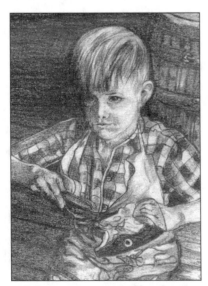

This style of drawing was emerging throughout my teens.

Drawing Is an Action Word

My approach to drawing is simple: You learn by doing. The process of reading this book from cover to cover can't improve your drawing skills. The mere action of creating drawings will teach you how to draw. Be brave—just jump in and try drawing, and keep practicing!

Art Alert!

What you may perceive as a mistake may actually be a learning opportunity. Take time to examine those drawings you don't like. Skills that didn't work for that particular subject may be perfect for other applications. At the very least, you can look at a problem area and decide to never try that approach again!

My drawing abilities are still evolving. Many of my drawing projects turn out differently than I envision. But, by carefully examining my completed drawings, I often discover wonderful skills and techniques that could have been easily brushed away as mistakes. I call them happy accidents!

Drawing a Warm Fuzzy

I don't know the origin of the term warm fuzzy, but remember hearing it for the first time many years ago, when I was a leader of my daughter's Brownie group. I loved the term so much that I gave it a visual identity and incorporated it into my art curriculum. This adorable little critter has been the very first drawing of hundreds of my students, for more years than I care to remember.

The instructions for this project are super simple and your only goal is to have some fun. You will need a pencil, an eraser, some paper, a ruler, and a sense of humor!

Many of the skills you use to draw this cartoon come in very handy for drawing people. However, feel free to exercise your creativity and make your drawing a little different than mine.

Before you actually begin drawing, you need to choose the shape and size of the space from which your critter will emerge. A drawing space (sometimes called a drawing format) refers to the area occupied by your drawing subjects within a specific perimeter. It can be the shape of your paper or outlined by any shape you draw, such as a square, rectangle, or circle.

1. Draw a square any size you wish. This is your drawing space.

2. Connect the opposite corners with very lightly drawn straight lines. This x-shape helps you with the placement of everything in your drawing.

This drawing space is patiently waiting for a warm fuzzy!

After you have mapped out your drawing space, add the eyes and a nose.

3. Draw two circular shapes to outline the eyes.

These eyes are close together and slightly above the center point of the x shape.

4. Draw a big circle or oval for the nose, and add a little curved line below it as a mouth.

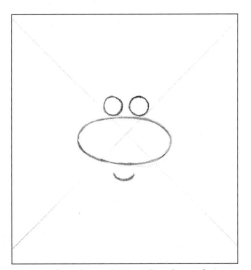

This happy face has a big ovular shape for a nose.

Helpful Hint

Place a sheet of scrap paper under your drawing hand as you work so that your hand doesn't smudge your drawing.

You need to create a simple map before you begin adding shading. Drawing a shading map involves lightly outlining the sections of your drawing that will be light or dark. Adding shading is much easier when you know where to put the various values. Values are different shades of gray created in a drawing by various means, such as varying the density of the shading lines and/or the pressure used in holding a pencil. (I show you how to draw different values in Chapter 7.)

5. Outline two small circles in the upper left of the eyes and draw a small horizontal oval in the upper left of the nose. Press very gently with your HB pencil in case you want to erase later. (Choosing pencils is covered in Chapter 2.) These small shapes will be left white on your paper.

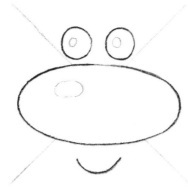

Circles inside the eyes and an oval inside the nose map out the lightest sections of this drawing.

6. Use your darkest pencil (6B is great) to shade in (fill in) the eyes very darkly, leaving the tiny mapping circles white.

With dark shading, two circular shapes become shiny little eyes.

7. Press lightly with your HB pencil and fill in the entire nose except for the small oval.

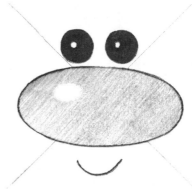

The nose looks shiny with the addition of shading.

8. Darken a crescent-shaped section of the nose extending from the upper right and curving around the bottom toward the left. You can darken this area by pressing more firmly with your HB pencil, or by switching to a 2B or 4B pencil.

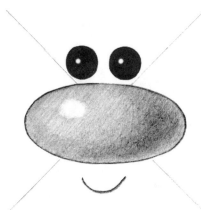

The nose becomes a three-dimensional form with a little crescent of darker shading.

The face is finished, and lots of space is left to draw Fuzzy's fluff (or fuzz, or fur, or whatever you want to call it).

9. Draw some straight lines directly out from the center of Fuzzy's nose (like children draw the rays of the sun).

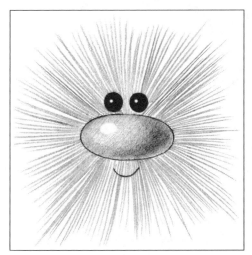

Lots of straight lines, extending from the center, create fluff for this warm fuzzy.

10. Make the fur a little thicker closer to the eyes and nose by drawing a few extra shorter lines.

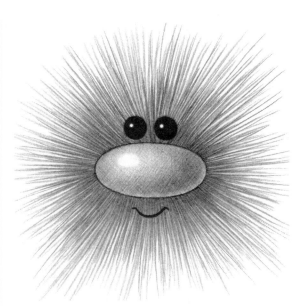

A simple little drawing of an adorable warm fuzzy is a welcome gift for anyone!

In this project, you drew a circle and an oval, mapped your values, and added shading to make three-dimensional forms. You also drew the texture of human hair. Pat yourself on the back, sign your name, and write today's date on the back of your drawing!

The Least You Need to Know

◆ Discovering the joys of drawing can enhance many aspects of your current life.

◆ Learning to see as an artist is the very foundation of drawing.

◆ The skills and techniques used for drawing people are easy to learn.

◆ Drawing is an action word—you learn by doing.

◆ You can teach yourself to draw!

In This Chapter

- ◆ Planning your artsy shopping list
- ◆ Easy steps to make a portfolio case
- ◆ Setting up an in-home studio space
- ◆ When it's time to take your art on the road

Preparing for Your Drawing Journey

You might feel like a little kid in a huge candy store when shopping for art supplies. With so many different products available, it's easy to feel overwhelmed. Actually, you need very little to get started! The basics for the projects in this book include pencils, sketchbooks, erasers, and a ruler.

This chapter offers guidance for buying drawing materials, and provides information about the things you need to complete the lessons in this book. I also offer practical suggestions for fitting personal drawing spaces into your home and for planning a portable studio.

Buying Drawing Supplies

You probably have pencils and paper lying around your home. However, most pencils and paper are not designed for drawing. You'll be much happier and less frustrated in the long run to begin your drawing journey with professional materials, designed specifically for artists.

Purchase the best quality sketchbooks, pencils, and erasers that you can comfortably afford. As with almost every activity, the better your tools, the better the outcome will be. Take the time to shop around and compare prices.

Art stores that specialize in supplies for artists are best for finding everything you need under one roof. However, you can also check out art sections in some department or business supply stores. If you like shopping online, top-quality supplies at fantastic prices are available at various art supply websites (I offer some suggestions in Appendix B).

Sketchbooks and Drawing Papers

Within the pages of a sketchbook, you create a pictorial journal of your artistic progress. Your confidence grows when you can reflect back on your successful drawings. As I've mentioned, even drawings you don't like present opportunities to spot problems and seek new ways of doing things. A totally disastrous drawing can teach you not to try that particular approach again! In essence, you also learn from mistakes.

Art Alert!

Buy only drawing papers and sketchbooks that are labeled acid free. Your drawings can be ruined when poor-quality paper deteriorates and turns yellow.

While soft-covered sketchbooks (sometimes called drawing books) tend to be a little less expensive, your drawings may become easily crumpled and damaged. A hardcover sketchbook is a much wiser choice. Because of its durable construction, it's also a practical alternative to carrying a drawing board when you travel or sketch outside. Your sketchbook should be small enough to be portable. However, choose one that is larger than 9 by 12 inches so your drawing options won't be too limited. Check out a few sketchbook options in the next illustration.

You don't need to be a dentist to examine the tooth of drawing papers. Tooth refers to the surface texture of paper and can range from silky smooth to very course. The more tooth a paper has, the rougher it feels to the touch. Stay away from papers with a glossy surface. Graphite doesn't adhere to them very well because they have almost no tooth.

Here's a small sampling of various types of sketchbooks and drawing papers.

Some artists like smooth paper, while others love to see rough, textured shading on coarse paper. Many prefer a drawing surface somewhere in between—not too smooth and not too rough. Consider the qualities of the following three types of paper:

◆ Fine tooth (smooth) paper allows you to draw your own textures, and creates nice smooth shading, which is especially important when you are drawing people. However, dark values are often difficult to achieve on very smooth paper.

This close-up of shading was rendered with a 6B pencil on smooth, fine-tooth paper.

◆ Medium tooth papers are ideal for most portrait drawings and work beautifully for rendering a full range of values from light to dark. The surface allows you to easily create diverse textures, such as smooth skin and shiny hair.

Shading with a 6B pencil on medium-tooth sketchbook paper created this wonderful delicate texture.

◆ Coarse, highly textured paper holds graphite very well. Some really great textures appear when the peaks of the paper grab the graphite and some of the crevices show through as white.

The peaks and crevices of rough paper helped create this textured shading.

Drawing papers come in various colors, textures, and sizes, and are great for experimenting with different shading techniques. Go to an art supply store and purchase as many types as you can comfortably afford. Play with sketching on each until you discover your favorites. Try my personal favorite, 140-pound, hot-pressed, smooth watercolor paper.

Portfolio Case

A hard-sided portfolio case keeps your paper and completed drawings safe from being crumpled or damaged. Use it to safely store or transport your drawing papers and drawings. Suggested sizes include 17 by 21 inches for small drawings and 23 by 31 inches for larger drawings.

You can easily make a portfolio from a large sheet (or two smaller sheets) of acid-free cardboard or matte board. You also need wide tape (duct tape is great), a sharp knife, and a straight edge or long ruler (such as a T-square). Follow these simple instructions:

1. Cut out a large, rectangular piece of cardboard. When choosing a size, take into account that you'll need to fold the cardboard in half. In other words, the finished portfolio will be half the size of your cardboard.

2. Reinforce both short ends with wide tape.

3. Draw a straight line (slightly off-center) parallel to the taped ends.

4. With your knife and a straight edge, cut very slightly through the board (sometimes referred to as scoring) along the straight line.

A large sheet of cardboard, with taped ends, is ready to be folded along the score line.

5. Fold your board along the scored line toward the side not scored.

6. Tape both short sides of your portfolio together, leaving an opening along the top.

7. Reinforce the bottom edge (the long side with the fold) with more tape.

8. To add handles, make two holes in the center section of each open side. Thread the ends of string or thin rope through the two holes and tie them together on the inside.

A drawing of a butterfly personalizes the side of this homemade portfolio case.

Warm Fuzzy

You are a unique and innately artistic being. Nurture your creativity! Decorate your portfolio with your own drawings and add creative handles such as brightly colored shoelaces.

Choosing Pencils

Artists have been drawing with graphite for centuries. It has withstood the test of time for permanence, and lends itself beautifully to all styles of drawing.

Pencils are your most important drawing tools, so buy the best quality you can afford. Cheap pencils may have hard spots in the lead, which can scratch your drawing paper and damage (or even ruin) your drawings. This is especially annoying when a big ugly scratch mark ends up in the middle of smoothly drawn skin.

I love mechanical pencils. They don't need to be sharpened, come in different sizes, and can hold various grades of graphite from very hard to soft. I use 0.5 mm (available in lots of stores)

for regular drawings and 0.3 mm (check out art supply stores) for very detailed drawings. For sketching loosely or on a large surface (or both), try 0.7 or 0.9 mm.

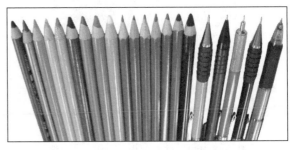

Here's a small sampling of my favorite pencils.

The graphite in some pencils is soft for making dark marks, and others have harder graphite for making lighter marks. Unfortunately, manufacturers of pencils didn't identify the various grades of pencils with fun names, such as Bertha or Harvey. Instead they assigned a letter and a sequential number to each grade.

H pencils tend to be hard and B pencils are soft. Think of an HB pencil as being in the middle, neither hard nor soft, fitting into either the H or B category. A 2H pencil is harder than an HB, and each progressively higher number (such as 6H) becomes even harder! On the other end of the scale, a 2B is softer than an HB, and a 6B is very soft for making very dark marks.

While some manufacturers make pencils all the way from 8H to 8B, you can make do nicely with only a few different pencils. Choose an assortment of both H and B pencils. The ones I use most frequently are 2H, HB, 2B, 4B, and 6B. In this selection, the 2H is the lightest (hardest) and the 6B is the darkest (softest).

A selection of H pencils (see their values in next drawing) works beautifully for light and middle values, and they are perfect for rendering highly detailed drawings.

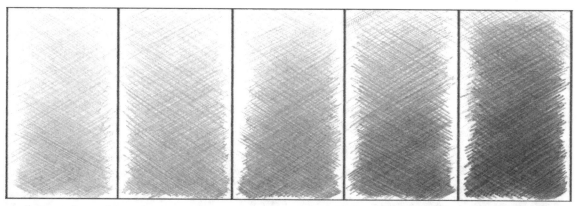

Here are a few value scales that can be rendered with some different H pencils, from 5H (on the far left) to 4H, 3H, 2H, and finally HB (on the far right).

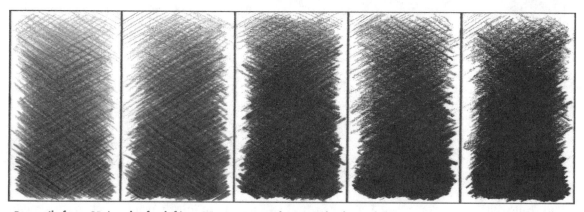

B pencils from 2B (on the far left) to 3B, 4B, 5B, and 6B (on the far right) create these wonderful middle and dark values.

B pencils, when used with H pencils, provide you with lots of flexibility for creating a full range of values in your drawings. In the second drawing above, you can see the diversity of a sampling of B pencils.

Supplies for Drawing with Paper

If you prefer to use sheets of paper rather than a sketchbook, a drawing board is a wonderful portable surface. Many art supply stores sell different types in various sizes.

Info Tidbit

If you (or someone you know) are handy with tools, you can make your own drawing board. Just cut a piece of thin plywood to a size slightly larger than your drawing paper and then sand it until it's smooth.

Your drawing paper can be taped or clamped to your drawing board. At most art supply stores you can find special tapes, specifically designed for this purpose, or clips which are available in various sizes. I prefer clips (available at most art supply stores) because tape can sometimes damage the paper.

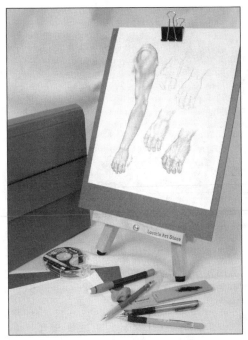

These supplies are all set up for sketching on sheets of paper.

Selecting Erasers

Many different types of erasers are available, but you really only need two: kneaded and vinyl. Kneaded erasers can be molded to a point or wedge, are great for erasing or lightening tiny sections of drawings, and don't leave eraser crumbs on your paper. If a section of shading becomes too dark, you can either pat, or gently rub, the surface of your paper with your kneaded eraser to make it lighter.

You can easily clean your kneaded eraser. Simply stretch and reshape (also known as "kneading") it several times until it comes clean. However, kneaded erasers eventually get too dirty to work properly, so pick up some extras.

Vinyl erasers aren't overly abrasive to the surface of your paper, and work well for erasing complete sections of drawings. When you need to erase a tiny detail on a drawing, you can use

a small slice of the eraser, which you have cut off with a utility knife. A pencil type of vinyl eraser is perfect for erasing grid lines and you can buy refills for it.

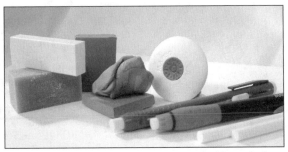

Vinyl and kneaded erasers are invaluable tools for both reparative and artistic uses.

Other Drawing Supplies You'll Need

When wandering through the labyrinths of art supply stores, it's tempting to pick up drawing supplies you don't need, but try to limit yourself to the basics as you're starting out. Here's a list of additional drawing supplies I frequently use:

◆ A pencil sharpener is a must have, even if you're mostly using mechanical pencils. You don't need a fancy or expensive one. Choose a basic, hand-held metal one with two openings for regular and oversized pencils. They seem to last forever and you can buy replacement blades for them.

◆ Sandpaper blocks have several layers of sandpaper, and are great for sharpening only the lead part of a pencil. Your pencils last longer when they aren't sharpened each time you simply need a sharper point. When one sheet is worn out, you simply tear it off and there's a fresh one underneath.

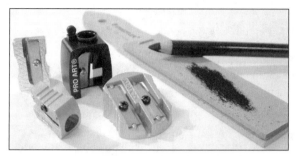

These artistic tools keep the points of your pencils sharpened.

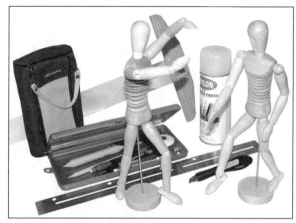

Expand your selection of artistic tools with additional drawing supplies.

◆ You need a ruler for drawing grids, outlining drawing spaces, and as a guide for cutting straight pieces of drawing paper with a utility knife. Find one with a beveled edge, so your drawings aren't easily smudged as you draw. Metal rulers are a little more expensive, but they last longer and are easier to use and clean.

◆ A utility knife is a great alternative to cutting paper with scissors. Your cut edges are straighter and neater. I prefer the ones with the little snap-off blades.

◆ A large zippered pencil case neatly holds your drawing media and erasers.

◆ Spray fixative protects your completed drawings from being accidentally smudged. Read the directions carefully, especially the part about spraying only in a well-ventilated area (such as outdoors). Less is more! Two or three thin coats are better than one thick coat.

Don't limit yourself to my suggestions. Check out some of the hundreds of different drawing materials and products currently available. But keep in mind that you don't need to spend a lot of money on lots of supplies and gadgets you may never use!

Setting Up an In-Home Studio

There's always a way to fit a personal drawing space into your life, from a corner of the dining room table to a large professional studio. You can have a lot of fun planning a place of your own with adequate space for you and all your supplies.

When you choose a location for your studio, consider your surroundings, such as its proximity to your computer and phone and the view from the windows. In the next illustration you can see why I chose my studio space.

Art Alert!

Don't use a spray fixative on your unfinished drawings, because you won't be able to erase anything. Even trying to draw on a sprayed surface can be frustrating; the spray changes the texture of the paper so the graphite doesn't adhere properly.

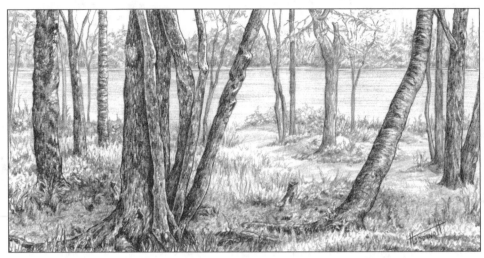

My very favorite part of my studio is this serene landscape outside the window.

Your special drawing place should be peaceful and free of distractions. If friends or family use the same space, compromises, careful planning, and respect are critical. Choose a drawing time that provides minimum inconvenience for others.

With a serious commitment to drawing and ample room in your home comes an opportunity to set up a fully equipped art space. An in-home studio provides privacy and a very special personal space you can design and customize to suit your needs.

Visit some furniture and art supply stores and look through some decorating books and magazines for ideas. Plan some shopping trips to stationery, art supply, business, furniture, and department stores, and explore a vast selection of potential options for customizing your very own drawing space.

Lighting

To prevent your eyes from becoming too tired, always make sure you have adequate lighting, such as natural light from a window in the daytime, and from artificial light on overcast days and during evenings. Use a flexible-neck study lamp to focus light directly on your drawing surface. Color schemes that are light and bright enhance available light sources, and also ensure that your special drawing place is hospitable and pleasurable.

Drawing Surface

You can set up a drawing surface on your kitchen or dining room table or on a computer or study desk. Make a sloped drawing surface by using books to prop up one end of a piece of plywood.

An adjustable drawing table or drafting desk provides additional comfort to creating art. Check out art supply stores, yard sales, or the classified ads of your local newspaper to find a drawing table or drafting desk that fits your budget and your space.

Selecting a Chair

A comfortable, adjustable chair saves your back from becoming tired and sore. Make sure your chair and drawing surface are conducive to proper posture. An ergonomically correct chair, with or without wheels, is a necessity if you spend several hours a week drawing.

Display, Storage, and Work Spaces

Bulletin or display boards are relatively inexpensive and provide display space for your drawings, inspirational images, photos, and art articles. You can even designate a specific wall in your home for an ongoing exhibition of your drawings.

Storage areas for your drawings and art materials keep your space organized and uncluttered. You may have some storage containers or shoeboxes already lying around your home. If not, you can find inexpensive plastic or cardboard containers in most department or craft stores. Storage containers can be easily put away under a bed, in a closet, in a drawer, or on a shelf.

If you have extra space in your studio, consider the following:

◆ A small table or storage cart on wheels can conveniently hold your drawing materials as you work.

◆ A worktable is perfect for cutting your drawing papers and for working on large projects.

◆ A shelving unit is ideal for storing your art books and frequently used drawing materials.

◆ A filing cabinet or a set of binders can keep your reference materials and files organized.

Helpful Hint

Three-ring binders are ideal for organizing art files, small drawings, and reference materials. I simply punch holes in text sheets and file them away in binders. I insert small drawings and photos into plastic sheet protectors, which are specifically designed for three-ring binders. Supplies for this type of file system are available in most department, stationery, and business supply stores.

Small drawings and reference materials stay organized and easy to find in three-ring binders.

Adding Comfort, Music, and Technology

A comfortable chair in which you can sit, read, and research your drawing projects allows you some precious opportunities for creative introspection.

From a simple set of headphones connected to a small music player to an elaborate sound system, a collection of your favorite music is a fantastic addition to any drawing space.

Your access to information and drawing subjects is greatly enhanced with technology. A computer, printer, scanner, digital camera, and photography supplies can enrich your personal drawing space and your artistic experiences.

Don't limit yourself to these suggestions. Be creative! You will enjoy customizing a drawing space to meet your individual needs. Make it a place you will enjoy spending time in.

Taking Your Art on the Road

Having a set of drawing materials prepacked and ready to go is convenient when you travel. A quick sketch done on location from your portable studio provides an excellent reference for a more-detailed drawing when you return to your home studio.

Consider the following when planning a portable studio:

◆ An old briefcase, knapsack, or a toolbox or fishing box (available at hardware stores) is great for holding your supplies and even a lunch.

◆ If you like to draw on sheets of paper, you need your drawing board and tape or clips. A hardcover sketchbook is a great alternative to a drawing board and will often fit inside a briefcase or knapsack.

◆ Your portfolio case protects your completed drawings and drawing paper.

◆ A portable music player with headphones blocks many distracting noises, and helps keep spectators from interrupting your work!

◆ Whenever you draw outside, carry an old blanket to sit on and a couple of plastic bags to protect your drawings (or you) in case of rain.

◆ Depending on where you go, you may also need bug repellant.

◆ Don't forget your sunscreen!

The Least You Need to Know

- Always purchase the best quality art supplies that you can comfortably afford.
- Make sure drawing papers and sketchbooks are acid free.
- It's easy to make a portfolio to protect your drawings.

- Create a peaceful drawing space in your home that is comfortable, with adequate lighting, and free of distractions.
- Have a basic set of drawing materials prepacked so you can spontaneously take your art outside your studio.

In This Chapter

- ◆ Getting to know the families of lines
- ◆ The ultimate drawing tool: your left brain and right brain working together
- ◆ Positive and negative spaces
- ◆ An exercise in switching sides of your brain
- ◆ Putting your face on paper

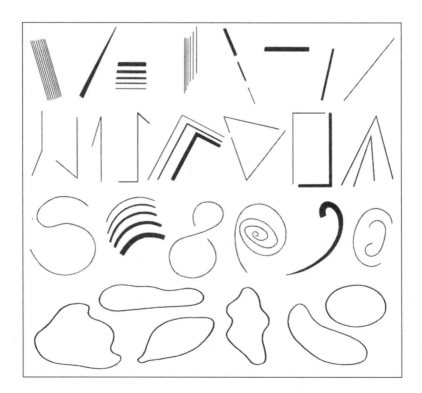

An Eye for Lines and Spaces

The humble line is the primary building block for constructing drawings. You can use lines to illustrate everything you can see in the world around you, as well as all the stuff floating around inside your imagination.

In this chapter, you discover how to identify each family of lines. I tell you a little about the artistic merits of each side of your brain, and how they work together or separately, to help you see and draw lines. In simple step-by-step exercises, you use lines to create an optical illusion and draw an outline of your own face.

Welcome to the World of Lines

Lines can visually separate the forms of the various parts of a person's body and face. Contour drawings (also called line drawings) are made up of lines, which outline the contours of a subject's forms and parts. Lines can create an infinite array of simple or highly detailed contour drawings. In the next drawing, a few simple lines tell you a lot about the little boy, such as his facial expression and hair style.

This expressive contour drawing of a boy is made up of simple lines.

Several lines can be grouped to make a set. Sets of lines come together to create shading, which helps you add realistic, three-dimensional depth to your drawings. (Refer to the chapters in Part 2 to discover how to render shading.) Compare the next drawing, with shading, to the previous contour drawing of the same boy.

Sets of shading lines create the three-dimensional forms of this boy's face and hair.

Three "families" of lines (straight, angle, and curved) can be combined to make line drawings. Each family includes an endless range of different lines from thick, dark, and bold, to thin, light, and delicate.

Encircling People with Curved Lines

Curved lines are by far the most common lines used for drawing people. When a straight line curves or bends (as in the letters "C" and "U"), a curved line is born. A compound curve is created when a curved line changes direction (think of the letter "S"). A curved line becomes a circular shape (as in the letter "O") when its ends meet.

Circular shapes are the primary ingredient for drawing the numerous and varied forms of the human face and body. Examine the rounded shapes in the next drawing that come together to create a mouth, eye, and nose.

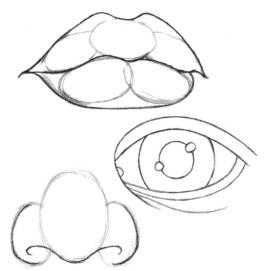

These facial features are rendered with curved lines and rounded shapes.

Examine the next two drawings. In the first, you see various curved and compound curved lines. All the shapes in the second drawing are made up of curved lines. Take a moment, look at objects around you, and see how many curved lines you can see. Try drawing some different curved lines and circular shapes in your sketchbook.

When different types of curved lines meet, diverse rounded shapes are created.

Lining Up Straight and Angle Lines

Straight and angle lines also have a place in drawing people. They are fundamental for rendering many types of shading.

Warm Fuzzy

Don't worry if your first few tries at drawing straight lines freehand end up curvy. With practice you will get better. In the meantime, it's perfectly okay to use a ruler when you need to draw precise straight lines, such as those needed for drawing a grid.

Straight lines can be thick or thin, long or short, and they can be drawn in any direction. Each falls into one of these three categories:

- Horizontal lines are level and at a right angle to vertical lines.
- Vertical lines are straight up and down and at a right angle to horizontal lines.
- Diagonal lines slant or slope at an angle.

Angle lines occur when two straight lines meet (or join together). Angle lines are used to draw straight sided shapes, such as squares, rectangles, and triangles.

The first drawing (in the set of two on the next page) has examples of the three types of straight lines. The second shows several variations on angle lines. Practice drawing various types of straight and angle lines in your sketchbook.

Try your eye at identifying horizontal, vertical, diagonal, and angle lines.

Picking Your Brain Apart

Many drawing tools, such as pencils and paper, are integral to creating drawings. However, the most important drawing tool of all is your brain. Your brain collaborates with your vision to identify lines, which are critical components of drawing people.

Info Tidbit _____

Both sides of the brain don't always work together in harmony. Many artists have noticed that they can't talk coherently and draw well at the same time. Talking is considered a left-brain function, and many aspects of drawing are processed by the right brain.

Every aspect of your artistic development is enhanced with a basic understanding of how your brain works. Your brain has two sides, the right hemisphere (right brain) and the left hemisphere (left brain). Left-brain thinking is analytical and verbal. Right-brain functions are visual and perceptive. My philosophy is that both sides of your brain play an equally important role in drawing.

Your Logical Left Brain

The very nature of academic education tends to enhance left-brain functions. The left brain controls most mathematical and verbal skills. As a result, many persons are left-brain dominant. Your left brain helps you draw by …

◆ Using mathematical logic to establish proportions, such as examining measurements of lines and spaces, and drawing grid lines.

◆ Naming the individual parts of the person you are drawing.

◆ Analyzing the numerical and verbal sequences of step-by-step instructions.

◆ Keeping track of time frames when needed, by constantly referring to a watch, clock, or computer as you draw. This is especially important if you have scheduled appointments, meetings, or personal commitments.

Your Creative Right Brain

Many of the perceptive skills needed for drawing are processed by the right brain. Your creative and insightful right brain plays various roles in drawing, such as …

◆ Seeing abstract connections between lines, shapes, and spaces.

◆ Helping with the process of drawing in a non-narrative context by instinctively seeing proportions.

◆ Combining the varied visual components of your drawing subject to form a whole image.

◆ Planning instinctive compositions.

◆ Allowing you to better concentrate on drawing by blocking distractions and losing track of time.

Seeing Lines, Spaces, and Shapes

Contour lines can outline a complete person, as well as the many small sections and intricate details of his or her face and body. Contour lines exist wherever the shared edges of the shapes of two spaces meet—on your face, in your home, at the coffee shop, and everywhere else! You simply need to train your eyes and brain to work together to see them.

Simply stated, positive space is the space occupied by an object or person and/or its various parts. Negative space is the background around and/or behind the positive space. Both positive and negative spaces assume distinctive shapes, sort of like pieces of a puzzle. Being able to see the shapes of positive and negative spaces allows you to find and subsequently draw lines. Try this exercise to practice seeing positive and negative spaces:

1. Think of the shape in the first drawing (in the next illustration) as a piece of a puzzle.

2. Use your imagination to visually lift the shape out of the first drawing and place it into the white space inside the negative space (the second drawing).

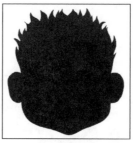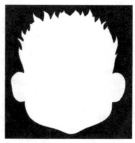

Visually lift out the positive space (left) and put it inside the negative space (right).

3. Find the lines where the two types of spaces meet.

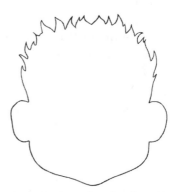

This outline of a boy's head is found between positive and negative spaces.

You can simplify your mental image of any person into simple lines, spaces, and shapes. Practice looking at people and visually identifying them as positive spaces. Identify their surroundings as negative spaces. You can find their outlines where the two spaces meet.

Switching the Sides of Your Brain

Exercising some dormant abilities of your right brain helps you draw better. The right brain sees lines differently than the left brain. It focuses on the way the lines curve, and how they create shapes and spaces.

Helpful Hint

The next time you go outside on a cloudy day, sit or lie down, relax, and examine the clouds. Your left brain sees only clouds. However, your right brain eventually allows you to see other things in clouds, such as objects, animals, or faces.

Sometimes when you look at a picture for an extended period of time, each side of your brain registers a completely different image. The following exercise, sometimes referred to as an optical illusion, helps you notice when your brain switches sides.

Take a look at the next drawing. What do you see? Do you see a vase? Can you see two faces?

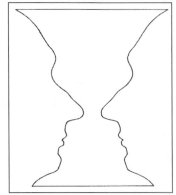

Stare at this drawing until you can see two different images, a vase and two faces in profile.

If you could see both the vase and the two faces, you just experienced a switch of your

right- and left-brain functions. If you had difficulty seeing both, the next two drawings may help. In the first one the vase is black. In the second, the profiles of two faces are black.

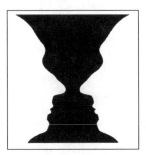 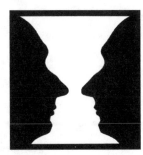

These two silhouette drawings solve the mystery of the vase and two faces!

Creating Magic with Faces and a Vase

Symmetry in drawing is a balanced arrangement (sometimes referred to as a mirror image) of lines and shapes, on opposite sides of an often-imaginary center line. Now it's time to create your own optical illusion using the magic of symmetry!

You'll need a ruler, pencils, and an eraser. Read carefully through all the instructions for the entire project before you begin, refer to the first drawing on the next page, and then follow these steps:

1. Use your ruler to measure the horizontal midpoint of your paper and very lightly draw a vertical line down the center. This line serves as a reference to help keep both sides of your drawing symmetrical.

2. Draw a facial profile (facing the right) on the left side of your paper. (If you are left-handed, draw the profile facing the left on the right side of your paper.) As you draw each part of the face, think about its name: forehead, nose, lips, chin, and neck. This is a very left-brain exercise. By the way, the farther your facial profile is from the center line of symmetry, the wider your vase will be. For a narrow vase, draw the face closer to the center line.

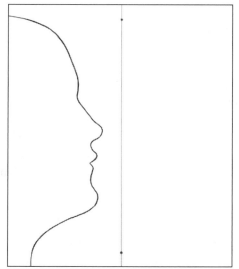

This facial profile completes one side of the vase.

3. Draw a second facial profile facing the first. I prefer to turn my paper upside down or sideways to draw the second face. As you draw, *don't* think about naming the parts of the face. Constantly refer to your first drawing on the opposite side of your paper. Imagine you are drawing its reflection in a mirror. Think about the shapes of the spaces in between the two profiles. Concentrate on the lines and the directions in which they curve, their angles, and the lengths of the lines as compared with your first drawing.

? Info Tidbit _____

Drawing upside down or sideways exercises your right brain by confusing your left brain. When the left brain can no longer identify and name the individual parts of a face, it gives up. Your right brain jumps in and takes over.

You may notice that you are drawing somewhat differently for this second profile. Your right brain is now in charge!

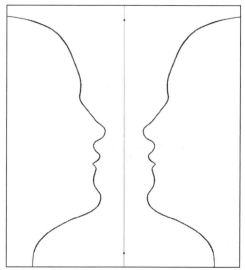

With the addition of a second facial profile, both sides of the vase are complete.

4. With a ruler, draw two horizontal lines. The first runs across the top of your paper and the second along the bottom. These lines don't have to be the same length. However, the points, where the ends of these lines meet the facial profiles, should be the same distance from the center line of symmetry. Adjust your drawing accordingly.

5. Erase the line of symmetry and any extra facial lines outside the perimeter of the vase.

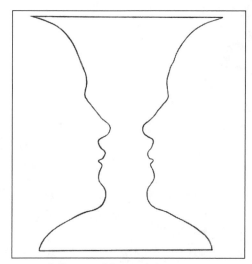

The magical illusion of faces and a vase is complete.

Sharing the Magic

You can have lots of fun creating and sharing a personalized collection of faces and vase drawings. Think about drawing original and unique gifts for your family and friends with this amusing illusion. Consider the following options:

◆ Dig into your imagination and make up a unique facial profile.

◆ Have a friend or family member pose sideways and make a contour drawing of his or her profile.

◆ Take a photo of someone's facial profile and use it as a reference for drawing.

When you have an outline of the side of a face, you can follow the instructions in the previous section to create a totally original optical illusion.

This photo was the inspiration for my optical illusion.

Drawing a Self-Portrait with Lines

In addition to separating the shape of a human head from the background, lines can outline individual facial features. The goal of this exercise

is to identify, and then draw, the contour lines of an actual, real-life face and its features.

All you need is your drawing supplies and your reflection in a mirror! Step-by-step drawings can't really help since I don't know what you look like. However, I guide you through the whole process with simple instructions. Before you begin to draw your own self-portrait, examine the next contour drawing of a real-life person, and visually locate the lines that separate the following:

◆ His eyebrows from his forehead

◆ His eyes, nose, and mouth from his face

◆ The irises of his eyes from the eyes

◆ The forms of his ears from his head

◆ His upper lip from the lower lip

Simple lines identify the sizes, shapes, and locations of this young man's facial features.

Info Tidbit

Very few faces are truly symmetrical. However, frontal views of faces look more realistic when drawn proportionately similar on both sides.

Locating Lines, Shapes, and Spaces

In the following exercise, you examine your reflection in a mirror to become familiar with your own face from an artistic perspective. The only drawing tools you need are your brain and vision.

1. Visually explore the shape of your face and look for lines (and I don't mean laugh lines). Size up the edges along your cheekbones, jaw, and chin. Take note of the directions in which curved lines bend.

2. Locate curved lines that change directions to make compound curves, such as in the letter "S."

3. Identify circular shapes. Examine your eyes, eyebrows, nose, mouth, and ears.

4. Visually measure the distances between lines and shapes that appear to be the same length or height. For example, compare the width of your nose to the width of each eye and the space between your eyes.

5. Take note of the sizes of the spaces between individual shapes on your face. Size up the vertical distance from the bottom of your nose to your upper lip, and compare it to the space between your lower lip and the bottom edge of your chin.

Continue looking at your face until you can see numerous lines, shapes, and spaces.

Putting Your Face on Paper

Drawing a frontal view of your face is easier than drawing it from an angle. Find your drawing supplies and set yourself up in a location where you can comfortably see your reflection in a mirror. Use whichever pencils you prefer.

1. Examine your face (see the previous section) and identify the lines, and the sizes and shapes of the various spaces.

2. Look at your drawing paper and imagine your face on the paper.

3. Decide where on the paper your face is to be positioned.

4. Use loose sketch lines to draw the basic outline of your head. Continuously refer to your reflection in the mirror.

5. Lightly sketch the outlines of the shapes of your ears, eyes, nose, mouth, and hair. Continue visually measuring the vertical and horizontal distances to help you put everything in the right place.

6. While constantly referring to your reflection, adjust the various lines in your sketch.

7. When you're happy with your sketch, you can darken and refine your lines.

Helpful Hint

When drawing a frontal view of a face, draw a line of symmetry on your paper before you begin. This line serves as a guideline for visually measuring horizontal distances so the head and face don't end up lopsided.

The Least You Need to Know

- Lines are the main ingredient for all aspects of drawing, including shading.

- When you can see and draw the shapes of positive and negative spaces, your line drawings will become more proportionately correct.

- When you draw, you employ valuable resources and abilities from each side of your brain.

- You can enhance your artistic development by practicing mental and visual exercises, such as optical illusions.

In This Chapter

◆ Horizontal or vertical: selecting a format for your drawing

◆ Choosing and emphasizing centers of interest

◆ Proportion, balance, overlapping, and other compositional guidelines

◆ A step-by-step exercise in planning a successful composition

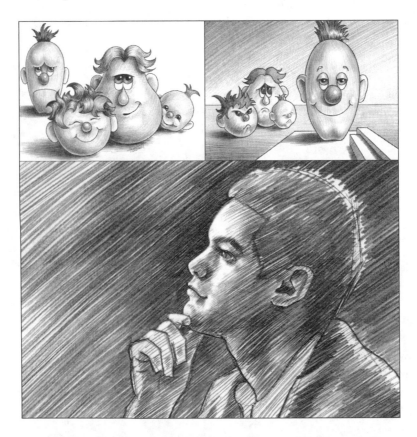

It's All in the Composition

I bet you've heard somebody say, "I don't know much about art, but I know what I like." Chances are, the reason why that person intuitively likes a particular drawing is because it has a strong composition. Composing drawings of people relies on your personal preferences and an understanding of basic compositional guidelines.

Composition refers to the arrangement of the various parts of your drawing subject within the borders of a drawing space. A strong composition brings the eyes of the viewer to what you consider to be the most important elements in your drawing. In a drawing of a face, it can be the eyes; and in a figure drawing, it can be the face, a hand, or even an elbow!

In this chapter, I tell you about a few integral compositional components for drawing people. Then, you can follow along with me through the process of applying compositional principles to the planning of an actual drawing.

Placing People into a Space

The shape of your drawing space (also called a drawing format) helps determine how your composition will look. Rectangular formats are the most popular. However, other options, such as circles, ovals, or squares, challenge an artist to enjoy experimenting with more unusual creative compositions.

When choosing a format, consider the shape of your subject and which aspects are the most important to you. You also need to make sure there's plenty of room in your drawing format to include important extras. For example, if your model is a baseball player in uniform with a ball and bat, or a dancer in a beautiful costume with a fancy umbrella, the props, pose, and clothing all add character to your drawing.

A vertical drawing format fits the shape of a sitting or standing figure quite nicely. In the next drawing, I chose a vertical format to draw a seated female figure. A horizontal format would have left a lot of wasted space.

If you consider only the upper section of a person to be important, the composition may be more effective by not including the lower section of the body. Either a vertical or horizontal format can work.

I included only the upper section of the violin player's body in the composition below. The mischievous grin on his face and the intricate details of his hands playing the violin become the centers of attention.

A vertical drawing format works well for this figure drawing of my friend Claudette.

My friend Christopher and his violin fit beautifully within this horizontal drawing space.

Primary and Secondary Focal Points

A primary focal point is the most important center of interest (or focus) in a drawing. In a portrait it may be the eyes, the entire face, or a whole section of the body that is especially fascinating.

A drawing can have more than one center of interest, known as secondary focal points. In the drawing of the violin player in the previous section, the face is the primary focal point, and his hands and violin are secondary centers of interest.

The following cartoon drawing demonstrates a fun composition with a primary focal point and three secondary ones.

This primary focal point takes center stage as three secondary focal points look on.

Helpful Hint

Your choice of focal points is personal to you. Remember what attracted you this particular subject in the first place and select your focal point accordingly.

Art Alert!

Don't position a focal point dead center (sometimes called a *bull's eye*). Although this serves to make your focal point stand out, all the other parts of your drawing might be ignored and your overall composition becomes weak.

Once you decide on a primary focal point, you need to find ways to make it stand out within your drawing space. Consider the following:

◆ Give the focal point more space within your drawing format than other components. For example, a face can be drawn larger than anything else.

◆ Position your focal point within the boundaries of your drawing space so it commands attention and the viewer's eye is drawn to it. A focal point becomes more powerful when you place it off center. For example, a face that is angled toward the left can be positioned closer to the right side of your composition.

◆ Draw your focal point with more detail and a stronger contrast in values than other aspects of your drawing.

◆ Use objects to "point" to your focal point. For example, drawing some less-interesting objects (secondary focal points) close to the primary focal point helps direct the viewer's eye toward your center of interest.

Putting Compositional Pieces into Place

Your drawings become more aesthetically pleasing when the various components within your drawing space are harmoniously balanced. When you have devised a plan for emphasizing focal points, you are ready to consider other important aspects of composition.

Understanding the following basic guidelines of composition allows you to place more trust in your intuitive abilities:

◆ Proportion is the relationship in size of one component of a drawing to another or others. Viewers tend to pay more attention to those areas of your subject that occupy more space within your drawing. To bring attention to parts that you consider important, draw them proportionately larger than they actually are. For example, I love drawing hands and I usually draw them quite large. Assign less space to areas you consider unimportant.

◆ Balance refers to a stable arrangement of subjects within a composition. Before you begin to draw, identify the shapes of individual masses of light and dark values. Try not to have all the dark objects or all the light objects on one side of your drawing space. You can bring balance to a lopsided composition by moving various components slightly up or down or to the right or left. Values can be balanced by drawing some sections lighter or darker than they actually are.

◆ Some edges of the subject can serve as lines to help navigate a viewer's eye around your composition. (I demonstrate this concept later in the chapter.)

◆ The shapes and values created by positive and negative spaces need to be balanced within a composition. (I tell you about positive and negative space in Chapter 3.)

Creating Unity with Overlapping

Overlapping refers to the position of a drawing subject in a composition, when it visually appears to be in front of another (or others). Overlapping gives the illusion of depth and is especially important when you draw more than one person (or a person with additional objects) in the same drawing. Multiple subjects, which are positioned so some overlap others, give a drawing a sense of unity.

In the next illustration, compare two different compositions with the same four silhouette shapes. The first, without overlapping, looks disjointed and scattered. The second shows the strong unified composition created by overlapping the four shapes. Overlapped, they look like one large shape rather than four little ones.

Four shapes come together and overlap one another to create a stronger, more interesting composition.

Refer to the following cartoon drawing and identify three levels of depth:

◆ The older child, with the big smile and the curly hair, is in the foreground (the front).

◆ The light-haired adult and the baby peeking out from behind him are in the middle ground.

◆ The grumpy-looking dark-haired adult is in the distant space (behind the others).

This fun cartoon demonstrates how overlapping creates the illusion of depth.

The Rule of Thirds

Although I rely primarily on my instincts for planning composition, I often take the rule of thirds into consideration. The rule of thirds is a simplified variation of an ancient Greek compositional formula known as the golden mean. This simple formula works beautifully for drawings of people by identifying ideal locations for focal points.

Setting up your drawing format for a rule of thirds is quite easy:

1. Draw a horizontal or vertical rectangular drawing format.

2. Divide your drawing format into three equal sections both vertically and horizontally (nine sections in total).

Any of the four points where the lines intersect (I've drawn circles around them in the following illustration) offer a great place for a focal point. The best two points are the ones on the upper- and lower-right. We are taught to read from left to right. This is why the eye usually enters a drawing from the lower left. By placing a focal point on the right, the viewer is naturally brought into a drawing and towards the focal point.

This rule of thirds composition identifies four ideal places for focal points.

Planning and Playing with Composition

You've probably heard the old expression "When you know the rules, you can break them." For a discussion on composition, I prefer, "The more you understand composition, the more you can trust your intuitive abilities." In other words, never allow a compositional rule to pull rank on your instinctive abilities to compose a drawing.

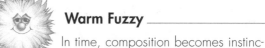

Warm Fuzzy

In time, composition becomes instinctual. You discover ways to successfully modify guidelines and break rules without sacrificing the artistic integrity of your composition.

It's time to follow along with me and take a compositional concept through its various stages of planning. The subject is a profile of a young man looking upward. My compositional goals include the following:

◆ I want his facial area to be my focal point, and I plan to use a simplified version of the rule of thirds.

◆ His head needs to be the largest section of the drawing, to help bring attention to his face.

◆ I plan to balance my subject within the drawing space by playing with the shapes created by positive and negative spaces.

◆ I will use extremely dark and very light values beside one another to make his face stand out.

Putting the Focus on the Focal Point

To keep the composition simple, my rectangular horizontal format will contain only his head, shoulders, and right hand. Refer to the next sketch and follow along with me as I plan ways to emphasize his face:

◆ The rectangle is first divided into nine equal sections. His head is sketched in the upper-right, with his eye close to the point where the lines intersect. According to the rule of thirds, this is an ideal location for a focal point.

◆ His face is tilted upward to help create an introspective mood. I drew three parallel lines on his face to help place the angle of his features correctly.

◆ His head occupies the most space within the format so as to bring attention to his face.

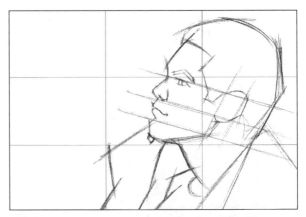

This simple sketch places a man's facial profile into a rectangular drawing space.

Checking Positive and Negative Spaces

I have used a computer program to fill the negative space with a dark gray tone. As I assess the composition, my instinct tells me I need more negative space on the right to balance the composition.

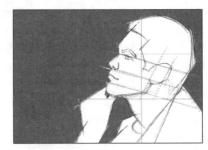

By assessing the negative space, I discover that the man's head appears to be too close to the right.

The composition seems to work much better when I move the figure a little to the left and add more space behind him.

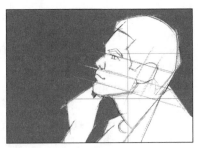

The vertical lines of the drawing format have been adjusted so the figure has more space behind his head.

Helpful Hint

By checking the positive and negative spaces, you can get an understanding of how the composition is working. Do a rough sketch, outlining the spaces, and fill in the negative space with shading. Another option is to scan the outline and fill in the negative space with a computer program such as Adobe Photoshop (like I did).

Following the Visual Flow

A viewer's eye enters a composition from the lower left. My goal is to find a way to keep the viewer engaged within my drawing space for as long as possible.

In the next illustration, I've numbered the elements that can help the flow of this composition. By identifying these visual aids, I then have the option of using shading to make them stand out more.

1. The viewer's eye enters the drawing space.
2. The angle of the edge of the hand draws the viewer toward the face.

3. The outline of the nose, the curved shape of the eyebrow, and the edge of the hairline bring attention around the face.
4. The shape of the ear draws the eye downward.
5. The edge of the collar of his shirt brings the eye toward the left.
6. The other side of his collar catches the viewer's attention and brings attention up toward the hand.
7. The details of the hand bring the focus back toward the face.

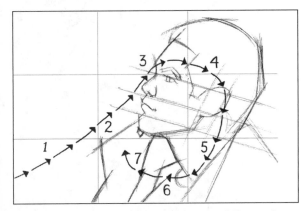

Arrows and numbers identify the visual flow I plan to emphasize with creative shading.

The various parts of the figure in this drawing provide me with an opportunity to keep the viewer's eye engaged within a circular flow. I hope to accomplish this goal by using a strong contrast of values around this circular shape.

Using Contrasting Shading Techniques

Contrast refers to the comparison of different values when put beside one another, and is an invaluable tool for heightening the effects of composition. (I tell you more about contrast in Chapter 21.)

High-contrast shading is created by placing the darkest darks next to the lightest lights. You can use this shading strategy to help accentuate the flow areas of a composition and draw attention to the focal point. Low-contrast shading has a limited range of values and works well to play down areas in a drawing that aren't as important.

I will use high-contrast shading to exaggerate the facial area and the directional flow plan. Low-contrast shading will detract attention away from less-important areas.

With the completion of this thumbnail sketch, the groundwork is now laid for creating a compositionally strong artwork. If you'd like to do a detailed drawing of this young man, refer to the step-by-step instructions in Chapter 21.

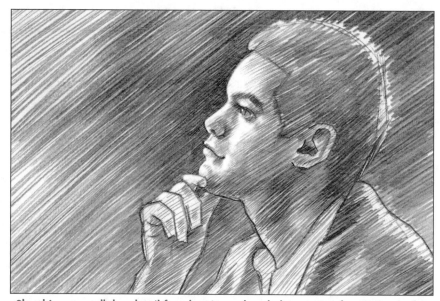

Sketching a small thumbnail for planning values helps prevent frustrating problems when shading the more detailed drawing.

The Least You Need to Know

- Choose a drawing format that best fits your subject, either horizontal or vertical.
- A composition becomes more intriguing when you highlight your center of interest.
- You become more confident in planning your drawings when you understand basic guidelines of composition.

- Taking the time to carefully plan a composition, before you begin drawing, saves a lot of frustration later.
- A shading plan, in the form of a thumbnail sketch, provides you with a blueprint for your composition.

In This Chapter

- ◆ Explore and identify different perspectives
- ◆ Watching someone disappear into distant space
- ◆ Create the illusion of spatial depth with figures
- ◆ A unique perspective on foreshortening

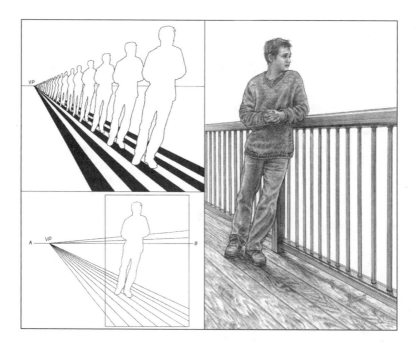

New Perspectives on People

The mysterious illusion of a third dimension on a flat piece of drawing paper is created with perspective. Perspective is the very foundation on which your compositions either stand or fall. A basic insight into perspective allows you to draw people, and various parts of people, visually correct and more realistic.

In this chapter, your perception of reality is about to be challenged! I show you how to identify some visual distortions of perspective and explain how to apply them correctly to your drawings. Simple perspective guidelines let you record the physical proportions of individuals as you actually see them, rather than as you know them to be.

Putting Everything into Perspective

The farther away people or things are, the smaller they appear to be. Artists use geometric perspective (sometimes called linear perspective) to draw this illusion in such a way that their subjects seem to recede into distant space.

When you look straight ahead, an imaginary horizontal line known as the horizon line divides your line of vision. In essence, the horizon line and your eye level are one and the same. Wherever you move—from the top of the highest mountain to the lowest valley—your eye level always stays with you.

As an artist, you can create the illusion that the viewers of your drawings are above, below, or at eye level with the people and objects in your drawing. You determine the viewers' eye level by choosing the horizontal position of the horizon line.

Examine the next drawing and pretend that you are the figure standing on the rock. The horizon line represents your eye level. Sections of objects (or people) that touch the horizon line are at your eye level. All things that are higher than your eye level are above the horizon line. Everything lower than your eye level is below the horizon line. If this were real life, you'd have to look upward to see the objects above the horizon line and look down to see those below.

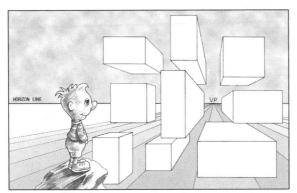

Boxes float above, at, and below the horizon line, which is also the boy's eye level.

Perspective lines (invisible in real life) are straight, mostly angular lines, which extend from the edges of objects and people, back to the horizon line. An imaginary point on the horizon line, where perspective lines seem to converge, is called a vanishing point (marked VP in the previous drawing).

One-point perspective is the technique of using a single vanishing point to create the illusion of a straight-on view into distant space. The illustrations throughout this chapter show how one-point perspective creates the illusion of three-dimensional spaces, and transforms two-dimensional shapes (such as squares) into three-dimensional forms (such as cubes).

Info Tidbit

Everything and everybody at your eye level seem to touch the horizon line, and their perspective lines converge both downward and upward.

A Worm's Eye View from Below

People (or individual parts of people) that are above your eye level are above the horizon line. Their perspective lines converge downward to a vanishing point. If you want viewers to feel as though they are looking upward, you draw your subjects above the horizon line.

In the interest of simplicity, I use boxes to illustrate this concept. However, the same theory applies to a human figure when viewed inside an imaginary tall rectangle. Later in this chapter, I tell you more about human figures viewed in perspective.

In the next drawing, you are the viewer. The horizon line (your eye level) is straight ahead of you. However, you get the feeling that the boxes are all above you. You sense that you are below the cubes, looking up into the sky, at a bunch of kites or balloons. The perspective lines look like strings holding the boxes from flying away. Each perspective line converges at the same vanishing point (marked VP).

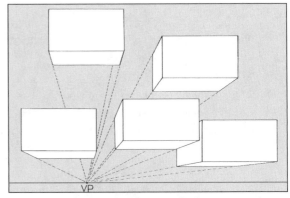

This worm's eye view has you looking upward at boxes above the horizon line.

A Bird's Eye View from Above

When you draw people and objects below the horizon line, you create the illusion that the viewer of your drawing is looking downward. The perspective lines below your eye level (horizon line) all converge upward.

As you look at the next drawing, imagine that you are standing at the top of a tall building or flying in a plane. Your eye level (the horizon line) is straight ahead of you, and you feel as though you are looking downward at the boxes. The horizon line is above the boxes, close to the top of the drawing space. The perspective lines angle upward toward the horizon line and converge at the vanishing point.

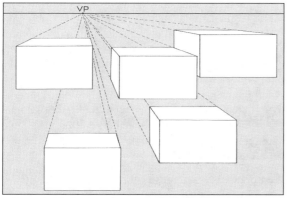

From a bird's eye view, you feel as though you are looking downward at these boxes.

Helpful Hint

When using geometric perspective, always draw the horizon line parallel to the upper and lower sides of a square or rectangular drawing space.

Drawing a Three-Dimensional Form

You can have some fun with one-point perspective in the following exercise. You draw a horizon line, a vanishing point, and use perspective lines to draw a simple box. Find a pencil, paper, eraser, and ruler, and follow along with me:

1. Use your ruler to draw a horizon line that is parallel to the top and bottom of a square or rectangular drawing space.

2. Add a small dot on the horizon line to represent the vanishing point. If you wish, you can mark it VP.

3. Draw a rectangle (or square) slightly below (or above) the horizon line. This rectangle or square represents the flat frontal face of a box and will be closer to the viewer than any of its other five sides. The horizontal lines need to be parallel to the horizon line. Both vertical sides need to be perpendicular (at a right angle) to the horizon line.

The rectangular shape represents the front side of a box. The letters "VP" identify the vanishing point on the horizon line.

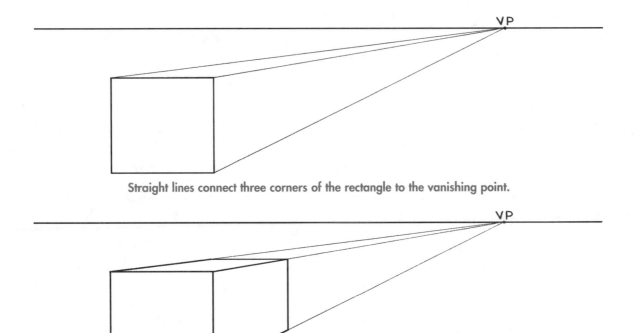

Straight lines connect three corners of the rectangle to the vanishing point.

This realistic box is accurately rendered with proper perspective.

4. Use your ruler to connect three corners of the rectangle to the vanishing point as in the drawing above. These three lines recede into space and converge at the vanishing point to identify the top and one side of the box.

5. Complete your drawing of a box by adding two more lines. The horizontal line at the top is parallel to the upper edge of the rectangle (and to the horizon line). The vertical line, representing the rear side edge of the box, is parallel to the sides of the rectangle (and perpendicular to the horizon line).

Moving People into Distant Space

Perspective challenges you to draw people, individual parts of people, and objects the size you actually see them, instead of the size you know them to be. Everything and everybody appears smaller the farther they are away from you. The closer they are to you, the larger they look.

Watching People Disappear

People seem to completely vanish when they get close to the vanishing point, but not like disappearing into the Bermuda triangle! Because someone is too far away to still be in your line of vision doesn't mean he or she has actually disappeared. They simply become too tiny to see.

Think of the stripes in the adjacent drawing as a bridge extending from the foreground all the way back to the vanishing point (VP). Consider each figure standing on this bridge to be the exact same size. Note the following illusions of geometric perspective:

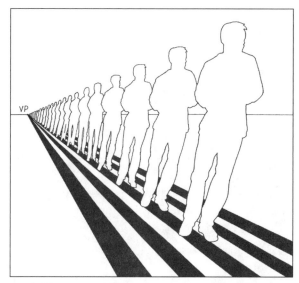

The figures in this long lineup appear smaller the closer they are to the vanishing point.

◆ The dark stripes become narrower, and the spaces between them are smaller, the closer they are to the vanishing point.

◆ The outlines of the figures appear to become smaller, until they finally seem to disappear into the vanishing point.

◆ The figures appear closer together the nearer they are to the vanishing point.

Look at the outline of the largest man in relationship to the vanishing point:

◆ Imagine a line extending from the top of his head back to the vanishing point. The tops of the heads of each man behind him are also touching this same line. Note that the upper section of each figure is above your eye level (the horizon line).

◆ Pretend a second line goes from the bottom of his shoes to the vanishing point. The bottoms of the shoes of all the other men are also along this line. Observe that the lower sections of all the men's bodies are below the horizon line.

◆ An imaginary line drawn through his waist (and the waist of each of the other men) to the vanishing point would be on the horizon line (at your eye level).

◆ The horizontal locations of all other parts of his and all other bodies, such as shoulders, elbows, and knees, also converge at the same vanishing point.

The next simple line drawing of a figure leaning on a railing is rendered with one-point perspective. All the edges of the boards on the deck, and the horizontal metal railings, extend back to the exact same vanishing point on the horizon line.

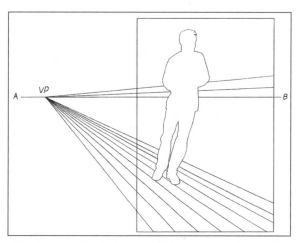

The lines of the deck and railings all converge at the same vanishing point.

Warm Fuzzy _____

Be patient with yourself! Your abilities to render perspective accurately will improve with practice and will eventually become instinctive. Careful observation of people and objects around you expands your understanding of perspective.

The next detailed drawing of a male figure, standing on a wooden deck, illustrates a practical application for the illusion of geometric perspective.

My friend Rob is leaning on a railing and standing on a deck, realistically rendered with geometric perspective.

Receding into the Distance

When drawing two or more figures standing (or sitting) in the same drawing, you often want to draw one farther away than the other. Perspective can help you draw those figures proportionately correct to one another. Drawing people with perspective is as easy as drawing rectangles or squares. Follow these steps:

1. Outline a horizontal, rectangular drawing space, approximately 11 inches wide by 8 inches high.

2. Draw a horizon line in the upper half, and add a vanishing point on the far right.

3. Draw a vertical rectangle 7 inches tall by 2 inches wide. Both vertical sides need to be perpendicular (at a right angle) to the horizon line. The top and bottom is horizontal. This box represents a standing figure who is 7 units tall by 2 units wide. (You can explore the proportions of figures of all ages in Chapter 17.)

A vertical rectangle represents a standing figure.

4. Use your ruler to connect each corner of the rectangle to the vanishing point.

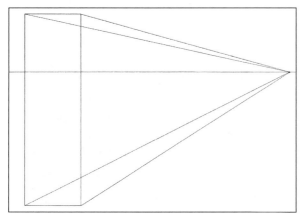

A line connects each corner of the rectangle to the vanishing point.

5. Draw a vertical line connecting the two inner perspective lines. The closer to the vanishing point you draw this line, the smaller the figure will be, and therefore the farther away from the first figure.

6. Draw two horizontal lines connecting the top and bottom of this vertical line to the two outer perspective lines.

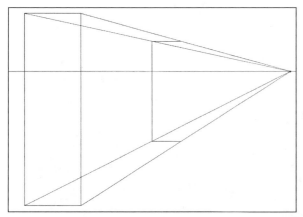

Plot the position of the second rectangle using the perspective lines.

7. Complete your drawing of the second rectangle with another vertical line connecting the two outer perspective lines.

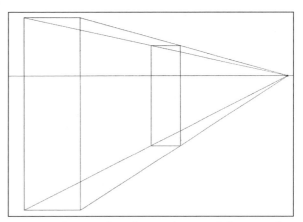

A second rectangle indicates the size of the second figure.

8. Measure and divide the height of the larger rectangle into seven equal sections.

9. Draw a figure in the larger rectangle. Sketch the head in the top section and add the body in the other six.

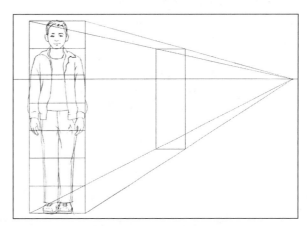

The standing figure of an adolescent boy fits into this rectangle perfectly.

10. Draw straight lines back to the vanishing point from the three distances indicated, the bottom of the chin (1), the tips of the fingers (2), and the bottom of the pants (3). (Refer to the next drawing.) In essence, you can pick any parts of the first figure and plot their positions in the second rectangle in the same way.

11. Draw a second figure in the smaller rectangle.

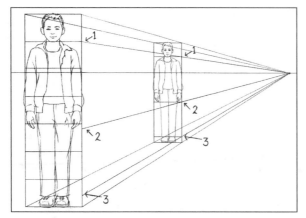

By plotting perspective points, a second figure farther away is drawn proportionately correct.

Foreshortening Figures

Foreshortening refers to the visual distortion of a person or object when viewed at extreme angles. The parts of a figure that are farther away from you look disproportionately small when viewed at an extreme angle. As the angle of viewing becomes more extreme, the level of distortion becomes more pronounced.

Foreshortening takes a little getting used to but is a critical component of creating depth in a drawing of a human figure. Foreshortening can make whole bodies, or just some parts of a body, look shorter than they really are. Long parts of a body, such as arms or legs, can look incredibly short when viewed from an end. Drawing this distortion correctly is the key to making drawings of figures look realistic.

The long boards in the next drawing are all the exact same length. Basically these boards can represent any human figure or part of a person, such as arms or legs. Observe how short they appear when viewed at extreme angles (from the ends).

Helpful Hint

Find opportunities to view people from extreme perspectives in real life. You can even lie on the floor and have a friend or family member (the taller the better) stand beside you. As you look up at the person, note that …

◆ The person's head will look especially tiny.

◆ His or her legs and feet look disproportionately large.

◆ The entire body looks much shorter than it actually is.

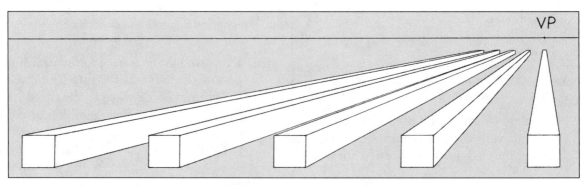

As objects of the same length are viewed from progressively extreme angles, the shorter they appear to be.

Resist the urge to turn this book upside-down as you view this unique perspective on foreshortening.

To draw foreshortening correctly you need to see parts of a body as they really appear, rather than as you know them to be. In other words, you need to trick your brain, which is conditioned to seeing people in certain ways. For example, when people look at the above drawing, many instinctively tilt their heads to see this person right side up. Your brain simply isn't used to seeing people from an upside-down perspective.

My friend Rob is of average height and his body is well-proportioned. He is posed in an unusual position to demonstrate the importance of drawing foreshortening correctly. His body is being viewed from an end and therefore appears to be disproportionately short. Foreshortening also creates extreme visual distortions to the sizes of various parts of his body. Only his left arm and head appear to be their actual lengths.

A basic understanding of foreshortening allowed me to draw this pose visually correct. I simply drew the following visual distortions exactly as I saw them:

◆ The lower section of Rob's left leg is drawn very short. I only drew the foot and ankle area of his right leg, because the rest was out of my line of vision, behind his torso. In fact, Rob's legs are in perfect proportion to his body.

◆ His right arm is drawn very short, because I was viewing it at a much more extreme angle than his left (which seems to be its actual length). In reality, both of Rob's arms are the same length.

◆ Rob's torso is in fact much longer than I have drawn it, but appears shorter because of the extreme angle from which I was viewing his body.

◆ I drew his right foot very tiny because it was farther away from me than any other part of his body. For fun, compare its size to that of his right hand (which was closer to me than his foot). Rest assured that in reality his feet are bigger than his hands and both are the same size!

The Least You Need to Know

- Perspective allows you to draw people visually correct and more realistic.
- The farther away people (or their various parts) are, the smaller they appear to be.
- The horizon line and your eye level are the same thing. Draw the horizon line parallel to the upper and lower sides of a square or rectangular drawing space.
- Objects at your eye level seem to touch the horizon line, and their perspective lines converge both downward and upward.
- Objects above your eye level are above the horizon line and their perspective lines converge downward; angular lines of objects below your eye level (below the horizon line) converge upward.
- Long parts of a body, such as arms or legs, look disproportionately short when viewed from an end.

In This Part

Translating Light and Shadows into Shading

If you're trying to locate the most important part of this book, you're in the right place. All drawing skills are built around your sense of sight. In these four chapters, you discover how to visually explore the various facets of people, see colors as shades of gray, apply shading to your drawings, and create silky-smooth textures using the skill of blending. Oh, and no kitchen appliances (blenders) are needed! You need only a careful eye and a skilled hand to create eclectic mixtures of values for shading.

Abracadabra! Shading is the magic key that allows you to create the illusion of a three-dimensional space on a flat sheet of paper. Crosshatching, hatching, and squirkling are three different methods of shading, which can render an infinite array of values and textures for drawing anything and everything. Unlike skilled magicians, artists are not sworn to secrecy surrounding our illusions. The sharing of my skills and techniques offers essential insights into your artistic creations!

As you work through these four chapters, plan on doing lots of exercises. Hidden among the fun illustrations and light-hearted step-by-step instructions you'll find many invaluable technical skills, which you can then apply to drawing people.

Your artistic endeavors do not require pulling a rabbit out of a hat. Creativity is not an illusion. It is an individual experience that requires ongoing nurturing and self-care. Move forward gently and nourish the precious gift of artistry!

In This Chapter

◆ Have a look at light and shadows on a sphere

◆ Drawing light and shadows on a circular form

◆ Investigate various values to identify light sources

◆ Translate your vision into different values

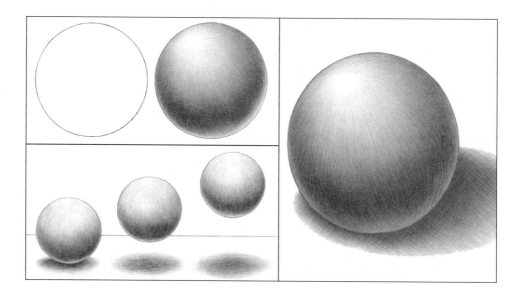

Seeing Light and Shadows

Seeing is a very important aspect of drawing realistic people. Before you can add shading to drawings, you need to be able to see which areas of your drawing subject are light and which sections are dark.

Forms are the three-dimensional structures of shapes. Values are individual shades of gray, which come together as shading to transform shapes into forms. Rounded and spherical forms are the primary ingredients for drawing almost every part of a human body.

In this chapter, you examine various components of light and shadows that make up realistic shading. I also explain how to identify the light and dark sections of your drawing subjects and translate them into various values. Keep your drawing supplies handy so you can follow along with me and draw the light and shadows of a form.

Light and Shadow Areas

Knowing where and how to draw light and shadows can turn shapes into forms, such as a circle into a sphere. The exterior forms of people's bodies, heads, and faces are made up of numerous three-dimensional rounded shapes, such as spheres, cylinders, and ovoids.

In the next drawing, notice what happens to a line drawing of a circle when the various components of light and shadows are added with shading.

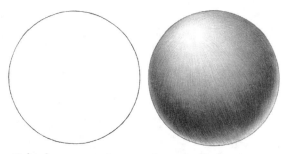

Light shows you where to draw shading so you can transform a circle into a sphere.

Highlighting the Highlight

Light source refers to the direction from which a dominant light originates. A light source identifies the light and shadow areas of a drawing subject, so you know where to draw shading. A highlight is the brightest area on a form and is usually the section closest to the light source.

In the next drawing, a sphere helps illustrate a highlight. The highlight is the white circular shape in the center of the lightest shading. (I tell you how to draw shading in Chapters 7, 8, and 9.) Those surfaces of the sphere that are closer to or in the shadowed areas are shaded with darker values.

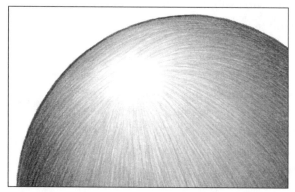

The brightest section on a form is called a highlight.

Highlights can help make forms look three-dimensional. In the next drawing of a nose, you find highlights on the center section and on the wing over one nostril (on the left).

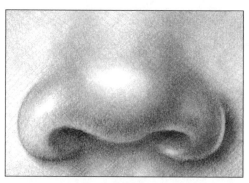

Highlights accentuate the spherical forms of a child's nose.

Dark Values in Shadow

Sections of a form that receive little light need to be shaded with dark values. The darkest shading on the surface of a form tends to be in areas that are farthest away from the light source, and/or where the light has been blocked by the form itself (or another object).

In the next drawing, look for the dark crescent-shaped shadow on the lower right of the sphere.

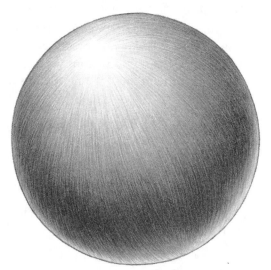

The shading becomes progressively darker, from the highlight to the crescent-shaped shadow section.

A whole side of a face or body can be drawn in shadow. Examine the shading in the next drawing of a young man's face. Observe how the dark values of the shadows give form to various sections of his face such as his nose, mouth area, and chin.

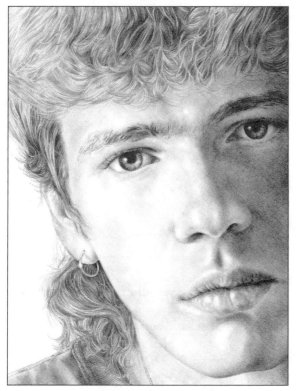

Shadows accentuate the forms of various parts of this young man's face.

Reflected Light

Reflected light is a faint light reflected or bounced back on an object from the surfaces close to and around it. Reflected light is especially noticeable on a sphere. Check out the spherical segment in the next drawing and observe the rim of light shading on the lower right. In this particular case, the reflected light (RL) is bouncing back from the light surface on which the sphere is sitting.

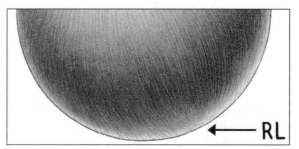

A tiny rim of reflected light (RL) is shaded with light values.

In the next detail section of a drawing, the muscular forms of a man's arms are enhanced by adding reflected light along their edges. Observe how the reflected light (on the left) also serves to visually separate the arm from the dark shading of the background.

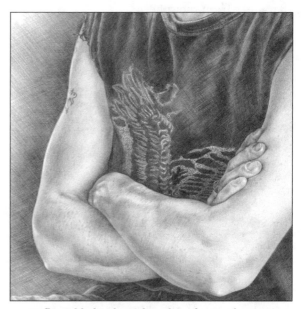

Reflected light along the edge of muscular arms greatly enhances the three-dimensional forms.

Info Tidbit

When you know how to add reflected light to your drawings, many independent forms, such as faces, noses, and arms, will look much more three-dimensional.

Cast Shadows

A cast shadow is a dark section on a surface, close to an object, that receives little or no light. In the next drawing, the light on the adjacent surface has been blocked by the sphere, resulting in a cast shadow. The values of the cast shadow are darkest right next to the sphere's lower edge and become gradually lighter farther away from the sphere.

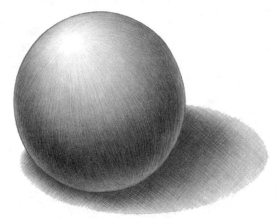

The darkest values in the cast shadow are closest to the sphere.

In the next sketch, a nose casts a dark shadow onto the lower-right section of the face. The shadow also anchors the nose so you can tell it's attached to the face. Shadows tend to be very similar in shape to whatever is blocking the light (in this case, a nose).

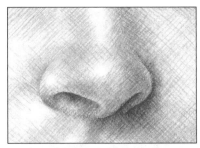

The section of the cast shadow closest to the nose is the darkest.

Helpful Hint

When you draw cast shadows, keep in mind that they generally take on the shapes of the forms that are blocking the light. However, their shapes can also be affected by the surface on which the shadow is cast. For example, if the cast shadow of a tall man is on uneven land, his shadow is shaped along its contours.

How and where you draw a cast shadow can create the illusion that objects are either touching or separated from adjacent surfaces (or other objects). The first sphere in the next drawing is sitting on the surface. The cast shadow is touching its lower edge. However, the other two seem to be floating, because the shadows are detached from the spheres.

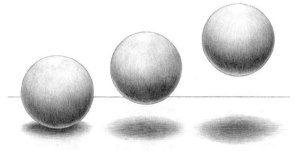

These shadows create the illusion that the spheres are floating rather than sitting on a surface.

Have a look at the shadows cast on a child's forehead by individual strands of hair (in the next drawings). The hair isn't shaded in the first drawing, making the cast shadows easy to pinpoint. Observe how they make the hair look like it's sticking out a little rather than resting flat against her forehead.

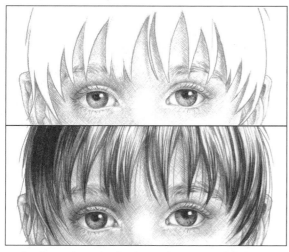

Thanks to the cast shadows, the hair looks like it's sticking out a little from the head.

Coming Out of the Dark

When you can draw rounded forms well, drawing all the individual forms of a human body will seem like a walk in the park!

It's time to put a little twist into your notions on drawing. In the first part of this exercise, you draw light with erasers. The second part shows you how to draw a spherical form with erasers for the light and a dark pencil to shade shadows.

Info Tidbit

The technique of taking away values, rather than simply adding them, is very popular in both figure drawing and portraiture classes. Many beginners love this method because it focuses on light and dark values separately rather than rendering a full range of values all at once.

"Drawing" Light with Erasers

You need white drawing paper, vinyl and kneaded erasers, a dark pencil (graphite or charcoal), and some tissues or paper towels. Follow these steps:

1. Use your darkest pencil to smoothly shade in the entire area of a drawing surface, any shape or size you want. A drawing surface (also called a drawing space or format) refers to the area in which you render a drawing. Mine is 6 by 3 inches. Use the side of the pencil point instead of the tip. It's faster and you end up with a smoother surface.

This rectangular drawing surface is shaded with a dark pencil.

2. With a piece of paper towel or soft tissue, very gently blend the whole surface until you have a solid tone. Don't apply too much pressure or you'll grind the graphite into the paper so much that it won't erase (thereby defeating the whole purpose of this exercise).

This smoothly blended background is waiting for light.

A vinyl eraser is a great tool for drawing crisp light lines and fine details, or erasing larger sections. Pencil type vinyl erasers are perfect for drawing with erasers (available in art supply stores). If the edges of your vinyl eraser are worn down, use a very sharp blade or knife to cut off a new piece with nice sharp edges.

You can either pat or gently rub the surface of your paper with a kneaded eraser to make a section lighter. Simply mold its tip to a point (or wedge) to draw fine lines or details. When your kneaded eraser becomes dirty, simply stretch and reshape it several times until it comes clean.

3. Use your erasers however you wish to experiment with pulling light values from the dark drawing surface.

Experiment with erasers as drawing tools and see what works best for you.

Drawing a Spherical Form

In this section, I take you step by step through a drawing of a spherical form. You draw light with erasers, and shadows with pencils.

1. Draw a square drawing space. Ideal sizes include 4 by 4 or 6 by 6 inches.

2. Shade the space with a dark pencil (I used an 8B) and use paper towel or tissue to blend it. The values of the background will represent the medium values of the sphere, so you only need to add the light and shadows.

3. Use your kneaded eraser to draw the light shading. Erase, pat, and pull out light areas until you can identify a circular shape. Don't worry if your circle looks more like a kidney! The goal of this project is to draw a three-dimensional circular form of any shape. Look closely at the first drawing on the next page and observe the following:

 ◆ The light is coming from the left. Remember, light affects the placement and value of every section of shading.

 ◆ The lighter values closer to the light source are close to the top of the sphere.

 ◆ The tiny glow of reflected light on the lower right is defined with the sharp edge of a vinyl eraser.

4. Use a sharp edge of your vinyl eraser to pull out the white circular area (the highlight) in the upper left. (Refer to the second drawing on the next page.) Don't worry if it doesn't come completely white (mine didn't). However, it should look a little whiter than the light area around it.

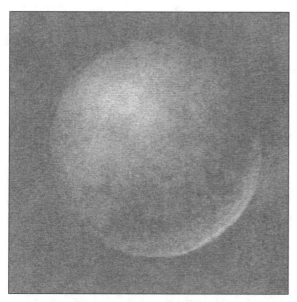

An eraser creates a circular shape in the drawing space.

5. Use your 6B pencil to outline your spherical form. This step is optional. You may prefer to leave the edges soft. You can draw this circular (or kidney-shaped) outline freehand if you wish, or even use a compass if you are picky (like me) and want a perfect circle.

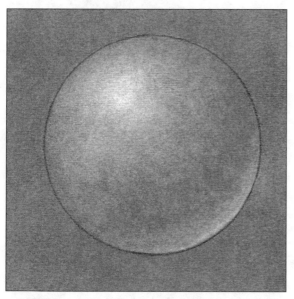

A three-dimensional form is emerging from the dark.

6. Use your pencil to add darker shading in the shadow area of the circle. This shading looks like a crescent shape or a backward "C."

7. Draw a cast shadow under and to the right of the sphere. The shading is darkest closer to the edge and becomes gradually lighter as it moves outward.

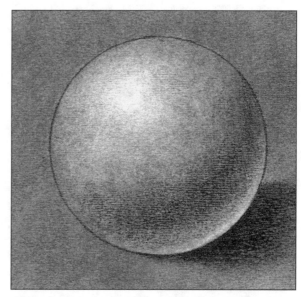

This sphere was created by drawing light and shadows.

Step back from your drawing and have a look at the overall values. You just drew a three-dimensional form on a two-dimensional piece of paper! Sign your name, write today's date on the back of your drawing, and put a smile on your face!

Shedding Light on the Source

Learning to draw is all about discovering how to see as an artist. For the most part, this means being able to look at your subject, identify the light source, and recognize the various values so you can draw them.

Helpful Hint

Examine your environment wherever you go, and try to figure out where the light is coming from. The light source may be the sun, bright windows, and/or artificial light sources such as lamps. Observe your friends and family under different lighting conditions. Take note of the light and shadow sections of their faces and bodies in relation to light sources.

Since there are no real human beings included with this book, our discussion on light sources will revolve around photos. You can rarely see the actual light source within the perimeter of a photo. However, you can examine the photo (or an actual subject) and use the following clues to figure out where the light is coming from:

◆ Sections of the body that are close to the light source are light in value.

◆ Parts that are farther away from the light are darker.

◆ The darkest shadows, such as cast shadows, are on the side farther away from the light.

In the next illustration, examine two versions of the same photo and identify the light source in each. (I flipped it around in a computer program so the light seems to come from a different direction in each.)

If you guessed that the light is coming from the left in the first photo, you'd be correct. The values are very light on the left, and the darker values and the darkest shadows are on the right. The light source is from the right in the second photo.

Can you tell where the light is coming from in these photos? (Photo © Bruce Poole, 1999)

The next photo of my grandson Brandon (in the middle) and a few of his friends has a strong light source (the early morning sun). Can you identify its origin?

Examine this drawing of a group of children to identify the origin of the light source.

As you probably guessed, the light is coming from the right. The bright highlights on the sides of the children's faces provide a strong clue. Also the shadows on their faces and clothing are darker on the left.

The lighting in the following photo is somewhat more subtle. This is my mom with my nephew Adam shortly after he was born. Refer to the three earlier clues, and try and determine the direction from which the light is coming.

Where is the light source in this photo of a grandmother and grandchild?

The light is coming from a window on the left.

How Light Creates Values

Light can identify the three-dimensional forms of every section of a human face and figure. However, you need to be able to see the various values before you can add them to your drawings.

By simply squinting your eyes as you look at your subject, you can filter out some details and focus on values. To help train your vision and brain to see shades of gray, place an object in front of you and look at it through squinted eyes. Find some photos, magazines, and books with photos of people, and try the same technique to identify various values.

Warm Fuzzy

Don't get discouraged if the squinting technique doesn't work the first time you try. With practice, it becomes easier. Dig out a few black-and-white and colored photographs with lots of contrasting values and keep practicing!

In the next photo, you can see various values defining the forms of a hand. The light source is from the right front. Examine this photo and find the following:

◆ Some light values.

◆ The darkest shadow areas. (Keep in mind that the darkest values may be in the cast shadows.)

◆ Some medium values. (Medium values tend to be in between the lights and shadows.)

Find the light and dark values in this photo.

By playing with the photo in a computer imaging program, I can give you an idea of how I see values when I squint. Examine the first drawing on the next page.

Squinting my eyes allows me to see different values more distinctly.

Compare the next drawing to the previous photos. Note how the shading defines the same values. Observe how the values all seem to flow into one another. (In Chapter 7, I show you how to draw shading.)

Shading identifies the same light and shadows that are in the previous photo.

Seeing Different Colors as Values

Of course, the real world is in color rather than simple shades of gray. Identifying different values on an actual person, or in a colored photo, is more challenging than examining a black-and-white photo.

It's easy to see some colors as different values. Let's say your drawing subject is wearing a jacket with pale blue and dark navy blue stripes. You simply draw the pale blue stripes with light values and the dark blue sections as dark values.

However, to throw a little spice into the pot, different colors can sometimes translate into the exact same value. For example, a dark purple and a dark red may appear to be an identical dark value. This may not always be an issue of concern, but sometimes you need to be able to distinguish one color from another in the actual drawing. In this case, you can simply use your own judgment and pick one color to be a lighter value.

In the next exercise, borrow a friend or family member or examine your own reflection in a mirror. Find a flashlight or a portable lamp. Shine the light on any section of the face (or a section of the body) and locate the following:

- The brightest areas (highlights)
- The shadows (usually dark values)
- The lightest values (sections not in shadow, usually close to the light source)
- The cast shadows (the darkest values)

Reposition the light source so the light shines on the face from another different angle. Note how the light and shadows also change position. Look closely at the cast shadows when the light is moved farther away from the face. A cast shadow becomes longer, shorter, darker, or lighter, depending on how close the light is to the face.

The Least You Need to Know

◆ Shading entails carefully observing your subject and then drawing the various values you see.

◆ Light and shadows define values.

◆ Three-dimensional forms are the primary ingredients for drawing people.

◆ Drawing a full range of values makes your drawings look three-dimensional.

◆ You can squint your eyes to filter out colors and details so they appear as shades of gray.

In This Chapter

- ◆ Choose your shading style
- ◆ Rendering shades of gray with hatching
- ◆ Creating smooth tones with crosshatching
- ◆ Fun with squirkles
- ◆ Exploring drawings to find shading styles

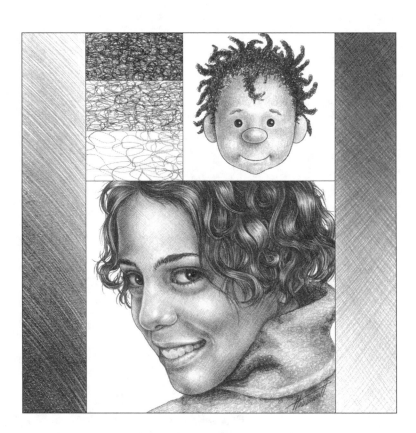

In Style with Practical Shading

When you understand how shading works you can begin to draw the illusion of depth (also known as three-dimensional reality). Simply stated, values (sometimes called tones) are various shades of gray. A broad range of different values is the primary ingredient of shading.

In this chapter, your goal is to transform three different drawing techniques into smoothly shaded values. Have your 2H, HB, 2B, 4B, and 6B pencils close by so you can follow along with lots of simple exercises!

Shading Techniques

To draw values, you need to combine various types of lines with different methods of drawing. Hatching, crosshatching, and squirkling drawing styles can give your drawings an infinite array of values and textures. (I tell you about textures in Chapters 15 and 20.)

Hatching is a series of straight or curved lines (called a set), drawn beside one another to give the illusion of a value. Depending on the shading effects you want, you can make the individual lines in hatching sets far apart or close together. In the hatching set in the upper left (in the next illustration), you can clearly see each individual hatching line. However, the hatching lines in the second set are drawn closely together to create a solid tone.

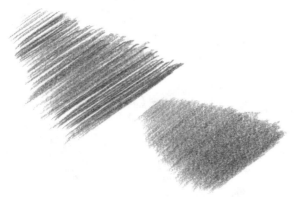

In hatching sets, the lines can be either far apart or close together.

Crosshatching is a shading technique in which one set of lines crosses over (overlaps) another set. In the upper set (see the next drawing), the crosshatching lines are far apart and lots of white spaces are visible. Lines that are close together (as in the second set) look like a solid tone.

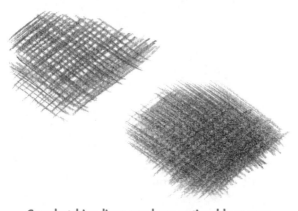

Crosshatching lines can have noticeable spaces between them or appear to be a solid tone.

What do you get when you cross squiggles and scribbles with circles? You get *squirkles!* I coined this fun word to describe this enjoyable shading technique. Many of my students from the past two decades are very familiar with squirkling squirkles!

The next illustration provides a peek into the versatility of squirkling. When squirkle sets have noticeable spaces between the lines, they work beautifully for shading various textures,

such as fuzzy fabrics and curly hair. Squirkles can look like a solid tone when the lines are drawn closely together, and are great for shading lots of different aspects of people, including skin tones.

Squirkles can create shading that is highly textured or very smooth.

Warm Fuzzy

Consider your personal preferences when deciding which method of shading to use. You may simply be more comfortable with one style than another.

Whether you decide to use hatching, crosshatching, or squirkling is completely up to you. Keep the following points in mind when making your decision:

◆ Hatching tends to be easier because you're working with only one set of lines. It's also the best choice for rendering realistic straight or wavy hair.

◆ Crosshatching can create a very smooth transition of values and is fabulous for drawing human skin. The two sets of overlapping lines allow values to flow smoothly in various directions by continuously extending or adding a few extra lines.

◆ Squirkling is the best choice for drawing the texture of very curly hair or fuzzy fabrics.

Being able to draw lots of different values is very important to shading. A range of different values from light to dark (or from dark to light) is called a value scale.

To warm up your engines for shading, find your art supplies and play with your various pencils. Draw several straight and curved lines with each and note all the different values an assortment of pencils can make.

Helpful Hint

Your 2H pencil is the lightest (hardest) and the 6B is the darkest (softest). The 4B and 6B are very good for darker values, HB and 2B are great for middle values, and 2H works well for light values. (See Chapter 2 for more on pencil types.)

Practice combining the following three techniques to draw some hatching, crosshatching, and squirkling sets of lines:

◆ Vary the density (placing lines either far apart or close together) of the shading lines.

◆ Vary the pressure applied to the paper with your pencils.

◆ Use different grades of pencils from hard (for light values) to soft (for darker values). Using various grades of pencils makes drawing value scales much easier. By letting your pencils do some of the work, you don't need to press as hard with your pencil to achieve dark values and you have more control doing light values.

Graduations (also known as graduated shading or values) are a continuous progression of values from dark to light or from light to dark. The goal of graduated shading is to keep the transitions between the different values flowing smoothly by combining the following three techniques:

◆ Progressively draw the shading lines closer together as the values need to become darker.

◆ Press gently with your pencil for light values and gradually apply more pressure to create darker values.

◆ Switch to darker pencils as the values become darker.

Let's take a closer look at each of the three shading techniques and practice when and how to use them.

Hatching

Hatching is a very fast and simple way to achieve various types of shading. In the next two drawings, I show you a small sampling of hatching styles. Note the various lengths and thicknesses of the curved and straight lines in these sets.

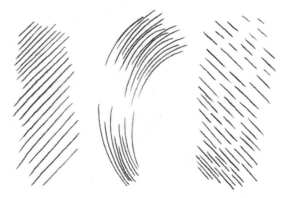

These hatching sets have very noticeable spaces between the lines.

The lines are closer together in the next hatching sets. Imagine how you could apply each set to something in a drawing. Try drawing them in your sketchbook.

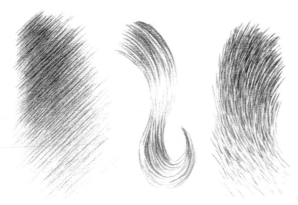

These hatching lines are drawn closely together.

Drawing a Value Scale of Hatching Lines

Closely examine the hatching lines in the next drawing of a value scale. The first (and lightest) value has very few lines with wide spaces in between each. The values created by the lines (in each of the other sets) become progressively darker toward the right. The last (and darkest) value has lines drawn so close together they are touching one another, creating the illusion of a solid tone of very dark gray.

Try your hand at drawing seven different values with hatching:

1. With your 2H and HB pencils, draw the first two values beginning with the lightest. Draw the first set with very few lines. The old expression "few and far between" works well here. The lines are far apart and few in number. The second set has more lines drawn closer together.

2. With your HB and 2B, draw the next three values. Remember, you can press a little harder with your pencil to make a value darker. Progressively draw the hatching lines in each set a little closer together as you work toward the darker values.

3. Use your 4B and 6B for the two darkest values. Note that many more lines make up the last two hatching sets, and the lines are much closer together.

Keep practicing value scales from light to dark in your sketchbook until you can draw seven (or more) different values. Then try this same exercise in reverse from dark to light (a little more challenging). Drawing individual sets of shading lines requires lots of practice before you can draw them well.

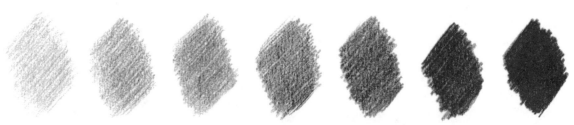

These seven different values are created with sets of hatching lines.

Creating Smooth Hatching Graduations

Graduations are generally rendered by beginning with the light values and then working toward the dark. By drawing the light values first, your medium shading can be layered on top of some light sections. The layers of dark values are then layered over sections of medium values. This layering technique creates a smooth transition between different values.

Info Tidbit

Some artists prefer to draw graduations up and down (vertically) instead of horizontally. Many left-handed artists prefer to draw graduations by beginning with light values on the right and gradually working darker as they get closer to the left. Use whatever technique is most comfortable for you.

In this exercise, you merge individual hatching values together into a smoothly flowing graduation. Remember, different grades of pencils help make a graduation silky smooth.

1. On one side of your paper, draw light hatching lines that slowly become darker toward the middle.

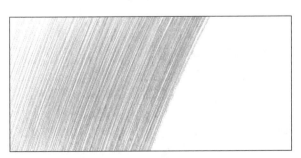

Hatching lines begin as light values and gradually become darker.

2. Continue making your shading progressively darker as you move toward the right.

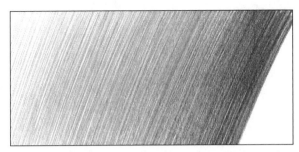

This hatching graduation becomes darker toward the right.

3. Draw the darkest values at the end.

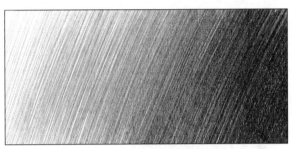

A full range of hatching values creates a smooth graduation.

When drawing people, your skills at rendering graduations need to be versatile enough to graduate a full range of values in a space of any length. Short graduations between values work perfectly for rendering a range of values within compact spaces. For example, shading the intricate details of fingers, toes, or a nose needs a short graduation. Other graduations may require the transitions between the individual values to be rendered more gradually, over a longer distance. Consider the length of the side of a face, for example, or an arm, or a leg.

Drawing graduated shading within a specific area, such as a rectangle, challenges you to contain (or spread out) your graduations. Use the same shading technique as in the last exercise to draw another hatching graduation over a long distance. Refer to the first drawing on the next page.

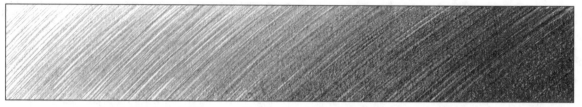

A hatching graduation can change from light to dark over a long distance.

Combing Hair with Hatching Graduations

The first step toward drawing realistic hair is rendering a graduation of curved hatching lines. In an actual drawing, the lines need to follow the perceived contours of the forms of the head and/or the individual strands of hair. (I tell you more about drawing hair in Chapter 15.)

Helpful Hint

Draw hair as if you were combing it with a pencil. In other words, draw hatching lines in the directions in which the hair grows. This technique gives you a realistic sense of its texture as you draw, and the resulting lines tend to look more natural.

By drawing the individual lines different lengths, you can make the transition from one value to the next barely noticeable. Try your hand at drawing a strand of hair with hatching:

1. Draw a light graduation of curved vertical hatching lines of various lengths at the bottom of your drawing space. Assume that the hair is growing from the top of the drawing space. Draw your individual hatching lines downward, in the direction in which the hair grows. Remember to keep the lines slightly curved.

2. Draw progressively darker hatching values as you get closer to the top. The lines become darker and much closer together.

If the transition isn't as smooth as you like, add a few more lines of various lengths in between other lines.

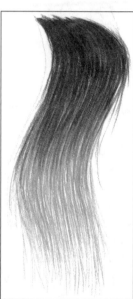

This type of hatching graduation works beautifully to draw hair.

Crosshatching

When drawing crosshatching, experiment with different ways of moving your pencil, rotating your paper, or changing the angle of your lines until you find the hand motions that are the most natural for you.

In the next illustration, you see several crosshatching styles. Note the different types of lines as well as the various fun textures created. Draw some different types of crosshatching sets in your sketchbook. Try inventing some crosshatching styles of your very own.

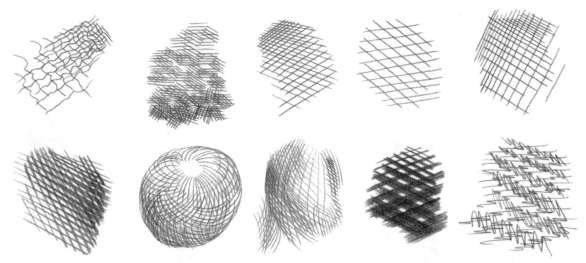

Imagine how you could apply each set of crosshatching lines to something in a drawing.

Drawing Values with Crosshatching

In this exercise, you use crosshatching to draw a value scale. Use the same methods of drawing crosshatching as you used for hatching. Use whichever pencils you prefer to make seven different values, as shown in the next illustration:

1. Begin with the lightest value in the first square. Draw a set of hatching lines and then add a second set overlapping the first. Now you have a crosshatching set!

2. Draw a second set of crosshatching lines closer together than in your first set.

3. Continue drawing crosshatching sets that become progressively darker. The seventh needs to be the darkest.

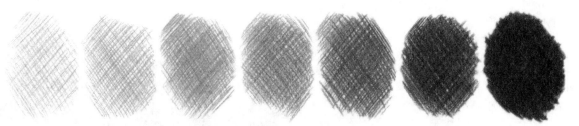

Seven different values are created with crosshatching.

Creating Graduations with Crosshatching

It's time to draw a silky smooth crosshatching graduation. Don't forget that you can turn your drawing paper or sketchbook around as you draw. I usually turn my paper sideways or completely upside down to draw the second set of lines in a crosshatching graduation.

1. Crosshatch light values on the left side of your paper. Continue to make your shading progressively darker as you move toward the right. The values get darker very quickly when you add the second set of lines.

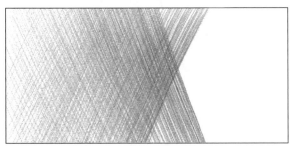

Overlapping lines graduate from light to medium values.

2. Add more crosshatching lines closer together as you get closer to the right.

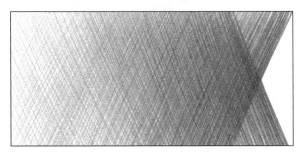

Crosshatching values become darker closer to the right.

3. Continue using different pencils, making your lines closer together and pressing harder with your pencils until the end of your graduation is as dark as you can make it.

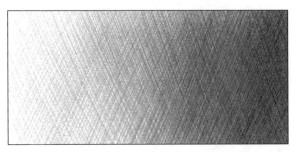

This crosshatching graduation is silky smooth.

In the next graduation (at the bottom of this page), the crosshatching values gently flow into one another over a longer distance. Give this graduation a try, and then draw it again in reverse, from dark to light.

Art Alert!

When drawing people, don't draw the individual shading lines in a graduation the same length. Instead, draw varied jagged lines of different lengths, so the transitions between the various values appear smooth. It's easy to fix places that don't turn out as smooth as you like by simply drawing extra lines in between other jagged lines.

Try drawing this long, smoothly flowing crosshatching graduation.

Squirkling

Squirkling is an easy method of shading in which randomly drawn curved lines create textured values. The next drawing demonstrates that squirkles can create both the smooth texture needed for skin and the curly texture of hair. Loosely rendered squirkles create more heavily textured shading than densely drawn squirkles.

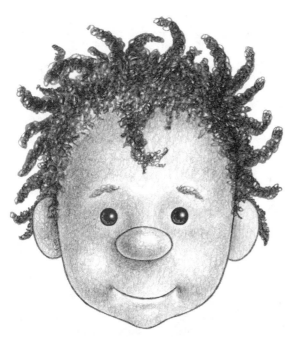

Both the hair and skin textures in this fun cartoon are made up of squirkles.

Scaling Scribbles to Create Squirkles

Squirkles are simple to draw, easy to control, and can produce a full range of values. You can draw the curved and compound curved lines either far apart or close together. Have some fun drawing light, medium, and dark values with squirkle lines.

1. Draw a rectangle divided into three sections.

2. Draw the lightest value in the first block. The lines curve in different directions all over your paper, with lots of white space showing. Some lines cut across themselves, creating lots of different shapes and an overall light value.

3. With your 2B pencil, draw the middle value, and then use your 6B to draw the darkest value. Many more lines, drawn closer together, make up the second set. In the darkest value, most of the paper is filled in with the texture of squirkles.

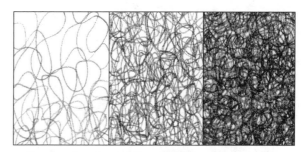

Try drawing three different values with squirkles.

Shading Graduations with Squirkles

This next exercise is a lot of fun, especially if you love to doodle! In a graduation, squirkle lines are lighter and farther apart for lighter values and gradually get darker and closer together toward the dark sections.

1. Begin on one end of a rectangular format and draw the lightest values of a squirkle graduation.

Squirkle lines graduate from very light to medium values.

2. Add the medium values. Continue making your shading darker and darker until you get almost to the end of your drawing space.

Squirkling graduations become gradually darker toward the right.

3. Draw the darkest values toward the end of your graduation.

Squirkle lines show off their abilities to graduate with a full range of values.

Try drawing a long graduation with squirkles. If the transition between your squirkle values doesn't go as smoothly as you like, you can improve it by adding a few more short curvy lines in between some of the other lines.

Squirkle values flow smoothly into one another to create a lengthy graduation.

Combining Different Graduations in a Drawing

Your personal preferences of shading styles allow you to creatively customize your drawings. I use various methods of shading for different parts of my drawings. To get you familiar with different shading styles, examine the next drawing of my friend Anne. Three types of graduations lend themselves perfectly to the different textures.

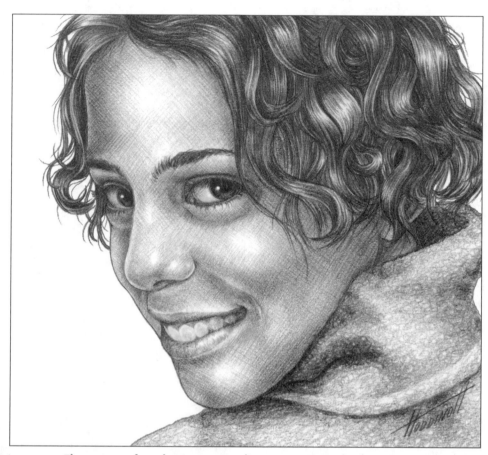

Three types of graduations create diverse textures in this fun portrait.

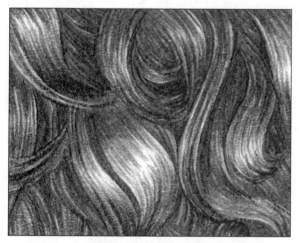

Each section of hair is an independent hatching graduation.

Each small section of Anne's gorgeous curly hair is drawn with its own hatching graduation. The curved hatching lines follow the contours of each section of hair.

Crosshatching is ideal for shading smooth skin tones. Examine the forms of Anne's nose, cheekbones, and the structures around her eyes. (Refer to the first drawing on the next page.) The darkest graduations are in the shadows and the shading becomes gradually lighter toward the light areas.

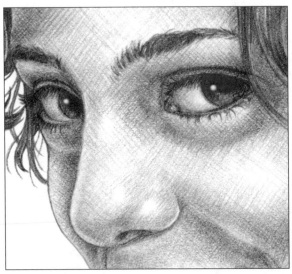

Crosshatching graduations give the illusion of depth to various parts of Anne's face.

Squirkling graduations enhance the soft fuzzy texture of the collar of Anne's jacket and provide an illusion of depth to the various folds in the fabric.

Squirkling graduations give depth and texture to clothing.

Many sections of a human face (or body) call for a lengthy graduation of values. For example, shading the width of a forehead or the length of the side of a face often requires values to graduate smoothly over a long distance.

The distance across Anne's forehead is shaded with a long smooth graduation.

Some graduations need to be drawn within a compact space. For instance, the intricate shading on the side of Anne's nose and the forms under her eyes need short graduations.

Graduated values are compacted into short distances in this section of Anne's face.

The Least You Need to Know

- The magical illusion of depth is created by using a broad range of values in your shading.

- You draw different values by varying the density of the shading lines, varying the pressure applied to the paper with pencils and using different grades of pencils.

- Your personal preferences are integral for deciding whether to use hatching, cross-hatching, or squirkling shading styles.

- The goal of graduated shading is to keep the transitions between different values flowing smoothly.

- Graduations are best rendered by layering darker values over lighter ones.

In This Chapter

◆ How does a shading map work?

◆ Rendering a shading map

◆ How to draw graduations within a shading map

◆ Using different graduations in a drawing

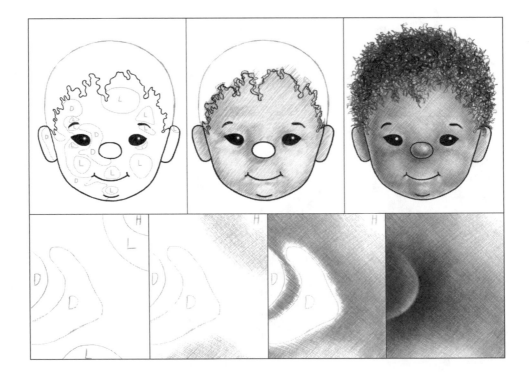

Chapter 8

Putting Seeing and Shading Together

Most of the parts of a human body are spherical or rounded forms. In this chapter, I discuss how and where to draw values to transform shapes into forms.

A shading map (often called a value map) is an invaluable tool for combining both seeing and shading into drawing forms. You create a shading map by lightly outlining the shapes of various sections of values. This map takes the guesswork out of where you have to put different values, allowing you to focus your full attention on shading.

To warm you up for some exercises in drawing with a shading map, I first show you how the process works. You can then follow simple step-by-step instructions to draw your own shading map, and shade some simple forms. Finally, a fun project takes you through the entire mapping process to complete a drawing with hatching, crosshatching, and squirkling graduations.

Mapping Values to Combine Seeing and Shading

Creating and implementing a value map makes shading forms much easier. However, before you can map values you need to be able to see the values in your drawing subject. Throughout Chapter 6, I explain how to visually identify the various light and dark values created by a light source. Knowing how to draw graduated values is critical to the process of adding shading to your map. (Review Chapter 7 for more on drawing values.)

Insights into the Mapping Process

Once your subject has been outlined on your drawing surface, you need to translate the values you see into shading. The process of drawing with a shading map entails four separate stages of development:

1. See values as shapes. In the first stage, you need to look closely at your subject and identify each of the following:

 ◆ Highlights tend to be easy to find because they are the lightest sections of your subject.

 ◆ Light values are the sections closest to the light source, adjacent to the highlights, and/or not in shadow.

 ◆ Dark values are on the actual subject and/or in various cast shadows.

 ◆ Medium values tend to fall in between the light and dark values.

2. Outline the shapes very faintly on your sketch. Different aspects of light and shadows assume various shapes. For example, a highlight can be a circle and a shadow can be a crescent shape.

3. Mark the various shapes with letters. Focus on the highlights (H), and the light (L) and dark (D) values. Middle (M) values will simply fill in the spaces between the lights and darks. (I usually don't bother to mark the medium values.)

4. Follow the shading map to draw values. Before you begin shading, make sure you lighten your mapping lines and erase the letters. Keep in mind that transitions between values can be dramatic and abrupt, or more gradual over a longer distance. I prefer to work from light to dark. If you choose this approach, you need to do the following:

◆ Add shading around the highlights (H) with very light values. The center section of a highlight is left white. With your lightest pencil, add shading lines very lightly and far apart, around the edges of the highlight.

◆ With various H pencils, add light shading to the sections marked with L. Follow the outlines of their shapes on your map. (Review Chapter 2 to refresh your memory on H pencils.)

◆ Graduate the light values (L) toward the darks (D) to fill in the medium values. HB and 2B pencils work well for graduating the middle values in between the lights and darks.

◆ Use darker pencils to graduate the middle values into the D sections.

◆ Shade in the D sections with dark values. Dark values are best rendered with 2B to 8B pencils.

Helpful Hint

Experiment with different approaches to shading, especially if mapping values doesn't appeal to you. Eventually you'll discover the method that is perfect for your unique needs.

How a Photo Becomes a Drawing

Curl up in a comfortable chair, relax, and follow along with me as I map values and turn them into shading. My shading plan will work as follows:

1. I first create a detailed line drawing based on my photo.

2. After careful observation of my photo I identify the locations of the various values.

3. I then lightly sketch their shapes on my line drawing.

4. The shapes are marked with letters so I know where to draw each value.

5. I follow this map to add shading to my drawing.

Using the next photo of my beautiful daughter Heidi as a reference, I lightly sketch her on my drawing paper. I then carefully refine my sketch until I'm happy with the sizes, shapes, and proportions of all parts. Refer to the next 3-part illustration.

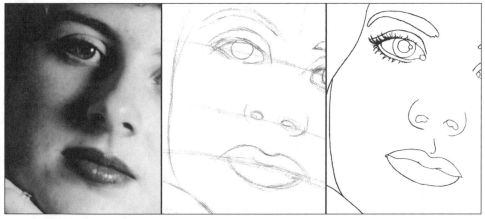

A line drawing is created from a photo of my daughter. (Photo © Bruce Poole, 1999)

In Chapter 22, I take you step-by-step through the entire process of rendering a full facial portrait.

When I squint my eyes, I can see the various values in the photo as shapes. Since you can't see through my eyes, I have adjusted this photo in a computer program to give you an idea of what I see when I squint.

I very lightly outline the shapes of the different values and mark them with letters (see the illustration on the next page). I've darkened my lines in a computer program so you can see them. In reality, these lines are so faint they are barely visible. By drawing lightly, the shapes are very easy to erase at a later time.

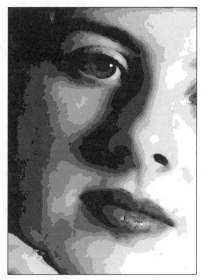

With careful observation, I can see many values as individual shapes.

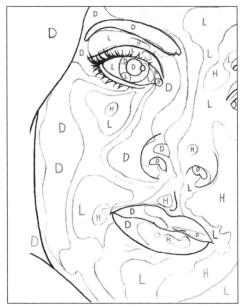

The shapes of the different values are outlined, and the map is complete.

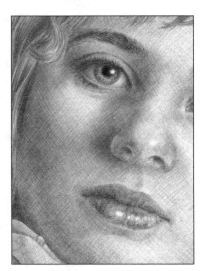

Warm Fuzzy

Eventually, you may not feel a need to mark letters on your map. (I rarely do.) With practice, drawing the graduations between the various shapes becomes second nature.

I follow my shading map to add the various values by using the techniques discussed in the last section. Refer to the next set of three drawings.

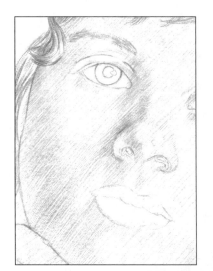

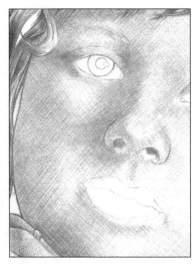

By following the shading map, the various forms of the face take shape.

Mapping Values for Drawings

The drawing in this exercise is of nothing in particular. However, it presents several shading challenges you may encounter when drawing an actual face or figure. Follow these simple steps to draw a map and add graduations of values:

1. Outline various circular shapes within a drawing space. If this is your first time using a shading map, keep the shapes very basic. The more shapes you draw, the more complicated the shading becomes.

2. Mark the highlights (H), light values (L), and dark values (D). Leave some unmarked areas as middle values (or you may prefer to mark them with M).

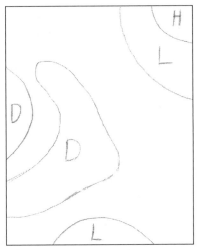

A shading map has rounded shapes identified with letters.

3. Erase the letters marked L, and lighten the lines around the shapes until you can barely see them.

4. Draw light shading with a 2H pencil from the H sections into the L shapes. Keep the shading lines different lengths, and extend them unevenly into the adjourning spaces. Refer to the next drawing.

5. Begin adding graduations (with an HB pencil) to the sections in your map needing medium values. Follow the contour of their shapes. Continuously adjust your lines so the graduations flow smoothly into one another. Make your values darker as you approach the dark areas. Examine the second drawing in the next column.

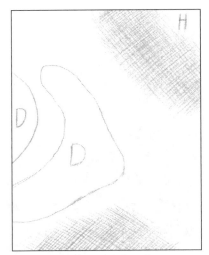

Light values are added to the sections marked with L.

Light values graduate into medium values.

6. Follow the first drawing on the next page and shade the dark values with a 2B pencil. Taper off the dark values' hatching as you approach any light areas, and darken your lines as you move toward the darkest shadow section.

7. Shade the darkest value with a 4B pencil. Take note of how it ends abruptly close to the backward C-shaped section.

Three-dimensional forms begin to emerge from the shading map.

8. Add some medium shading (with a 2H pencil) to the small crescent shape (C shape) left of the abrupt stop.

These silky smooth forms have been shaded with crosshatching graduations.

Graduating to Drawing Jody

There's a method to my madness in having you occasionally draw cartoons instead of realistic portraits. Cartoon drawings don't have a lot of intricate details, thereby allowing you to focus your full attention on the skills being introduced.

In this project, I take you step by step through the process of drawing an adorable cartoon with curly hair. You use hatching and crosshatching graduations to shade the facial forms and squirkles to create the texture of curly hair.

You need HB, 2B, 4B, and 6B pencils, a ruler, vinyl and kneaded erasers, and good-quality drawing paper.

Helpful Hint

Rotate your paper and view the face from different perspectives as you draw. This little trick often allows you insight into any problem areas.

You need to set up your drawing format and outline Jody's head and face before you plan the shading. A simple grid helps you draw a symmetrical face and accurate facial proportions. (I tell you about symmetry in Chapter 3.)

1. Draw a square as your drawing space. Suggested sizes include 4 by 4, 6 by 6, or 8 by 8 inches. Use a 2H pencil.

2. Measure the halfway point on each of the four sides of the square and mark them with dots.

3. Divide your drawing space into four equal sections by connecting the opposite dots. Draw these lines *very* lightly because you have to erase them later!

4. Use an HB pencil to draw a U shape (Jody's face) in the lower half of your drawing format. Use the grid lines to visually measure spaces so both sides of the face are symmetrical, rather than lopsided.

5. Draw the ears.

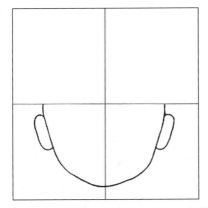

This U shape with ears is in the lower half of the drawing format.

6. Outline two almond-shaped eyes on the face.

7. Add slightly curved lines (eyebrows) above the eyes.

8. Draw an oval shape (the nose) below the eyes.

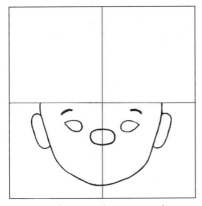

The face takes shape with eyes, eyebrows, and a nose.

9. Use your 6B pencil to shade the eyes, leaving the highlights white. The light source is from the right.

10. Draw a curved line below the nose (the mouth).

11. Add a tiny curved line on each end of the mouth.

12. Draw another curved line slightly above the bottom of the face to represent a double chin.

13. Lightly sketch the outline of the top half of the head.

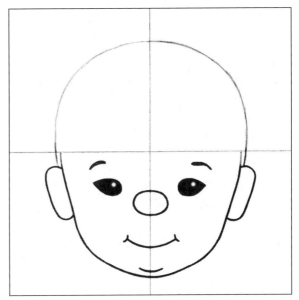

This adorable little face is completely outlined.

Now outline the hair and map the facial values. Planning your shading strategies becomes less complicated when you map the values before you begin shading.

14. Erase your grid lines.

15. Draw wiggly lines around the upper section of the face to separate it from the hair.

16. Outline the sections that will be dark and light. (Unmarked areas represent medium values.) Your lines need to be so light you can barely see them. Mark the dark shapes with a D and the light ones with an L.

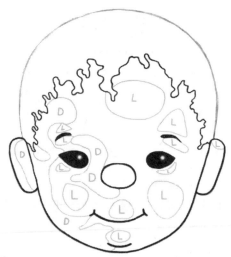

The facial values are mapped and waiting for shading.

Use hatching to create the skin tone. Remember that light from the right affects the placement and value of every section of shading.

17. With 2H and HB pencils, follow your map to shade the entire face with hatching graduations. (Refer to the suggestions earlier in this chapter.) Proceed as follows:

 ◆ Add shading to the L sections first.

 ◆ Graduate the shading darker (medium values) toward the D sections.

 ◆ Add dark shading to the D sections.

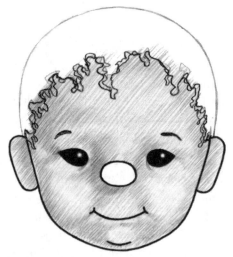

The shading is lighter on the right, closer to the light source.

Helpful Hint _____

You can easily fix areas of shading you don't like. Pat the shading with your kneaded eraser to make lighter values. Add more shading lines to make a section darker.

By drawing a second set of hatching lines, crossing over the first, you create crosshatching to indicate the darker values.

18. Use crosshatching graduations to add smoother values to the face with HB and 2B pencils. With the addition of the crosshatching lines, the overall shading becomes a little darker.

Darker shading with crosshatching makes Jody's face look three-dimensional.

In addition to creating the texture of curly hair, a graduation of squirkles helps make the hair look three-dimensional.

19. Shade the hair with graduated squirkles. Use a 4B pencil for the darker values (on the left) and an HB for the lighter sections. Lots of little curls extend around the edges of the head and onto the ears and forehead.

The finished cartoon: Jody seems happy with this
spiffy hairdo!

The Least You Need to Know

◆ Shading maps combine seeing and values
 into shading.

◆ A shading map is created by lightly out-
 lining the shapes of various sections of
 values.

◆ Using a shading map eliminates most of
 the guesswork of deciding where to draw
 different values.

◆ Drawing and implementing a value map
 makes shading forms much easier.

◆ Mapping values works well for planning
 all styles of shading, including hatching,
 crosshatching, and squirkling.

In This Chapter

- ◆ Comparing unblended and blended shading
- ◆ Some blending tools that work well
- ◆ Blending loosely drawn lines
- ◆ How to create silky-smooth graduations
- ◆ Drawing denim fabric using blending

To Blend or Not to Blend

When I was new to drawing, I used blending to make my shading smooth. However, most faces ended up looking like cartoons with shiny porcelain skin—not the results I wanted! I ruined lots of drawings before I figured out how to blend well.

In this chapter, I show you how to transform graduated hatching, crosshatching, and squirkling into smoothly blended graduations. You find numerous opportunities to try your hand at blending. Then you can have some fun using your brand new blending skills to draw realistic denim fabric.

Blending and Blenders

Blending is the process of rubbing shading lines with a blending tool (sometimes called a blender) to evenly distribute the drawing media over the surface of the paper, thereby achieving a smooth graduation of values.

Blended or Unblended Shading?

Many accomplished artists have perfectly mastered blending techniques, and their drawings look incredible. I rarely use blending in my own drawings because I love seeing shading lines and the textures they create. Ultimately, you have to decide for yourself what you like or don't like and whether you want to blend or not blend! Compare the following close-up views of unblended and blended shading.

Unblended and blended shading methods look very different.

Have a look at the next drawing of a child's nose before and after I blended the crosshatching graduations with facial tissues.

Keep your mind open and have fun trying different types of blenders and shading techniques. You can even use blending in some sections of a drawing and not in others.

Blenders You Don't Plug In

Various blending tools, used on different types of paper, can create some really cool textures. Consider the following:

- Facial tissues work nicely for delicate pencil strokes.
- Paper towels are durable and withstand vigorous blending.
- Cotton balls are great for blending large areas.
- Make-up wedges (available in the cosmetic sections of various stores) work well for silky smooth blending.
- Blending stumps (or tortillons) are tightly wound sticks of paper (they come in various sizes) with points on both ends. You can find them in art supply stores. Bigger ones work for blending large areas, and tiny ones are great in detailed sections.

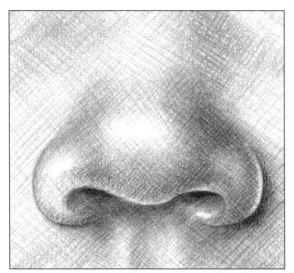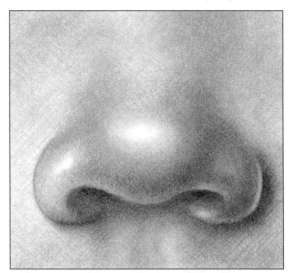

Blending transforms crosshatching graduations on a child's nose into a silky smooth skin texture.

◆ Q-tips are handy for blending tiny detailed sections of drawings.

◆ Different types of papers, when used as blenders, can bring out some really neat blended textures in a drawing.

◆ Fabrics such as felt and chamois are great for creating a broad range of blended textures. Check out craft or department stores. Pretest colored fabrics to make sure they don't leave their dyes on your drawing paper, or buy white so colored dyes can't spoil your drawings.

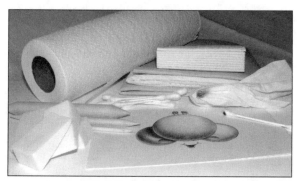

Experiment with different blending tools to find out which work best for you.

Art Alert! _____

Be careful not to wear away tissues or paper towels so that your fingers are doing the blending. You never want to use your fingers to blend because oil from your skin can transfer to the paper, which becomes noticeable after blending (especially in light values). Creating a smooth tone then becomes darn near impossible. Wrap several layers of tissue or toweling around your finger and check often that the material isn't wearing away.

In addition to blending tools, different shading techniques and the types of paper and pencils you choose affect the final look of blended shading.

Different Approaches to Blending

Blending is difficult for beginners. Many teachers of fine art even discourage blending techniques altogether. They generally encourage their students to focus on classical shading techniques such as hatching and crosshatching (see Chapter 7). However, because many artists love using blending in their drawings, I'd like to introduce you to a few techniques for doing it properly.

For blending to work well, you must first be reasonably skilled at putting graduated values on your paper. After all, there has to be something to blend. (Refer to Chapter 7 to find out how to draw smooth graduations with hatching, crosshatching, and squirkles.) Expecting blending to fix poorly done shading simply isn't realistic. Try the following exercise to see what I mean:

1. Draw lots of loosely sketched random lines with a 2B pencil.

These loosely sketched hatching lines are hoping to be changed into smooth shading.

2. Choose a blending tool and use any techniques you can think of to obtain a nice smooth graduated tone from these loosely drawn lines.

There's no way to get smooth blending from these lines!

Sloppy shading lines cannot be magically transformed into smooth blending. You inevitably end up with a smudgy attempt at blending, no matter what tools you use or how much time you spend trying to make it work.

Blending Lines in a Shading Graduation

Throughout this chapter, you find lots of opportunities to experiment with blending different types of shading. In time, you'll find methods of blending that work specifically for your unique needs.

Following is a close-up view of the process I use for blending all types of graduations. Most beginners find squirkles to be the easiest type of shading to blend. Grab your supplies and try your hand at blending squirkles:

1. Draw a small graduation of squirkles so you can experiment with blending. Leave a white section to represent a highlight.

This squirkle graduation can be used for shading various parts of a person, including the nose.

2. Blend the lightest values with a facial tissue wrapped around your finger. Use small circular movements to smooth out the pencil lines. Working progressively from light to dark, continue blending until the shading is smooth.

Light values blended into the dark values create a smooth graduation of values.

3. If the shading becomes too light in the dark shadowed areas, add more graphite.

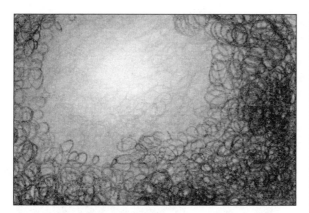

By drawing darker squirkle lines around the edges, we have a stronger contrast in values.

4. Blend again until you're happy with the results.

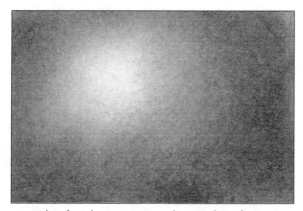

With a facial tissue wrapped around my finger, I used circular movements to very gently blend the dark values.

Art Alert!

The most common blending mistake is to overblend dark values. Either use blending very sparingly in dark shadowed areas or don't blend your darkest values at all. A realistic drawing needs a full range of values from very light to almost black.

Loosely Blended Shading

Sometimes you may want to use blending that isn't perfectly smooth. Blending can enhance textures in drawings, such as the fine hair of an infant or a soft corduroy or denim fabric.

When your goal is to create smooth shading with soft visible lines, draw your shading lines loosely. Try the following:

1. Carefully draw a loosely rendered graduation of values with hatching lines. (Use 2B and 4B pencils.)

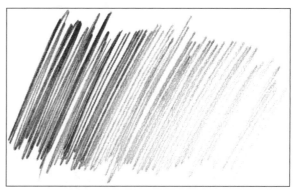

White spaces show between the lines of this hatching graduation.

2. Use a blending tool and blend the lines together.

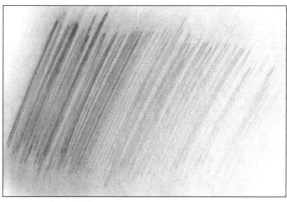

Some hatching lines are still visible after blending.

This blending style is very versatile and works well for creating various textures, such as denim fabric. (See "Creating a Denim Texture" later in this chapter.)

Become a Real Smoothie

Beautifully blended shading isn't a deep, dark secret! The key is to apply your initial shading with carefully rendered hatching, crosshatching, or squirkle graduations before you blend.

Warm Fuzzy

Experiment with lots of different shading techniques until you find what works best for you. You are a unique individual with distinctive artistic needs. Stay true to yourself and continue developing your own vision and style.

Blending a Mixture of Hatching Lines

Hatching provides a simple foundation for blending and works especially well for textures needing soft visible lines. Try your hand at creating a smoothly blended hatching graduation:

1. Use 2B, 4B, and 6B pencils to render a smooth graduation with hatching lines.

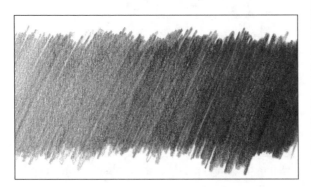

These hatching lines are drawn closely together.

2. Gently blend your hatching graduation from light to dark. Continue blending until your graduation is smooth, but be careful not to rub the surface of your paper off.

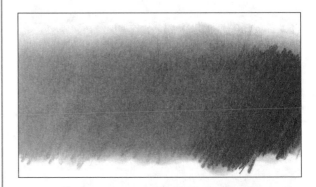

Here's the same hatching graduation after blending as well as a close-up view of the gorgeous tones created.

Helpful Hint

Remember to place a piece of scrap paper under your hand as you draw to protect your drawing from the oils of your skin.

Silky-Smooth Blended Crosshatching

Delicate crosshatched strokes on smooth paper create a softly rendered graduation of values without blending. However, blending can make the shading even smoother.

Find your drawing supplies and create a silky smooth graduation with crosshatching. Use the same process (and the same pencils) you used for blending hatched lines in the last section.

Before blending, you can see the white of the paper throughout this graduation. After blending, a nice soft texture is created.

Examine this crosshatched graduation before and after blending.

Slightly Textured and Smoothly Blended Squirkles

Depending on the density of your squirkle lines, blended graduations can look slightly bumpy or very smooth. A loosely blended squirkle graduation is perfect for drawing soft textures such as an infant's curly hair or fluffy fabrics. A smoothly blended squirkle graduation works nicely for most smooth textures, including human skin. Try your hand at both styles:

1. Use 2B, 4B, and 6B pencils to draw a loosely rendered graduation of squirkle lines.

2. Use any blending tool to blend your squirkle graduation.

3. Draw a tightly rendered graduation with lots of squirkle lines (use 2B, 4B, and 6B pencils).

4. Gently blend your graduation from light to dark.

After blending, this squirkle graduation becomes silky smooth.

Don't give up if you don't like your first few attempts at blending. With patience and practice, your blending skills will improve.

Creating a Denim Texture

With people as your drawing subjects, you won't get away for long without having to draw fabrics. Denim has survived several decades of fashion designers and seems to be here to stay. Its most endearing quality is that it takes on a distinctive personality as it fades, especially on the hems of jeans. In this exercise, I show you how blending creates softly textured denim fabric.

Before you begin, draw a rectangular shape as your drawing format, approximately 4 inches wide by 3 inches long (or 8 by 6 inches if you'd like a larger drawing). Then follow these steps:

1. Draw a slightly wavy line to indicate the edge of the fabric. This line begins about one third of the way across the bottom of your drawing space. It ends slightly above the lower-right corner.

A curvy line indicates the edge of the fabric.

2. Lightly sketch a map of the pattern on the edge of the hem. (I showed you how to map values in Chapter 8.) Observe that the little mapping shapes of the hem are almost parallel to the edge of the fabric and follow the same curve. You don't need to draw your shapes exactly like mine. Keep your mapping lines very light because you will need to erase them later.

Various shapes of different sizes create a map for shading.

Before you begin shading, use your kneaded eraser to lighten your mapping lines until you can barely see them.

3. Add graduated shading with hatching. The lightest value is where the fabric is curved. (Use your 2H or HB pencil.)

4. Shade all the little shapes in the hem a little darker.

Hatching lines add depth and texture to the denim fabric.

5. Outline a bunch of tiny, long oval shapes to represent the stitches along the lower set of shapes.

6. Shade in the shadow under the lower edge of the denim with your 2B pencil and crosshatching.

7. Use your 6B pencil to add the darkest part of the shadow directly under the edge of the fabric.

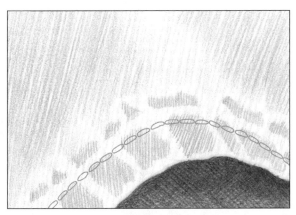

Long, thin ovals identify the stitching on the edge of the denim.

8. Add a dark line under and in between each stitch with your HB pencil to make them look realistic.

9. Use hatching lines and 2B and 4B pencils to shade the rest of the denim. The values graduate from dark on the left, to light in the middle, and then dark again on the right. Make the values a little darker inside each of the little shapes. Use your 6B pencil to add the darkest shading on the left section of denim.

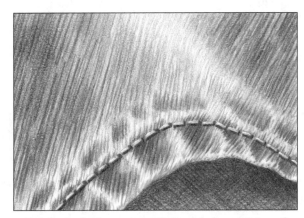

The denim looks more realistic with the addition of darker shading and stitching details.

Helpful Hint

When your kneaded eraser gets dirty, you can simply pull and stretch it (often called kneading) until it comes clean. Then you can reshape it and continue using it.

You need your blending tools and a kneaded eraser to add the final touches.

10. Blend your values slowly and carefully from light to dark. You may prefer not to blend the darkest shading under the edge of the fabric. If the shading becomes too light in some areas, add more graphite and blend again.

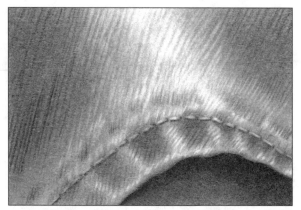

Blending the hatching lines makes the fabric look softer.

11. Shape your kneaded eraser into a thin edge. Draw lighter lines in the light shading with this thin eraser edge. You may need to reshape the eraser several times as you draw with it. Less is more! Don't add too many light lines or you'll ruin your drawing.

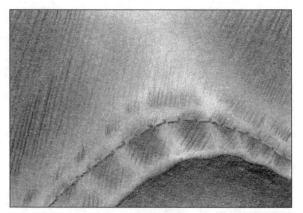

This fabric becomes realistic after a kneaded eraser lightens a few details.

Be careful not to overblend your drawings, especially dark shading. When blending removes a lot of the graphite, the values may become too light. If this happens, you can darken the values again by adding more graphite.

Blending graphite is unbelievably difficult to do well. Expect not to be happy with your first few attempts. However, with time, patience, and practice, you will get better!

The Least You Need to Know

◆ To blend or not to blend is completely a matter of personal preference.

◆ Various blending tools, different pencils, and assorted types of paper affect the final look of blended shading.

◆ Realistic shading with blending needs a full range of values from very light to almost black.

◆ You must be skilled at putting graduated values on your paper for blending to work well.

◆ Various techniques for blending graduations can create several different textures.

In This Part

Exploring the Human Head

What on Earth could possibly be more interesting to draw than a human face? Surprisingly, faces are no more difficult to draw than anything else! If you can make the letters "S," "O," "C," and "U," you can draw any section of a human face.

In this part of the book, I show you where to correctly draw the various features on faces. You discover how to set up simple proportional guidelines that you can use for drawing anyone. Several exercises, based on drawing rounded shapes, show you how to draw eyes, noses, mouths, and ears.

You can't help but smile (and perhaps even giggle) when you get to the chapter on facial expressions. In another chapter, you have a chance to investigate the entire process of how a human face develops and ages from birth through old age. I also guide you step by step through drawing various types, styles, and textures of hair. Drawing faces becomes even more fun when you find out how to top them off with hairstyles.

Remember, even Mr. Potato Head can have a difficult day. If you draw a nose that looks more like a mouth, or vice versa, rest assured that practice makes perfect. Hey, even Picasso explored his creative self by using nonstandard human anatomy! Don't expect to master all aspects of drawing faces right away. Once you get past the intimidation element and realize that faces are easy to draw, you're forever hooked!

In This Chapter

- ◆ Exploring infants' heads and faces
- ◆ Examining children's growing faces
- ◆ Identifying adult facial proportions
- ◆ Drawing diverse people using guidelines

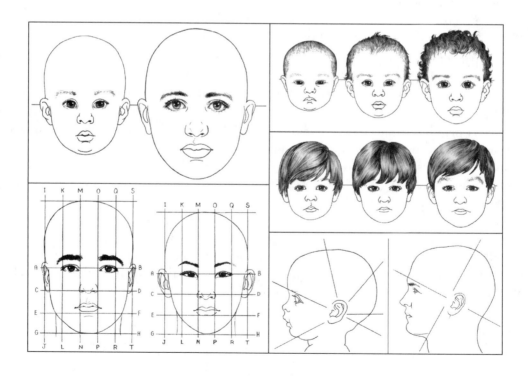

10

Facial Proportions from Infant to Adult

Human faces are all different, but the basic facial proportions of almost every person on our planet fall somewhere within standard sets of guidelines. For this reason, guidelines are extremely helpful to artists who like to draw realistic portraits.

When you know how to use guidelines, your drawings of people are proportionately correct and look much more lifelike. The faces of babies and young children follow one set of facial guidelines, and those of older children and adults adhere to another.

In this chapter, you explore the facial proportions of babies, children, and adults. By observing how diverse faces fit within proportional guidelines, you get a realistic sense of how these principles can help you with your drawings of people. For example, many artists struggle to get a baby or child looking young enough. By using the correct guidelines, portraits of children look like children, rather than mini adults.

Take the phone off the hook, find your drawing paper, let the dog in, sharpen your pencil, and find your ruler! Draw along with me in lots of fun exercises pertaining to facial proportions.

Babies' Heads and Faces

Babies look very different from older children and adults. A baby's face is much smaller when compared to the overall size of the head. The individual features of most babies fit on their faces in predictable positions. Hence, the basis of a facial guideline!

Comparing the Ratio of Face to Head

With a realistic sense of how tiny babies' faces actually are, you are well on your way to drawing their portraits. Drawing the size of the face, proportionate to the mass of the skull, is the key to correctly rendering portraits of babies.

For this discussion, you need to be familiar with two terms. The facial mass refers to the lower section of a human head, also called the face or facial area. The cranial mass is the upper section of the head, often referred to as the cranium or skull.

In the next illustration, compare the face to skull ratio of a baby to that of an adult. In the first drawing, lines visually separate a baby's head into sections (like pieces of a pie). Excluding the neck, the head is divided into four and a half segments. The itty-bitty face takes up only one section, and the cranial mass takes up all the rest of the shape. Accordingly, the skull is more than three times bigger than the face.

In the second drawing, an adult's head is divided into three pieces (excluding the neck). The face is one piece, and the cranial mass is two. Hence, the adult's cranial mass is twice the size of his facial mass.

Art Alert!

The most common mistake when drawing babies' portraits is making the face too big in relation to the skull. An adult's face is half the size of the skull, but a baby's face is only one third.

Profiling an Infant's Head and Face

When drawing the delicate faces of babies, your overall shading needs to be soft, and with little contrast. The darkest values are usually in the pupils of their eyes.

The goal of this exercise is to draw the profile of a baby's face in proper proportion to the size of his or her head:

1. Draw a square and divide it into four equal smaller squares. Check out the first drawing on the next page.
2. Lightly sketch a big circle in the big square and a small circle in the lower left square.

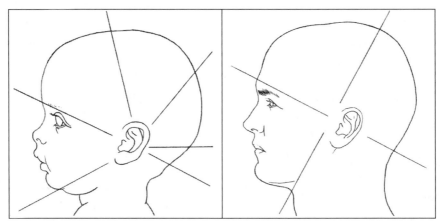

A baby's tiny face is only one third the size of his or her skull, but an adult's is half the size.

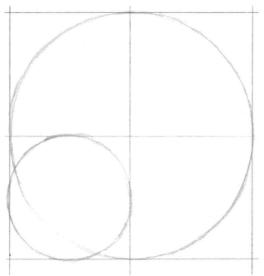

Big and little circles represent a baby's head and face.

3. Sketch the shapes of the face within the small circle.

4. Add a curved line to represent the back of the neck, and sketch the outline of the ear.

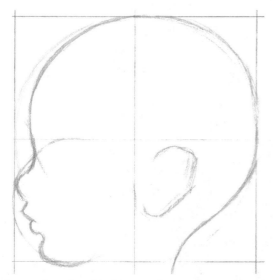

The tiny facial profile fits entirely into the small circle.

5. Sketch the eyes, nose, and mouth, and add details to the ear. Take note of how tiny the infant's neck is.

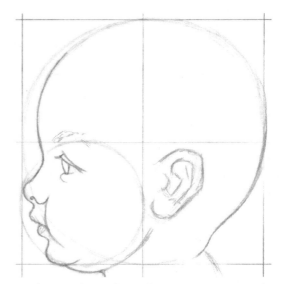

Tiny features bring the realistic proportions together.

6. Erase the outlines of the squares and circles.

7. Lightly sketch the hair and refine the outline of the face and neck.

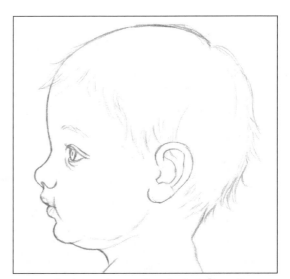

Neatly drawn lines refine the baby's outline.

8. With an HB pencil, add light hatching graduations to accentuate the three-dimensional forms of the face. Refer to the first drawing on the next page.

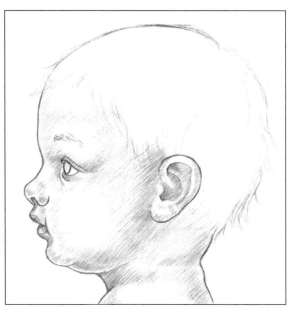

Light shading accentuates the forms of the tiny face.

9. Darken the shadow areas of the face with a 2B pencil.

10. Add the soft texture of the hair with short, curved hatching lines.

? Info Tidbit

Newborn infants can't hold their heads up by themselves. You understand why when you compare the size of their tiny necks to their disproportionately large heads!

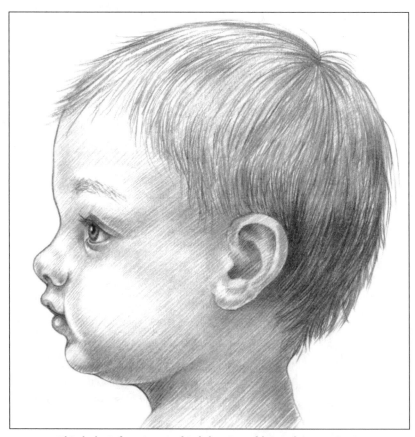

This baby's face is one third the size of his or her cranium.

Sizing Up Tiny Facial Proportions

The overall shape of a baby's head isn't simply that of a small adult. Proportionately, their heads are generally wider, and their chins are shorter and more rounded. However, keep in mind that average facial guidelines can't possibly be inclusive of all babies' faces. The placements and sizes of some infant's facial features may wander outside standard guidelines.

Four horizontal lines identify how babies' features generally fit horizontally on their faces. In the adjacent drawing, note the location of this baby's features in relation to the following generic guidelines:

◆ Eyebrows are on or slightly above line AB.

◆ The tops of the ears and eyes are touching or slightly below line AB.

◆ The nose and the bottoms of the ears are touching or slightly above line CD.

◆ The opening of the mouth is in between lines CD and EF.

◆ The lower edge of the jawbone is identified by line GH. The bottom of the chin isn't a reliable point for measurement because most babies have chubby chins or even double chins.

Vertical facial proportions also fit into standard guidelines. In the adjacent drawing, observe the placement of the babies' features relative to six vertical lines:

◆ Lines IJ and ST identify the widest points on a baby's head.

◆ The eyes are located inside the spaces between lines KL and MN, and OP and QR.

◆ Most (or sometimes all) of the nose and mouth fit in the spaces between lines MN and OP.

◆ The distance between a baby's eyes is slightly more than the space between lines MN and OP.

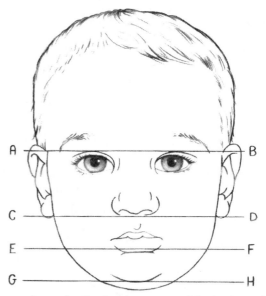

Four lines identify the placements of the horizontal features on a baby's face.

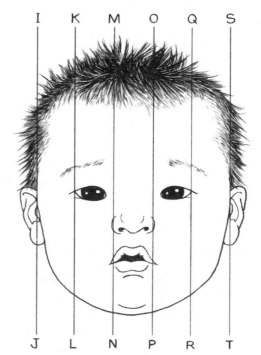

Six vertical guidelines line up a baby's facial features.

Putting a Baby's Face in Place

In this exercise you draw a complete facial guideline for a baby's face, and then place features in their correct places.

Think of a baby's horizontal facial proportions in terms of four halves. Basically, you divide the length of the head in half, divide the lower half in half, and finally divide the lowest quarter in half! Sound confusing? Don't worry! I take you step by step through this process.

1. Lightly draw a vertical straight line (a line of symmetry) down the very center of your paper. (I tell you about symmetry in Chapter 3.)

2. Draw an oval shape to represent the head, with the top half wider than the bottom. Use the line of symmetry to get both sides of the head looking the same.

Which came first—the baby or the egg shape?

3. Measure the total vertical length of the head along the line of symmetry. Divide this measurement in half and mark it with a small dot.

4. Draw a horizontal line (AB) through this dot, dividing the head into two halves.

5. Draw line GH, parallel to line AB, close to the bottom of the chin. Line GH identifies the bottom edge of the jawbone.

Line AB divides the head into two sections horizontally.

 Helpful Hint

When planning any frontal portrait, first draw a straight vertical line down the center of your drawing space to help you draw the head, face, and features symmetrically.

6. Draw the horizontal line CD halfway between lines AB and GH to divide the lower half of the head into two halves.

7. Draw line EF halfway between lines CD and GH to divide the lower quarter into two halves.

Four lines pinpoint horizontal guidelines on a baby's face.

A baby's vertical facial guidelines are determined by simply dividing the width of the head into five equal spaces. If you were drawing throughout your math classes (like me), feel free to use a calculator for figuring out the distances.

8. Draw vertical lines IJ (on the left) and ST (on the right) at the widest points of each side of the head. These two lines are perpendicular to the sets of horizontal lines.

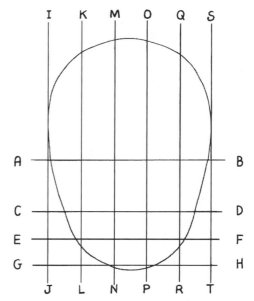

A completed facial blueprint patiently awaits a baby's face.

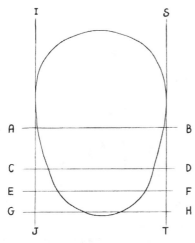

Two vertical lines mark the widest parts of a baby's head.

9. Measure the total horizontal distance between lines IJ and ST. Divide this total distance by five, and mark the four points on your drawing. Add four vertical, parallel lines (KL, MN, OP, and QR) at each of the four points.

10. Outline each part of a baby's face in its proper place within your facial guidelines. (Use the standard guidelines discussed in the previous section.) You don't need to fuss about drawing a baby's face exactly like mine. Focus on simply placing features in their proper places.

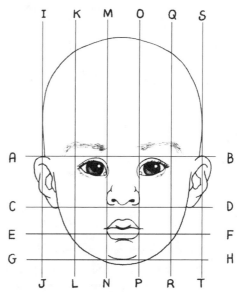

A facial blueprint helps put features in their proper places.

11. Erase your guidelines and the outline of the top of the head. Complete your drawing any way you wish. See my completed drawing on the next page.

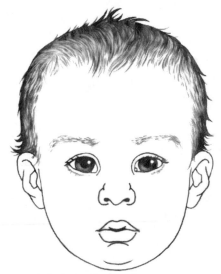

This cute little baby face is drawn proportionately correct.

How a Baby's Face Grows

From birth to age two, the facial mass grows very quickly, and undergoes drastic changes.

In the next illustration, the first drawing is of my daughter, Heidi, when she was an infant. During the first year, the lower half of her face grew to accommodate a few teeth (the second drawing). By two (the third drawing), her jaw had further developed, and her face had grown accordingly.

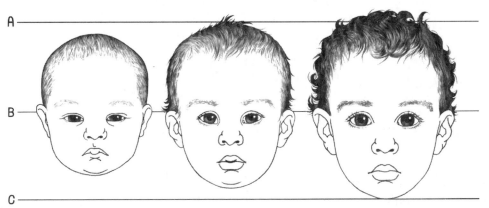

Infants' faces grow very quickly during the first two years of life.

As a child matures from a baby to an adult, the overall length of his or her head grows approximately 3 inches. The facial mass continues to grow more than the cranial mass. By comparing an infant's head to that of an adult, you can get a good sense of the drastic changes in size and proportions, which occur as a human head grows.

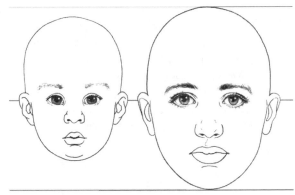

My daughter's face grew a lot and changed considerably from age one to adult.

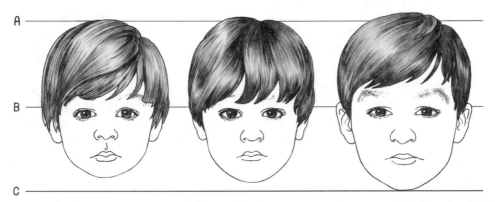

As a preschooler matures into an adolescent, the face grows much more quickly than the skull.

Children's Facial Proportions

The facial proportions of young children follow the same guidelines as for babies. By the time children become teens, their facial proportions more closely follow adult guidelines.

In the previous drawings, my son Ben's face progressively grows from a preschooler into an older child. The cranial mass grows very slightly, and the position of the eyes stays fairly constant. However, the facial mass continues to grow downward. As a preteen (on the far right), his chin touches the bottom line, which is approximately the same place an adult chin ends.

Info Tidbit

In addition to proportion, numerous other factors identify the ages of diverse peoples. Throughout Chapter 11, you time-travel with a face from birth to age 85.

As children grow, the sizes and positions of individual features, change as follows:

◆ Children's eyes become larger and more of the whites are visible. However, their irises stay much the same size.

◆ A large portion of children's eyes is below the halfway point on the head. The eyes of a preteen are closer to or on the horizontal center line.

◆ In preteens, the nose is longer and appears lower on the face than that of younger children.

◆ A preteen's mouth is larger and wider than a younger child's. His or her chin is more clearly defined because the baby fat is almost gone.

Adult Facial Proportions

Various factors influence the physical appearances of adult faces, such as the following:

◆ The sizes, shapes, and placements of features

◆ Physical development, gender, and age

◆ Diversity of ethnic origin

◆ Diet and lifestyle

◆ Differences in skeletal and muscular structures

Even though the heads and faces of adults come in many shapes and sizes, the same basic guidelines for proportions apply to almost everyone. In the next drawing, eyeball the following general principles of proportion:

◆ The widest part of the skull is around "five eyes wide." In other words, an eye is one fifth the width of the widest part of the skull.

◆ The nose is approximately the same width as an eye.

◆ The ears are approximately the same length as the nose.

◆ The outer corners of the mouth line up vertically with the irises of the eyes.

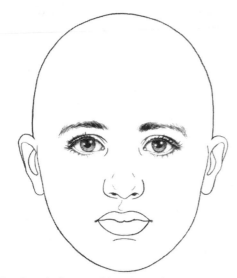

This female face and head are drawn proportionately correct.

Identifying Features Within Guidelines

Artists use various facial guidelines to depict the facial proportions of adults. Besides being super simple to set up, I consider the following guidelines more inclusive of diverse faces than some others.

Refer to the next drawing of a man's face as I explain how the following guidelines apply to most adult faces:

◆ Eyebrows are located above line AB.

◆ Eyes are on line AB. His right eye fits vertically in between lines KL and MN, and his left between OP and QR.

◆ The lower section of the nose is touching horizontal line CD, and mostly fits into the space between MN and OP. The nostrils are often below CD.

◆ The base of each cheekbone usually aligns with the bottom section of the nose.

◆ Ears are between horizontal lines AB and CD. The lower parts of the ears horizontally align with the bottom section of the nose.

◆ The mouth is generally wider than the nose. The lower lip is on or slightly above line EF.

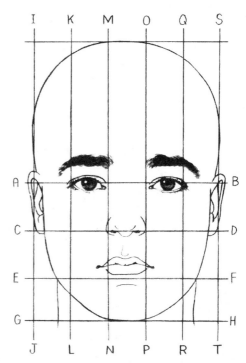

Facial guidelines mark the positions of every feature on an adult face.

Lining Up Adult Facial Proportions

Knowing how to set up guidelines helps you remember where everything goes. In time you'll be able to judge facial proportions visually without drawing a bunch of lines.

To set up horizontal guidelines, you divide the length of the head into two halves. Then you divide the lower half into three equal distances. You simply divide the face into five vertical sections to set up vertical guidelines. The following guidelines apply to the facial proportions of both men and women. Draw along with me and prepare a head and face for some features:

1. Draw a circular shape to represent an adult human head, with the top half wider than the bottom. Remember, a very faint line drawn down the center helps you draw the head and features symmetrically.

2. Draw a horizontal line (GH) at the bottom of the chin.

3. Measure and then draw another horizontal line (AB) halfway between the top of the head and the bottom of the chin.

4. Measure the total vertical distance between lines AB and GH divide it by three. Draw two more horizontal lines, CD and EF, at these points.

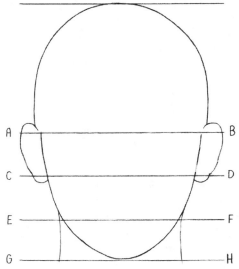

Four lines make up horizontal facial guidelines.

5. Identify the widest (horizontal) section of the cranium, and draw vertical parallel lines, IJ and ST, to mark the outside edge on each side.

6. Measure the horizontal distance between lines IJ and ST. Divide this total distance by five, and add four vertical, parallel lines (KL, MN, OP, and QR) at each of the four points.

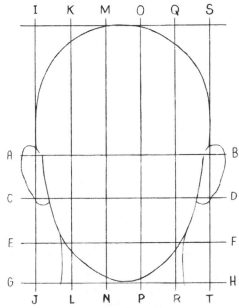

Carefully placed horizontal and vertical lines make up an adult facial guideline.

7. Your facial blueprint is complete. Refer to the guidelines in the previous section and add facial features to your drawing. You may even prefer to try drawing someone you know, such as yourself! Have a peek at the face I drew on the next page.

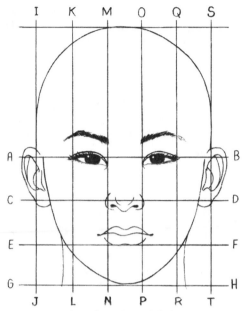

Features are placed on this adult face according to facial guidelines.

No Two Faces Are Alike

With all adult faces following the same proportional guidelines, you may think that every face you draw will look the same. Not the case at all! Cranial and facial masses come in an infinite array of shapes and sizes based on such factors as gender, genetics, and cultural origin.

Facial slope refers to the angle of the lower section of a person's head (excluding the nose) when viewed from the side, from the forward projection at the base of the upper teeth, upward to the forehead. When viewed in profile, you can really notice how the facial slopes of people vary.

In the drawing at the bottom of this page, three profile drawings demonstrate the three basic categories into which facial slopes fall. Angle lines added to the drawings help you identify the differences. In the first drawing, the facial slope is almost vertical. The other two facial slopes are more angular.

In the first drawing on the next page, you see the four basic frontal half views of some different shapes of both cranial and facial masses. You can mix and match these shapes to come up with lots of completely different head variations!

Art Alert!

The most common mistake of beginners is to draw an adult's eyes too high on the head. Think of an adult head as two halves, with the eyes positioned at the halfway point.

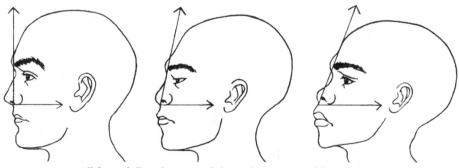

All faces fall within one of these three types of facial slopes.

Which of these skull and facial outlines best fits the shape of your head and face?

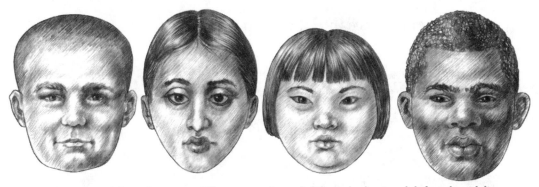

The drawings of these four very different people each follow the basic adult facial guidelines.

Find your drawing supplies and have some fun creating several unique people by mixing and matching skulls with faces:

1. Pick a skull shape and a face and draw them together to make a complete head shape.

2. Use the earlier adult facial guidelines to locate the placements of the features on each.

3. Use your imagination to outline facial features and a hairstyle.

4. Add shading to define the facial forms and the texture of the hair.

The Least You Need to Know

◆ The basic proportions of most people's faces fall somewhere within standard sets of guidelines.

◆ A baby's face is only one third of the size of his or her skull, but an adult's is half the size.

◆ When planning a frontal portrait, draw a straight line down the center of your drawing space to help you draw the head, face, and features symmetrically.

◆ From infant to adult, the facial mass grows much more than the cranial mass.

◆ The facial proportions of young children follow the same guidelines as for babies, and those of older children and teens follow adult guidelines.

◆ Think of an adult head as two horizontal halves with the eyes positioned on the halfway point.

In This Chapter

- ◆ Facial changes from birth to toddler
- ◆ How a face evolves through childhood
- ◆ The transition from teen to mature adult
- ◆ Aging a face into the senior years

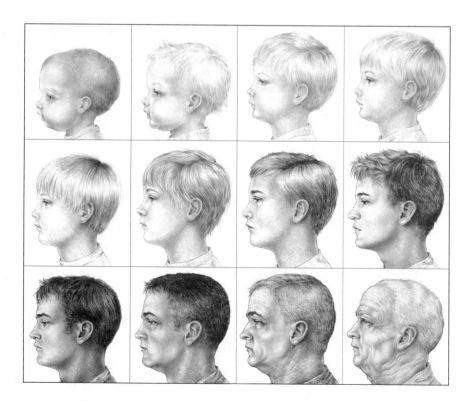

Time-Traveling from Birth to Old Age

With an understanding of the physical aging processes, you can more accurately draw people as their actual ages. You may even decide to have a little fun and draw Uncle Peter 20 years younger than he is (called age regression), or draw your friend Kathleen 20 years older (known as age progression).

The physical characteristics of aging are unique to each individual. Several factors may affect a person's aging process, including genetics, lifestyle, health status, gender, and ethnicity. Hence, an individual's physical age can appear significantly different than his or her actual age in years. In essence, a 40-year-old can look 30, and a 50-year-old can look 60.

All people's faces change considerably throughout their lives in natural and predictable stages of development. However, there's no way to accurately determine how a person will look at a specific numerical age. For this reason, age regression and progression techniques are generally considered an art rather than a science.

In this chapter, you watch the transformation of the face of my best friend, Rob, as it travels through time, from infancy through old age. You also explore the visual facets that generally identify each stage of the natural aging process. In the next drawing, observe the sequential aging process of Rob's face from birth through old age.

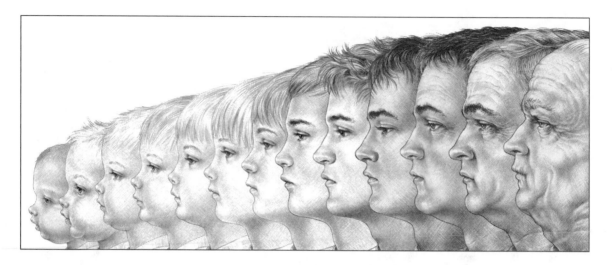

Watching an Infant Grow into a Toddler

A face undergoes more drastic changes during the first three years of life than at any other stage of development. The following general characteristics can help you accurately draw the faces of babies from birth to toddler:

◆ The forehead appears disproportionately large.

◆ The eyes are large, with not much of the whites showing.

◆ The nose is generally upturned because the nasal bones are not well developed.

◆ The cheeks and lower face are chubby.

◆ Ears seem large when compared to other miniature features.

◆ The chin is very small, and subsequently the lower lip appears to be far back on the face.

◆ The neck is quite little when compared to the size of the head.

Warm Fuzzy _____

With patience, careful observation of people's faces, and lots of drawing practice, learning the anatomy of facial aging will seem easier. In the meantime, you can refer to the drawings and basic principles discussed in this chapter for accurately portraying or modifying the ages of your portrait subjects.

The New Kid on the Block

The heads of newborn infants are very tiny, only about 5 inches long. However, when compared to the total length of their bodies, their heads are huge—approximately one quarter of their total height. If the newborn has hair, it tends to be very fine and silky, and the hairline begins far back on the head. Some infants have soft, downy fuzz extending onto their foreheads.

Newborns' eyes are sensitive to bright lights, so they often have their eyes partially closed. They open their eyes more in dim environments. The eyelids are sometimes pronounced, making the eyes look puffy. The eyes appear to be mostly iris with very little of the whites visible.

Newborns' noses and ears tend to look too large for their tiny faces. The upper lip often protrudes forward almost as far as the tip of the nose. The mouth is usually open a little (or a lot if he or she is unhappy). To emphasize these characteristics, I've exercised my artistic license in the next drawing of a newborn. In reality, newborns' necks are too tiny to hold their heads upright like this.

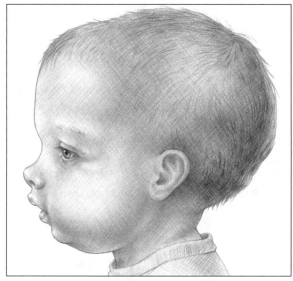

A newborn has a very small neck, tiny face, and large head.

An Infant Grows into a Baby

During the first year, a baby's head grows to approximately 6 inches in length. The neck is stronger and longer. Eyes are fully developed, and the irises are large. The eyelashes and hair (if there is any) become a little longer and thicker. The entire face is a little chubbier, especially around the cheeks, neck, and chin.

The nose and ears look proportionately smaller than those of a newborn, because the face has caught up in size.

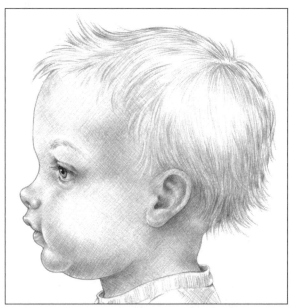

Chubby cheeks, big rounded eyes, and a tiny chin characterize the face of a one-year-old.

Maturing into Fascinating Toddlers

A toddler's cranial mass is approximately two and half times larger than his or her facial mass. The overall facial proportions are similar to those of younger babies.

Between two and three, the hair becomes thicker and the hairline grows forward onto the forehead. Toddlers' jaws and chins have developed to allow space for a few small teeth. He or she is beginning to look more like a child than an infant.

Toddlers' cheeks are full and rounded, and their chins are still proportionately small. The baby fat becomes a little firmer, especially around the mouth, as a child approaches three. Eyebrows tend to be a little darker, the eyelashes appear longer, and more of the whites of the eyes are visible around the irises.

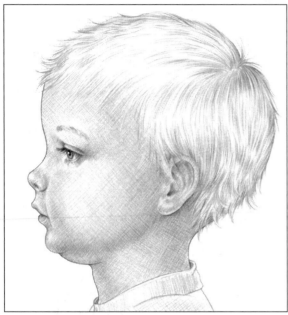

A toddler's face begins to lose its baby look and develops childlike characteristics.

Helpful Hint

Eyes are very important to accurately depict the age of a child. Draw the irises of babies' (and children's) eyes a little larger than they actually are to accentuate their youth.

A Preschooler Becomes a Mature Child

The size and placement of eyes is the key to portraying the accurate age of a child. The irises of eyes grow very little after age three, resulting in children having irises almost as large as those of adults.

Throughout childhood, the facial mass continues to grow faster than the cranial mass. As children grow older, their facial characteristics develop as follows:

- The eyes, nose, and mouth appear lower on the face.
- The nose becomes longer and is less upturned.
- The baby fat on the lower sections of the face becomes a little firmer.
- The individual features grow proportionately larger.
- More of the white of the eyes is visible, as the eyes grow larger around the irises.

Almost Old Enough for School

Preschoolers look less like babies and take on more distinctive facial attributes. The nose has grown a little longer and is less upturned. The jaw is still rounded, but is slightly larger. The chin is more pronounced, and the mouth and lips are firm and expressive. The baby fat on the neck and under the chin is less distinct.

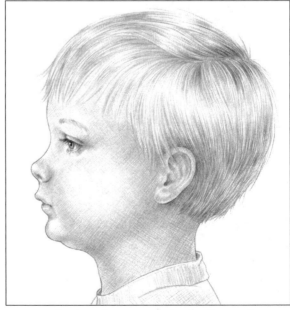

A preschooler takes on a distinctive personality as defined by a quickly growing face.

Ready to Take on the World

A six- to eight-year-old may no longer appreciate being referred to as a baby. His or her eyes are almost as large as an adult's, and the eyebrows are more defined. Along with the continued growth of the face comes a longer nose, more pronounced chin, and a larger mouth area. The jaw is larger and shows signs of becoming angular. The hair is thicker and less fine.

While the neck is a little longer, soft baby fat is still hiding under the chin. The baby teeth now have a lot more room in the mouth, especially when the tooth fairy comes to collect those that are falling out.

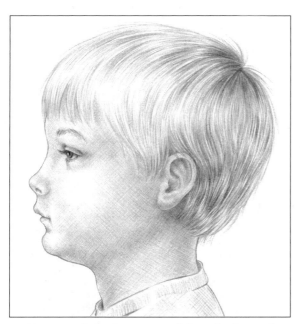

Not many baby features are left on the faces of school-age children.

Moving from Childhood into Adolescence

An older child's facial proportions are close to those of an adult. His or her face continuously grows downward, and the eyes appear proportionately higher on the head. The nose and chin continue to grow longer, and the mouth appears lower on the face.

Between 8 and 12, a child closely resembles how he or she will look as an adult. However, to make sure a drawing of an older child still looks like a child, you need to exaggerate the following:

- ◆ The brow ridge is very softly rounded.
- ◆ A section of the eyes is below the halfway point of the head.
- ◆ The nose is smaller than an adult's and gently curved.
- ◆ The chin and jaw are rounded and not yet fully developed.

Approaching Adolescence

The eyes of older children occupy more space on their faces than adults. The jawline is soft, gently curved, and still somewhat pudgy. However, the forms of bones and muscles are beginning to emerge from under the baby fat.

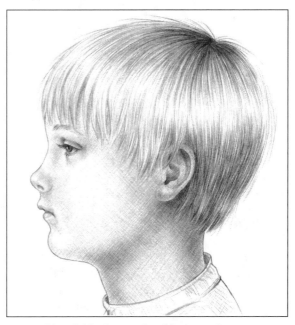

An older child's face is developing and maturing, but still has many childlike characteristics.

Almost a Teenager

The eyes of preteens are shaped more like those of adults, and the overall construction of their faces is more defined than children's. However, many of the structures of bones and muscles are still hidden under a thin layer of baby fat. The jaw and chin will continue to develop for a few more years.

Facial hair on the upper lip and chin, often referred to as peach fuzz, begins to appear on some boys' faces.

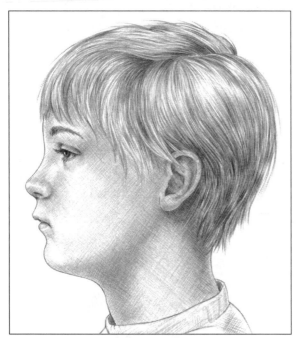

Adolescence marks the phase of development between childhood and teenager.

A Teenager Matures into an Adult

The overall facial proportions, and ratio of facial mass to cranial mass, become that of an adult during the teen years. As children physically mature into adults, their faces exhibit many of the following traits:

- ◆ The brow ridge becomes more angular.
- ◆ The bridge of the nose becomes pronounced.
- ◆ The mouth appears lower on the face and becomes wider.
- ◆ The chin and jaw become more prominent.

The Early Teen Years

A young teenager's nose tip is still rounded, like a younger child, but the baby fat is almost completely gone. The forms of the facial muscles, cheekbones, and jawbone are more noticeable. The eyes are less rounded and take on the proportions of an adult.

Facial hair becomes more abundant on some male faces (not all men have facial hair), and their Adam's apples become conspicuous.

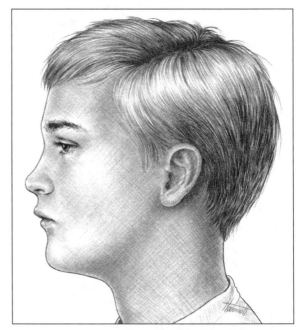

Throughout the teen years, a child's face takes on many physical characteristics of an adult.

A Teen Approaches Adulthood

During the late teens, the facial muscles create more independent facial forms. Cranial and facial bone structures become more pronounced, especially the brow ridge. The tip and bridge of the nose are firm and well defined.

The cheekbones of a young adult female tend to be more defined than her jawbone, which is generally smaller than that of a male. Young adult males have a fully developed Adam's apple, their necks appear a little heavier, and facial hair (for many males) is abundant.

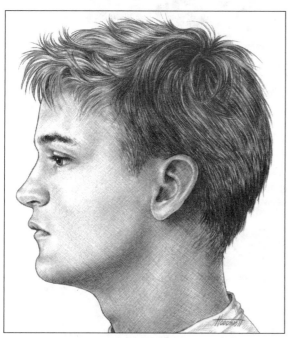

An adolescent has physically matured into a handsome young man.

The Transition from Youth to Maturity

The facial bone structure is fully developed by age 30 and changes very little from this time onward. The eyebrows, lips, and chin stay much the same throughout the aging process. With the onset of maturity, the following signs of aging may appear:

◆ Subtle character lines appear on the forehead and around the eyes and mouth.

◆ The forms of the face begin to show signs of moving downward.

◆ Skin begins to lose its elasticity and becomes slightly thinner.

◆ Bulges begin to appear under the lower eyelids.

? Info Tidbit

An individual's weight can contribute significantly to his or her visual age. A heavy person tends to have more fatty tissue on the cheeks and under the jaw. Extremely thin people, with little body fat, exhibit more age lines and wrinkles.

Evolving into a Mature Adult

An individual's mouth, jaw, cheekbones, and chin are well defined by the understructures of their faces during their 30s. Women's facial forms tend to be rounder and softer than men's, due to having a little more fatty tissue.

The curve under the brow ridge of a young male's face is more angular than that of a female. Hence, a male's eyes generally appear smaller and more deeply set. A man's neck generally becomes thicker and more muscular as he approaches maturity.

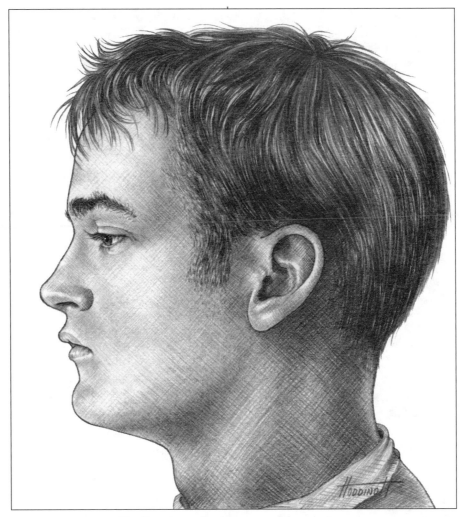

The first signs of aging come with maturity.

Life Begins at Forty

Maturity generally brings with it a more distinguished appearance. Simply drawing a bunch of lines to represent wrinkles cannot realistically depict a mature person's face. You need to be able to identify and then draw the changing three-dimensional exterior forms that identify the physical aging process.

Info Tidbit

A wrinkle is formed when the skin begins to lose its elasticity, becomes thinner, and loses fat. While these biological changes are taking place, gravity plays a role in the aging process by pulling the skin downward.

Wrinkles around the eyes (crow's feet) and the corners of the mouth and on the forehead become more pronounced. Bone structures become more obvious, especially around the eye sockets. The flesh around and under the jaw area becomes softer and begins to sag.

Hair often becomes a little thinner overall, possibly even receding slightly at the temples. Gray hairs may appear.

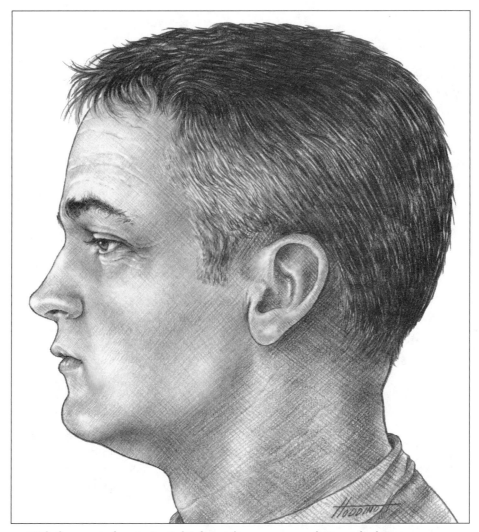

With the onset of maturity, Rob's face takes on a more distinguished appearance.

Gracefully Maturing into the Golden Years

Considering the forces of gravity, it seems logical that if people stood on their heads for 12 hours a day throughout their whole lives, they would never look old. In fact, this can't possibly work. In addition to gravity and time, other factors contribute to the aging process, including the following:

◆ Continuous facial movements of chewing and talking, and facial expressions such as smiling and frowning

◆ Stress, unhealthful life styles, and psychological turmoil

◆ Biological changes such as thinning skin, muscle flaccidity, and the loss of skin elasticity

When accurately rendering an older person's face, you need to take the following into account:

◆ Structures of the forehead, brow ridge, and cheekbones create distinctive independent forms.

◆ The jawbone becomes less noticeable, as the skin at the sides of the mouth, chin, and jaw, droops down toward the neck.

◆ Eyes are deeper set within the eye sockets, making the bones around the eye cavities more pronounced.

◆ Upper eyelids and the skin above the eyes droop downward.

◆ Crow's feet form deep wrinkles around the eyes, and the bulges and pouches under the eyes are more pronounced.

◆ The neck is soft with wrinkles on the sides, and a bulge at the back of the neck becomes more noticeable.

◆ Forms of the cheeks and ears stretch and sag downward.

◆ Lips become thinner.

◆ Hair becomes thinner, and for some individuals significant hair loss creates baldness.

◆ Nose and ears change shape and appear to grow larger.

◆ Hair begins growing more in such areas as the eyebrows, nose, and ears. Females may discover new hair growth on their upper lips and chins.

◆ The understructure of the nose is more pronounced, and its tip appears longer.

◆ Bone tissue of the upper jaw decreases, creating the illusion of a more prominent lower jaw.

Aging Like Fine Wine

With the onset of middle age comes the gradual transformation of various facial forms. The curve under the brow ridge between the eyes is deeper, and the understructure of the nose is more clearly defined. A fleshy bulge at the back of the neck may become more pronounced, along with a few additional wrinkles.

The hair may be graying and thinner. The hairlines of men (and some women) recede at the front, top, and/or temples.

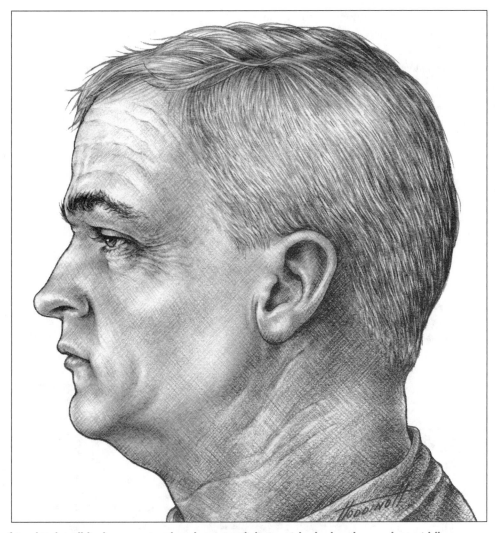

My friend Rob will look even more handsome and distinguished when he reaches middle age.

Finally Eligible for Senior Privileges

To reach an age where you are considered a senior is a blessing. An older person's life journey has been long; and in spite of modified dreams and hard times, there is still much to celebrate.

Most people over 80 don't need to show their IDs to get seniors' discounts! Men (and some women) tend to have a lot more face to wash as their hairlines further recede. Without the magic of hair-coloring products, many individuals have soft, silky white hair by now.

While the hair on their heads becomes thinner and finer, eyebrow, nasal, and ear hairs become increasingly noticeable, or even downright unruly.

A lot of fat has disappeared, and subsequently the understructures of the face and skull become more noticeable. The cheeks may appear hollowed or sunken. Women (and some men) have very pronounced vertical wrinkles around their mouths. Deeper folds, pouches, and wrinkles appear, especially around the eyes, mouth, and neck.

The eyes often seem lighter in color and less bright. The overall posture may change drastically as the shoulders become more rounded, and the head seems to tilt back on the neck, especially when seated.

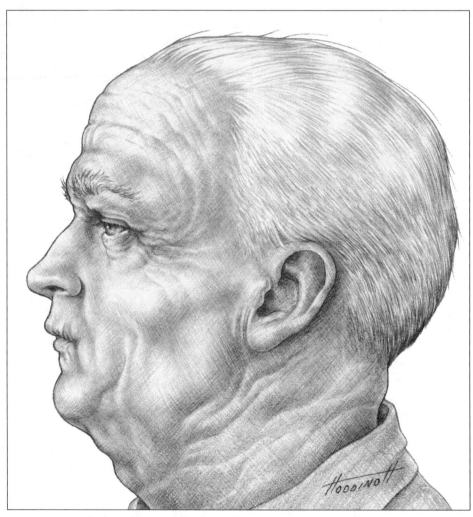

After untold years, this face tells some spectacular stories.

The Least You Need to Know

◆ Diverse peoples age at different rates, primarily determined by genetics and lifestyle.

◆ A human face changes more during the first three years of life than at any other stage of development.

◆ Draw children's irises a little larger than they actually are to help make them look young enough.

◆ The facial mass grows faster than the cranial mass throughout childhood.

◆ The facial structures under the skin create independent forms as a teenager matures into an adult.

◆ The aging process is best rendered by drawing the changing three-dimensional exterior forms of the face.

In This Chapter

- ◆ A look at the parts of an eye
- ◆ How to draw eyelashes correctly
- ◆ Constructing an eye from the inside out
- ◆ Exploring the eyes of babies and children
- ◆ An exercise to test your "eye-Q"

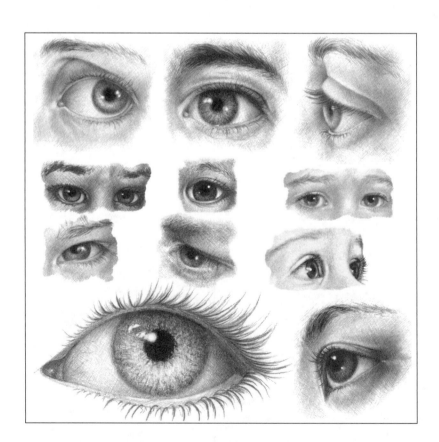

Eyes: A View into the Heart

It's been said that the eyes are the windows to the soul. We communicate our emotions through our eyes, the most sincerely expressive part of us. Like magnets, our eyes seem to be automatically drawn toward the eyes of others. In a portrait, the eyes alone can often tell us something about the person. The shapes and sizes of people's eyes vary, depending on their gender, age, and cultural origin. An individual's changing facial expressions, and the angles from which you view his or her eyes, can also drastically change the way that person looks.

In this chapter, plan to draw lots of eyes from different perspectives, and from the inside out—beginning with the eyeball and finishing with the facial forms around the eye. You also confront the nemesis of portrait artists, natural-looking eyelashes. Finally, in a fun test you can examine your eye-Q!

The Parts of an Eye

Drawing eyes correctly involves illustrating the facial structures and the fleshy folds of skin around the eyes. I use very simple names to identify each part of an eye and the facial anatomy surrounding it. Refer to the next drawing and identify each of the following:

1. The arch-shaped group of hairs above each eye is the eyebrow.
2. A fold in the skin defining the location of the top of the eyeball above the eye is called an upper eyelid crease.
3. The upper eyelid is a movable fold of skin that opens and closes to protect the eyeball.
4. A small, reddish, triangular shape in the inside corner of the eye, close to the nose, is called the inner corner.

5. The white of the eye (a section of the eyeball) is light, but not really white.

6. A highlight is the brightest area where light bounces off the surface of the eye.

7. Eyelashes are fine hairs that grow from the outer edges of the upper and lower eyelids.

8. The pupil of an eye is the darkest circular shape within the iris and adjusts its size under different lighting conditions.

9. The iris is the colored circular section of the eyeball surrounding the pupil.

10. The lower eyelid is a fold of skin protecting the lower section of the eyeball.

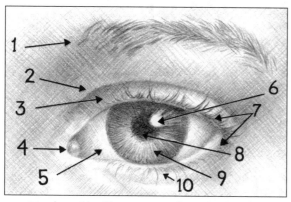

Numbers identify 10 parts of an eye that are important to artists.

Drawing Natural-Looking Eyelashes

The most challenging parts of human anatomy to draw realistically are among the tiniest: the eyelashes. Even if every other aspect of your portrait is perfect, incorrectly drawn eyelashes can ruin your creation. In the next drawing, have a peek at some of the major problems, such as eyelashes that are too thick, too straight, or too long.

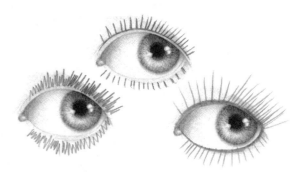

Incorrectly drawn eyelashes can ruin a drawing of an eye.

Refer to the next illustration and note that correctly drawn eyelashes …

◆ Grow in many different directions, mostly outward from the eyelids.

◆ Are rendered with thin lines of different lengths.

◆ Are curved.

◆ Appear thicker closer to the eyelids.

◆ Grow from the outer edges of the upper and lower eyelids and not the white of the eye.

◆ Are drawn in groups rather than single lines.

◆ Are unevenly spaced.

◆ Gradually become longer and thicker toward the outer corners of the eye.

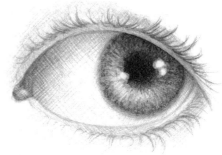

Correctly drawn eyelashes look natural and lifelike.

In the next drawing, you see unnatural-looking eyelashes that are the same value and thickness from root to tip.

Thick curved lines do not look like natural eyelashes.

Art Alert!

Never draw eyelashes from the tip down toward the eyelid. Always draw them in the direction in which they grow, from the eyelid (or root) outward.

With lots of practice, you can draw natural-looking eyelashes that are thick and bold at the base, and thin and light at the tip. A simple little drawing technique provides a realistic-looking eyelash every time. Grab some paper and a 2B pencil. Refer to the next drawing as you try your hand at drawing some fabulous looking lashes:

1. Begin at the base of the eyelash and press firmly with your pencil. Eyelashes need to be drawn in the direction in which they grow, from the eyelid outward.

2. Slowly release the pressure you apply as your curved line extends toward the tip.

3. Gently lift your pencil from the paper when the tip of the line is very thin and light in value.

Realistic eyelashes look like inverted commas (thick at the bottom and thin at the top).

Now warm up your drawing hand and draw an eyeful of eyelashes! Refer to the earlier criteria for drawing eyelashes as you follow these steps:

1. Lightly sketch the almond shape of an eye with a double line at the top and bottom to represent the thickness of the flesh of the eyelids.

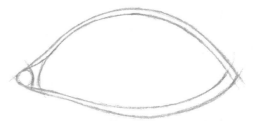

This almond-shaped eye is awaiting eyelashes.

Helpful Hint

Whenever you draw eyes, keep the initial sketch lines very light so they can be erased later. No part of an eye should be drawn with dark bold lines. Instead of lines, use contrasting shading graduations to separate the various parts of the eye and give depth to their forms.

2. Use 2H and HB pencils to draw an average quantity of eyelashes on the outer edges of the upper and lower eyelids.

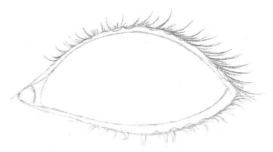

Lots of men and women sport an average smattering of eyelashes.

3. Add a few darker lashes of various lengths (with a 2B pencil) toward the outer corner of the eye for thick eyelashes.

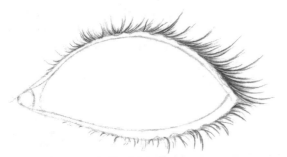

Many individuals have long, thick eyelashes.

4. Use a 2B pencil to add a few thicker lines to create the illusion of very thick eyelashes (or eyelashes with mascara applied).

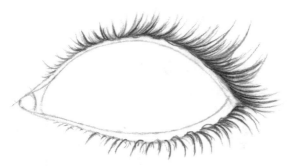

Some people's eyelashes appear very thick, dark, and long, especially if they are wearing mascara.

Don't expect to master drawing eyelashes right away. Take lots of time to practice before you try adding them to your drawings.

Diverse Eyes from Different Perspectives

Diverse individuals naturally have distinctively different eyes. For instance, the eyes of babies and children appear to be much larger than adult eyes. Female eyes are often more rounded and occupy more space on the face than their male counterparts. Their eyelashes are often thicker and their eyebrows are thinner. The male eye tends to be proportionately smaller than that of the female.

The shapes of various parts of eyes seem to change when viewed from different perspectives. For example, when viewed in profile, you see very little of the actual eye and you can really notice the way the upper eyelid protrudes outward farther than the lower.

Different facial expressions can also drastically affect the shapes of eyes and the folds of skin around them. Even babies can exhibit crow's feet for some facial expressions. To accurately depict expressive eyes, you need to pay close attention to the forms and wrinkles around the eye. (Refer to Chapter 16 to view numerous eyes and various facial expressions.) Throughout the next sections, try your hand at drawing human eyes of different shapes and sizes from various perspectives.

Shading an Iris and Pupil

In the last section, you created a lovely drawing of eyelashes. But, don't file it away just yet. You can now add a pupil and an iris and finish shading the eye.

The pupil of an eye is similar to the aperture in the lens of a camera in that it opens and closes as the light gets brighter or darker. When you say that someone has blue, brown, or green eyes, you're actually referring to the color of their irises. Within the iris, you can often see itty-bitty lines that radiate outward from the pupil. These lines are tiny muscles (more noticeable in light-colored irises) that help the pupil open and close.

1. In your drawing, outline an iris, pupil, and highlight (or highlights). The light source is from the left. Feel free to make your highlight a simple circle rather than the two squiggly shapes I show in the following drawing.

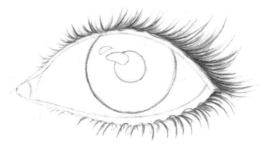

Simple circular shapes define an iris, pupil, and highlights.

2. Add shading to the iris and pupil. I've used a 2B pencil and squirkles to shade the iris. The shading of the iris is darker around the perimeter and under the upper eyelid, which is in shadow. A few tiny lines radiate out from the pupil. The pupil is filled in with an 8B pencil.

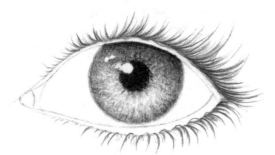

A strong contrast in values highlights the pupil and iris.

Helpful Hint

Always add some shading to the whites of eyes. Different values can illustrate their spherical forms, tiny blood vessels, and cast shadows from eyelids and eyelashes. Only the highlights of eyes are white.

3. Refer to the drawing below and add shading to the whites of the eye, the edges of the upper and lower eyelids, and the inner corner of the eye. If you want, you can add some thin lines extending onto the whites from the corners to look like tiny blood vessels.

Info Tidbit

You can indicate the color of the iris of an eye by using different values of gray. Brown eyes are very dark in value, almost as dark as the pupil. Hazel, blue, or green eyes are mostly shaded with middle values. Pale blue, green, or gray eyes are very light in value and contrast sharply to the dark pupil.

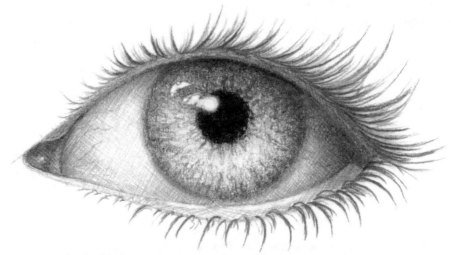

The highlights on the shiny surface of the eye are bright white.

Eyeing an Eyeball

An eyeball (commonly referred to as the white of an eye) is a fragile sphere nestled safely inside a protective bone cavity of the face, called the orbital socket (or orbital cavity). When you look at a person's eyes, you see very little of his or her eyeballs. The iris and pupil take up most of the visible section of an eye, with only a little of the whites showing.

The largest section of the eyeball is hiding inside the frontal section of the skull. To truly understand how to draw an eye correctly, you need to be aware of its construction behind the small section you see. In the next drawing, you see an eyeball as it would appear if it were outside the eye.

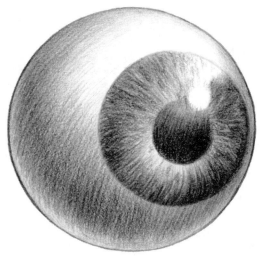

Only a small section of an eyeball is what is commonly referred to as the eye.

Drawing and Shading Adult Eyes

Grab your supplies and try your hand at drawing eyes from the inside out. You can draw all four examples shown at once or focus on one at a time. The instructions are the same for each:

1. Refer to the drawing below and draw a circle with an outline of an iris and pupil inside. An iris and pupil visually change shape from a circle to an oval (an ellipse) with the changing angle of the head and it is rarely perfectly round. In profile, you can see that the eyeball is not a perfect sphere. The cornea of the iris bulges slightly outward.

2. Draw the eyelids as curved lines that follow the contour of a sphere. Refer to the first drawing on the next page. Allow for the thickness of the flesh of the eyelid. Keep your lines really light so you can erase them later.

 Keep in mind that the eyelids are not attached to the eyeballs. The upper eyelid needs to be able to open and close to shield the eye from potential dangers such as foreign objects, dirt, or bright lights. Depending on the perspective from which you are viewing the eye, the rims (edges) of both, or just one, of the upper and lower eyelids are visible.

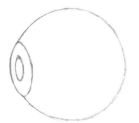 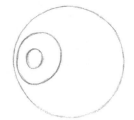 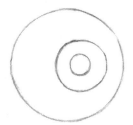

As your perspective of an eyeball changes, the irises and pupils appear to be in different locations.

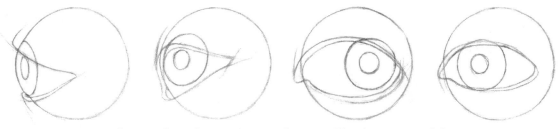

The top edges of irises are partially covered by the upper eyelids.

3. Add shading to the white of the eye with a 2H pencil. Keep in mind that an eyeball is spherical rather than flat. Your goal is to convey its spherical form.

4. Outline where you want to place the highlight, so you remember to leave it white.

5. Use HB and 2B pencils to shade the iris. The iris has a graduation of values (rather than just a solid tone), which helps the surface of the eye look shiny.

In addition to their basic almond shape, realistically drawn eyes need to illustrate the three-dimensional forms of the eyeball, eyelids, and the orbital socket.

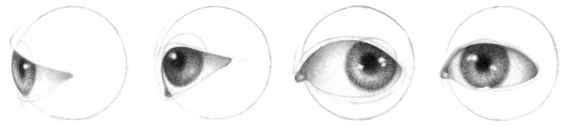

Shading makes the eyes look shiny and three dimensional.

6. Erase the outlines of the eyeballs.

7. Add shading to the upper and lower eyelids.

8. Draw an average quantity of eyelashes on the outer edges of the eyelids on each eye.

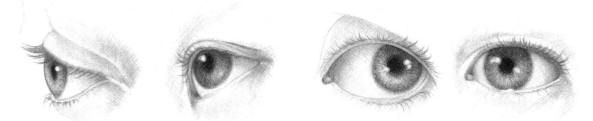

The forms of the eyes and eyelids come to life with shading.

9. Add shading to the facial structures around the eye. Lifelike drawings of eyes need to be anchored within the facial structures. Carefully placed shading graduations fool the observer's eye into thinking that lines define various aspects of the eye, such as the upper eyelid crease.

10. Draw an eyebrow above each eye. Concentrate on accurately drawing the shape and different values rather than the individual hairs.

Eyebrows range in value from very light to almost black and can be narrow and thin or big and bushy. They can be arched, straight, or even wavy. Eyebrows follow the shapes of the brow ridge and seem to change shape when the head is viewed from different angles.

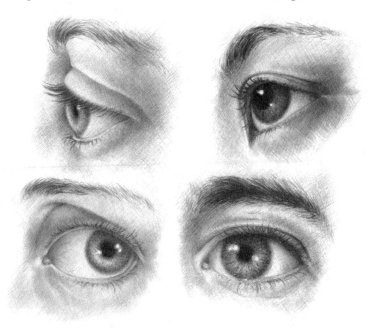

Even when looking directly at you, eyes can be various shapes.

Drawing the Eyes of Little People

Even though children's eyes are more rounded and their eyebrows are generally lighter, the shading techniques are the same as for adult eyes. Less of the whites of their eyes is visible, creating the illusion that the irises are much larger. The shapes of older children's eyes tend to be a little less rounded than those of babies.

In the next drawings, you can explore a few different eyes of babies and children.

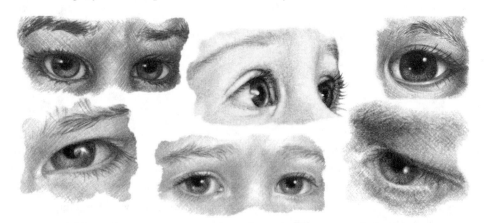

Children's big innocent eyes seem to have disproportionately large irises.

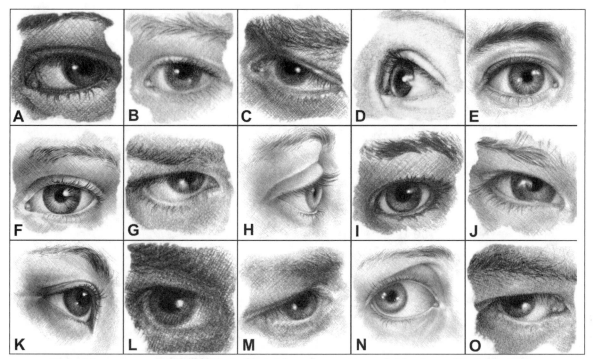

These 15 eyes represent a small sampling of frontal, angular, and side views of individual eyes.

Testing Your Eye-Q

Now that you have worked your way through lots of information and drawings of eyes, let's have some fun and test your "eye-Q." I don't provide you with answers, but if you're stumped, review what you've learned in this chapter. The simple goal of this exercise is to have you closely examine the various eyes in the drawing above. Find at least one of each of the following:

1. Eye that appears to be dark brown
2. Eye that seems to be blue
3. Baby's eye
4. Man's eye
5. Woman's eye
6. Frontal view of an eye
7. Profile view of an eye

The Least You Need to Know

- The many different shapes and sizes of people's eyes are determined by gender, age, and cultural origin.
- People's eyes change shape with different facial expressions.
- The various parts of eyes look very different when you view them from different angles.
- When drawing eyes, you need to draw the forms of the face and the various folds of skin around the eyes.
- Realistic eyelashes need to be drawn in the direction in which they grow, from the eyelid outward.
- The eyes of babies and children are more rounded, the irises appear to be much larger, and their eyebrows are lighter than those of adults.

In This Chapter

- ◆ Drawing the spherical forms of a nose
- ◆ Different perspectives on noses
- ◆ Diverse nose shapes and sizes
- ◆ Exploring the noses of babies and children
- ◆ An exercise to test how well you know noses

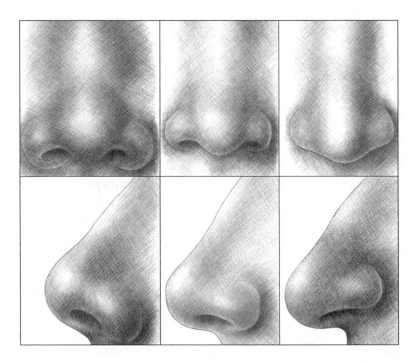

A Nose for Noses

There's not too much I can say to make noses sound exciting. They aren't expressive like eyes or mouths; they tend to just sit there on a face. But noses help define one's character and become a personal trademark (think of Jimmy Durante, Bob Hope, or Barbra Streisand). And on the plus side, noses are the easiest feature of a face to draw. You can impress the socks off your family and friends with a well-drawn nose.

As with most structures of a human body, the individual parts of a nose are also based on spheres and/or circular forms. In this chapter, I show you some very simple techniques for drawing wonderful noses.

Picking a Nose Apart

Before you draw a nose, you should become familiar with its different parts. Refer to the next drawing and identify each of the following:

1. The bridge (sometimes referred to as the nasal bone) is the section of the nose where the upper bony section joins the cartilage. While barely visible on young children, the bridge on an adult nose often protrudes as a noticeable bulge or bump. The contoured shape of the bridge is most obvious when the nose is viewed in profile.

2. The ball (also called the tip) refers to the largest, central rounded form on the lower half of the nose. The ball is not necessarily spherical. It can also appear oval-shape, triangular, or even rectangular (with rounded edges, of course).

3. The wings are two soft, rounded (often triangular-shape) forms extending from the sides of the ball of the nose.

4. A nostril is the opening on the lower section of each side of a nose.

5. The base of a nose (also called a septum) is in between the nostrils and connects with the lower face above the upper lip.

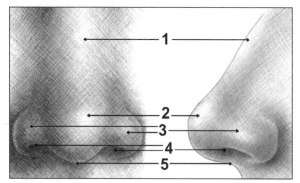

Numbers help you get to know the parts of noses.

Male noses appear longer and larger than those of females simply because men's overall head sizes are apt to be bigger. Female noses are generally softer and more rounded, due to more fatty tissue covering the under forms.

The basic shape of the lower section of a child's nose is very similar to that of an adult. However, children's noses are generally smaller and shorter, with an upturned ball and an underdeveloped bridge. When viewed in profile, children's noses tend to appear curved, sort of like a ski slope.

When a person's facial profile is level, rather than tilted up or down, you can really notice the forms of his or her nose. Adult noses come in all shapes and sizes, but each falls into one of the following three categories:

◆ Upturned noses angle upward and the ball is higher than the wings.

◆ The ball and nostrils of straight noses line up horizontally with the wings.

◆ On down-turned noses the ball is lower than the wings, creating a downward angle.

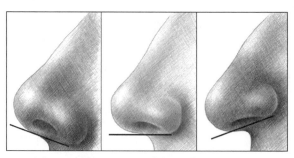

Adult noses fit into one of these three categories.

Info Tidbit

An ideal or perfectly shaped nose tends to be highly subjective. What is considered perfect to one person is completely different from someone else's concept of ideal.

You can draw any nose by following these three simple steps:

1. **Establish the proportion.** To accurately establish the proportions of a nose, you first sketch the overall size and location of the nose in relation to the face. Then you visually measure the size ratio of each part of the nose when compared to the whole and adjust your sketch accordingly.

2. **Outline the shape.** Noses come in an infinite array of shapes. You need to closely observe your subject's nose to determine the shapes of the individual parts.

3. **Define the form.** Simply stated, shading the lower section of a nose is like shading three independent circular forms. Defining the upper section is similar to shading a rounded wedge-shaped form or half an ovoid.

Straight-On Shading of a Nose

Drawing a nose doesn't have to be boring. This crazy cartoon character, named Smelly Spheres, offers you a fun opportunity to draw a frontal view of a nose. The spherical forms are highly exaggerated to give you an easy-to-remember sense of how to accurately draw three-dimensional noses.

Drawing and shading the spherical structures of a nose is the educational component of this exercise. Giving a nose a face and personality is an entertaining perk.

The first phase of drawing Smelly Spheres entails sketching three circles in proper proportion to one another:

1. With an HB pencil, lightly sketch a big circle.

2. Draw two smaller circles slightly below (or above or level with) the big circle. Observe that a portion of each smaller circle is drawn inside the big circle.

The foundation for a frontal view of a nose is three overlapping circles.

3. Erase the sections of the small circles that are inside the big circle. The big circle (the ball) now appears to be in front of (overlaps) the smaller circles (the wings).

The ball of the nose (the big circle) overlaps the wings (the two smaller circles).

Prior to adding shading, the shape of the nose and each of its parts needs to be accurately rendered.

4. Pat all your lines with your kneader eraser until you can barely see them. Add neat crisp lines to redefine your rounded shapes.

5. Draw a curved line in the lower-inside section of each of the smaller circles to represent the nostrils.

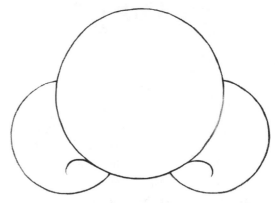

Three simple circles are transformed into a nose shape.

As you add shading to these spheres, keep in mind that the dominant light source is from the right. The curved hatching lines used for shading follow the curves of the circular shape.

Helpful Hint _____

When shading noses, let your pencils, from light (2H or HB) to dark (4B), do a lot of the work. You only need to decide where to place all your values.

6. Use various pencils and curved hatching lines to add light and medium values to the ball of the nose. Leave the highlight white. The values begin light (close to the highlight), become dark, and then light again close to the lower right edge of the sphere (reflected light).

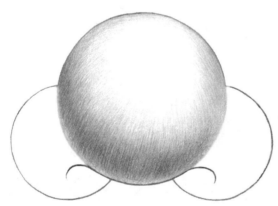

Shading defines the spherical form of the ball of a cartoon nose.

7. Shade in the wing on the right in the same manner as you shaded the ball. Pay close attention to the shading on the lower right, which indicates the nostril.

8. Add darker values in the shadow areas of the ball and on the right wing.

Art Alert! _____

Your drawings of noses will appear flat rather than three-dimensional if you use too little contrast in values. So a word to the wise: Unless your model actually has a very flat nose, use a broad range of values.

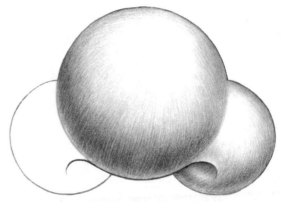

A full range of values gives contrast between the light and shadow areas of a nose ball and wing.

9. Add shading to the wing on the left. The shading in the cast shadow (on the upper-right surface) is darker closer to the ball and becomes gradually lighter as it moves outward.

10. Get creative and give Smelly some eyes and a mouth (no need to draw them like mine).

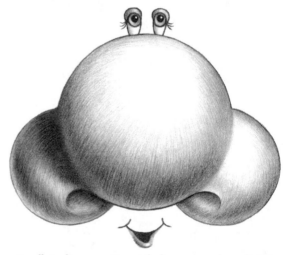

Smelly's disproportionately large nose has slightly exaggerated three-dimensional forms.

Step back from your drawing and take a look at the overall values. Add final touches to the shading, if needed.

As the Nose Turns

In addition to the shapes of noses being different, the perspective from which you view someone's face contributes to the look of his or her nose. If the person's face is angled upward, the ball may be above the wings. When angled downward, the ball is usually below the wings. When viewed straight on, the ball can be level with, above, or below the wings.

> **Helpful Hint** _____
>
> When drawing noses, try and forget that you are drawing a nose. Instead, concentrate on defining the various forms according to the light and shadows.

Noses in Profile

When drawn from the side, only two circular forms come into play, the ball and one wing. Follow along with me and draw a profile view of each of the three basic types of noses. You can draw one at a time or all three at once. The instructions are the same for each:

1. Draw a large circle for the ball of the nose and a smaller one for the wing. As you can see in the followng illustration, the circles overlap one another.

 The illustrations for the following steps are on the next page.

2. Follow the outlines of the circles to draw the shapes of the ball and wing.

3. Add the outline of the bridge of the nose, the nostril, and the tiny section of face under the nose.

4. Add light shading to identify the forms of the nose. Light from the left creates darker shadow sections on the right.

5. Use crosshatching to complete the shading of the various forms.

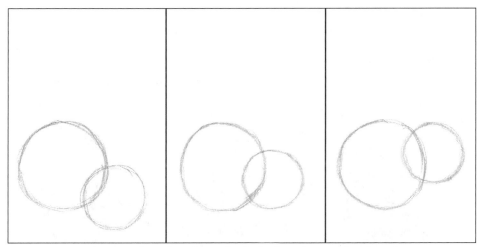

A large and small circle marks the ball and wing of each nose.

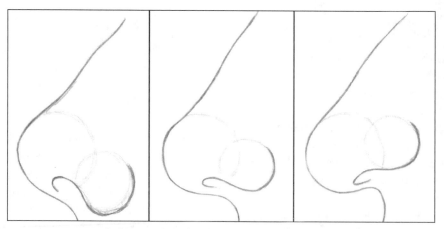

Simple lines outline the shapes of three different noses.

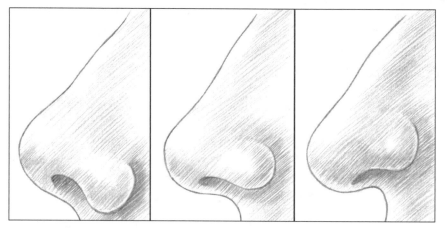

Light shading brings out the three-dimensional forms of each nose.

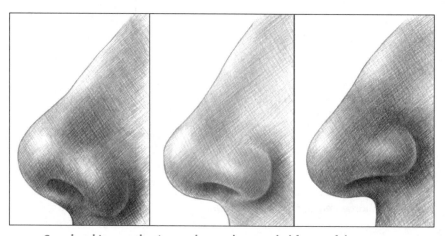

Crosshatching graduations enhance the rounded forms of three noses.

Noses from the Front

A nose is somewhat more challenging to draw from the front than from the side. You're dealing with two nostrils and two wings. You can draw the following three noses at the same time or draw each one separately. The instructions are the same for each.

1. Draw a large circle for the ball of the nose and two smaller overlapping ones for the wings.

2. Add an oval shape to represent the bridge of the nose.

3. Use the circular shapes as guides to outline the ball, wings, and the nostrils of the lower section of the nose (as in the second drawing below).

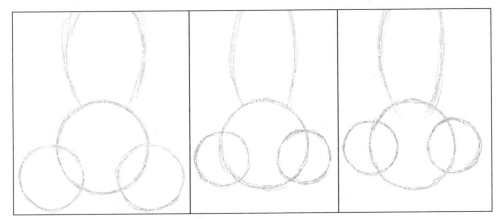

Circular shapes outline three different frontal views of noses.

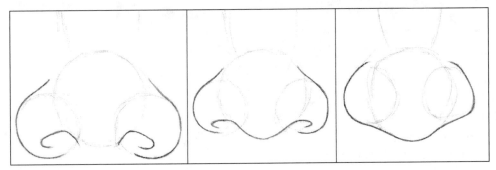

Outlines of the lower sections of three noses are different shapes and sizes.

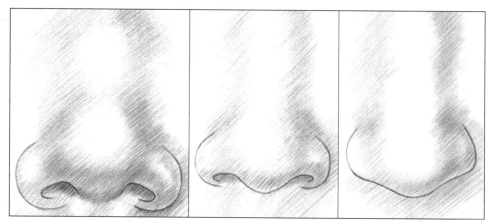

With light shading, the forms of the noses are beginning to emerge.

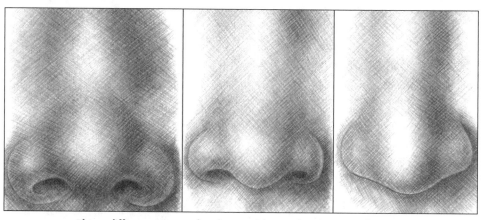

Three different noses take shape with crosshatching graduations.

4. Refer to the first drawing and add light shading to define the forms. Assume the light is from the left.

5. Use crosshatching to complete the shading of the nose and its various parts (as in the second drawing above).

Drawing Children's Noses

When compared to an older child's nose, a baby's nose is smaller and more upturned and has a less-developed bridge. When viewed in profile, a baby's nose begins between the eyes and curves gently downward toward the ball. From there it sweeps inward on the face and then gently curves outward again as it approaches the upper lip.

Children's noses may be less upturned than babies', but they are usually more upturned than those of adults. When viewed from the front, you can usually see both nostrils.

The upper sections of babies' and children's noses are not well developed and require very little shading. Refer to the drawings on the next page and try your hand at drawing frontal views of each:

1. Draw a rounded shape as the ball and two smaller ones on either side as the wings.

2. Refine the outline of the nose and nostrils.

3. Use the third drawing as a guide to add shading with crosshatching. Don't forget to lighten your outline with a kneaded eraser before you begin shading.

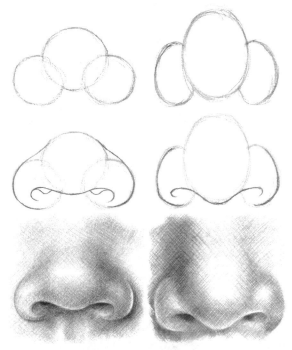

Drawing the noses of a baby (on the left) and an older child follow similar guidelines.

Who Knows Noses?

Just for fun, test your skills at identifying different aspects of noses, according to the info presented throughout this chapter. Find at least one example of each of the following in the adjacent illustration of 15 different noses:

- ◆ Child's nose
- ◆ Side on view of a nose
- ◆ Baby's nose
- ◆ Upturned nose
- ◆ Adult nose
- ◆ Frontal view of nose
- ◆ Down-turned nose

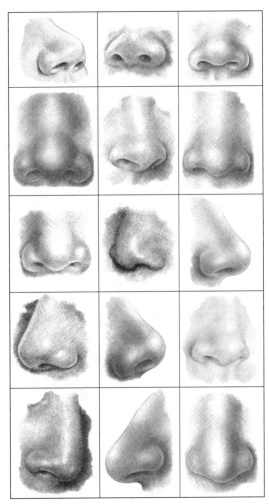

Fifteen different noses represent a small sampling of the diversity of human noses.

The Least You Need to Know

- ◆ Noses are the easiest feature of a face to draw.
- ◆ The individual parts of the lower half of a nose are based on spheres and/or circular forms.
- ◆ Male noses are usually longer and larger than those of females.
- ◆ Babies' and children's noses are smaller, more upturned, and the bridge is less developed than those of adults.

In This Chapter

- ◆ Here's to diverse ears
- ◆ Drawing ears from different perspectives
- ◆ Examining various views of mouths
- ◆ Sketching lips from simple shapes
- ◆ How to draw realistic-looking teeth

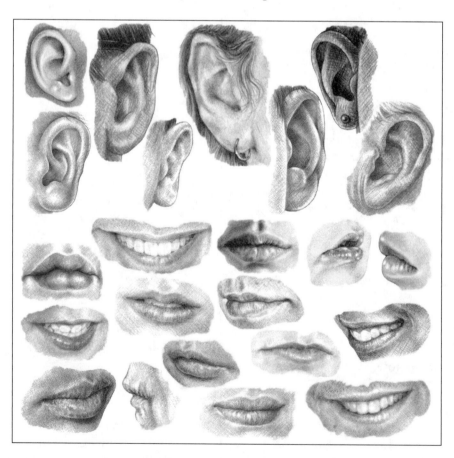

Expressive Ears and Mouths

The overall impact of a portrait is only as strong as its weakest part. Drawing individual facial features is like drawing pieces of a puzzle. When each piece is accurately drawn, the puzzle fits together to become a powerful and dynamic drawing.

Ears and mouths become quite easy to draw when you become familiar with the shapes of the individual parts. In this chapter, you discover how to draw realistic ears and lips around a foundation of simple rounded shapes. I also take you step by step through an exercise in drawing teeth correctly within a warm smiling mouth.

Seeing Ears from Different Perspectives

The primary difference between adult ears and those of children is size. Adult ears are generally larger; however, tiny ears on an adult, and big ears on a child, can in fact be the same size. Regardless of size, ears are as unique to each individual as fingerprints.

The Parts of an Ear

Drawing ears is a little less intimidating when you become familiar with the ear's five basic parts. In the first drawing on the next page, I've added numbers and arrows pointing to the five primary forms of an ear. I use easy to remember names for each:

1. The outer rim is the long form along the outside edge of the ear that meets up with the earlobe at the lower section.

2. The inner rim is the smaller long form inside the ear, which circles the rear of the opening to the ear canal.

3. The small lobe is the small round form over the frontal section of the opening to the ear canal. It joins the earlobe at the front of the ear, where the ear joins the face.

4. The ear canal is the opening to the inner ear.

5. The earlobe is the soft, fleshy, lower section of the ear.

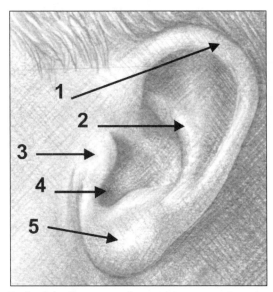

Each of the five parts of an ear is easy to draw by itself.

Helpful Hint

Drawing ears from life is the very best way to understand the various nuances of their forms from different perspectives. Borrow the ears of your family and friends, observe them from different angles, and note how very different they are. In your sketchbook, draw as many different ears as you can find.

Ears from Various Angles

In the next drawing, you see a small sampling of ears of various shapes and sizes. Some are straight-on views, and others are seen from the front or at an angle.

Each ear is rendered with a broad range of values, thereby creating the illusion that their individual forms are three-dimensional. Observe the highlights and light shading on the outer and inner rims, the small lobe, and the earlobe. The shading is generally dark behind the small lobe where the opening to the ear canal is located.

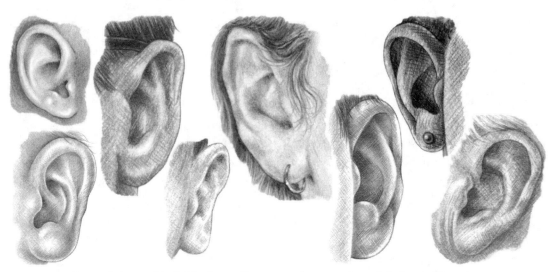

Several views of individual ears illustrate a tiny sampling of their vast diversity.

Info Tidbit
Children's ears look very similar to adults', but are generally smaller, and the individual forms are softer and more rounded. Children's ears come in a variety of shapes and sizes and generally look too big for their small faces. However, as their faces get bigger, they usually grow into their ears.

Drawing Different Viewpoints of Ears

As a whole, the structures and forms of an ear are complex and challenging to draw. However, when you break an ear down into five distinct sections, and tackle only one at a time, it becomes much easier.

Sketching Step by Step from Oval to Ear

In this exercise, I take you step by step through the entire process of drawing the forms of an ear, when viewed straight-on to a side view of the head:

1. Sketch an oval shape slightly tilted to the right at the top. (Refer to the first drawing in the next set.)

2. Outline the long, inverted C shape of the outer rim (1). It begins inside the oval (on the left), extends up and toward the right, and then curves down along the outside edge of the ear.

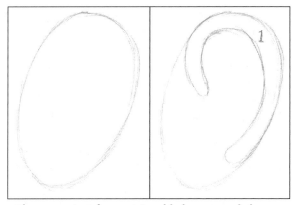

The outer rim of an ear is added to an oval shape.

3. Outline a comma shape for the inner rim (2). The shape is wider at the top and becomes increasingly narrower as it curves to the left at the bottom.

4. Sketch the outline of the small lobe (3) as a small oval.

5. Add a tiny oval to mark the opening to the ear canal (4).

6. Outline a larger rounded shape as the ear-lobe (5).

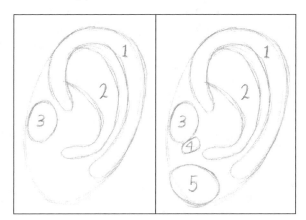

Simple shapes identify each of the five parts of an ear.

7. Lighten the sketch lines with your kneaded eraser and redraw the various shapes of the ear with neat lines. Keep your lines light. A curved line around the frontal and lower sections of the ear canal is the key to making the ear look real. This simple line connects the inside edges of the small lobe to the inner rim.

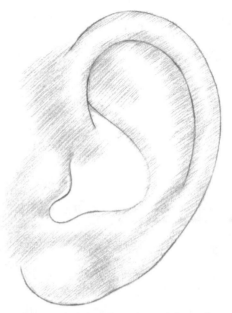

Light shading with hatching lines defines the outer forms of an ear.

9. Use an HB pencil to darken the shading to further emphasize the independent forms of the ear.

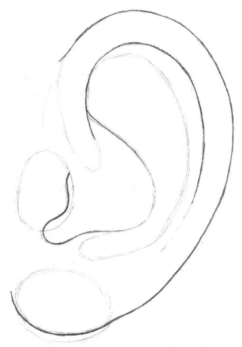

Curved lines join five shapes together to become an ear.

8. Add light shading with a 2H pencil to the earlobe, small lobe, and the inner and outer rims. Your goal is to identify their three-dimensional forms.

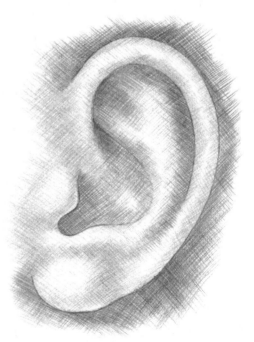

Crosshatching lines bring out realistic three-dimensional forms.

10. With patience and various pencils, complete the shading of the ear.

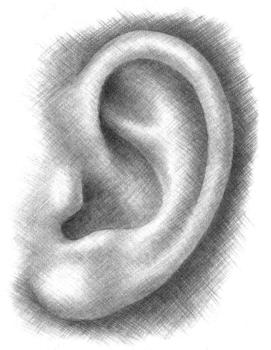

Dark values complete a lifelike drawing of an ear.

An Ear from the Front

In this exercise, try your hand at drawing an ear as it would appear when looking at a face straight-on:

1. Outline a long oval shape as in the first sketch below.

2. Sketch the four visible parts of the ear (as in the second drawing). From this angle, the opening to the ear canal appears to be hiding behind the small lobe.

3. Gently pat these lines with your kneaded eraser until you can barely see them.

4. Redraw the various shapes of the different parts of the ear with neat lines.

5. Complete the ear by adding shading with crosshatching (as in the fourth drawing). The highlights and lightest shading are on the earlobe, outer and inner rims, and small lobe. The darkest shading is at the opening to the ear canal.

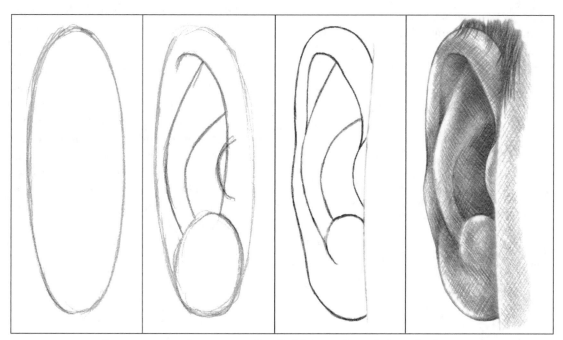

Draw an ear as it appears when looking at a frontal view of a face.

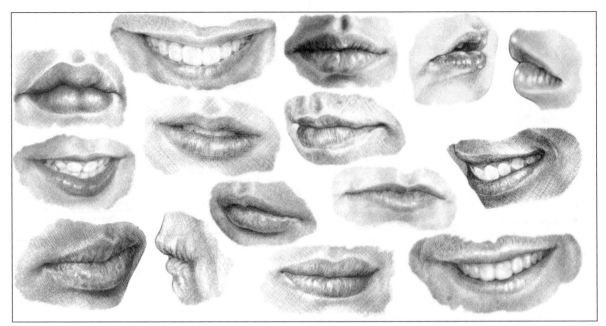

A small sampling of mouths demonstrates diverse shapes and sizes.

The Mouth in Motion

Mouths tend to be constantly in motion, doing such things as talking, chewing, and contributing to facial expressions. Yet no matter how busy a mouth is, the upper lip can usually be drawn as three rounded shapes, and the lower lip as two. In the above illustration, you see several mouths of different shapes and sizes, viewed from various perspectives.

Helpful Hint

Subtle nuances help make a person's smile unique to that individual, thereby contributing to a more accurate likeness. Watch for spaces between some teeth, unusually shaped teeth, or teeth that are chipped or somewhat crooked.

Drawing Shapes and Forms of Lips

In the first exercise, you draw the slightly open mouth of a young child and in the second, the closed mouth of an adult (or older child).

Children's mouths are usually not as wide as those of adults.

1. Draw five rounded shapes. (See the illustrations on the next page.) The structure of the upper lip is defined as three circular shapes, with the one in the middle is a little larger and higher than the other two. The lower lip consists of two circular shapes of the same size. Note the space in the center of the five circles. Keep your lines light, because you need to erase them later.

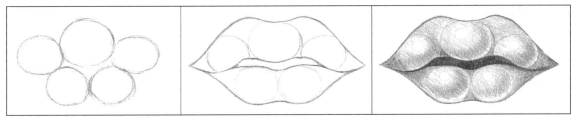

Five rounded shapes become a sketch of a child's mouth.

2. Use your kneaded eraser to lighten the lines of your five circles, and then outline the upper and lower lips. The perimeter of the lips is touching the outer edges of the circles (as shown in the second illustration above). Note that the two upper circles (on either side of the bigger one) have been cut into by the line that defines the lower edge of the upper lip.

3. Use your HB pencil to lightly shade the forms of the five circles (as shown in the third drawing). Assume the light source is from the left.

4. Shade in the areas of the lips that are not part of the circles a little darker.

5. Use a darker pencil to shade the opening of the mouth (the space between the lips).

6. Erase the lines around the perimeter of the lips with your kneaded eraser until they are barely noticeable. If you can still see the lines around the five circles, pat them gently with a pointed tip of your kneaded eraser until they are very faint.

7. Smooth out the shading of the lips, and use crosshatching to complete the facial forms around the mouth.

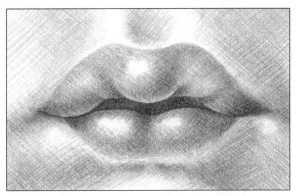

Crosshatching graduations transform five basic forms into a realistic child's mouth.

The individual shapes of five ovals determine the overall shape of an adult mouth. Try your hand at drawing a wider, more mature mouth, using the same drawing process as for the child's mouth:

1. Draw three elongated ovals for the upper lip and two for the lower lip. Outline the shapes of the lips based on the perimeters of the ovals.

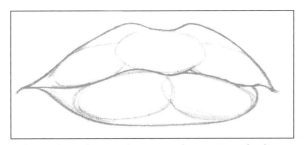

This outline of a mouth is patiently awaiting shading.

2. Add shading to the forms of the five ovals. Assume the light source is from the right.

3. Complete the shading of the lips and the face around the mouth (with graduated crosshatching).

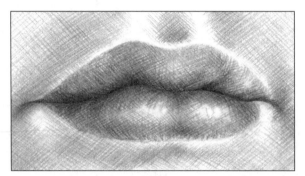

Shading five ovals is the foundation for rendering a three-dimensional mouth.

Drawing Teeth

Teeth are best rendered with a generous portion of minimalism! That is, the less you draw their shapes and forms, the more natural the teeth will look. Outlining teeth with lines is a huge no-no! Follow along with me and draw a big smile, featuring a mouthful of natural-looking teeth.

Art Alert!

Take your time when you draw teeth. Accuracy and attention to details are more important than speed. Too little shading and the front teeth look like a big white rectangular blob; too much shading and the teeth look dark, dingy, and stained. And no matter how tempting it may be, stay away from outlining each tooth.

1. Outline the basic shapes of the lips and nose. When a mouth is smiling, the five basic rounded shapes become stretched into long thin ovals. Lips are not flat; drawing these ovals helps remind you of their three-dimensional forms.

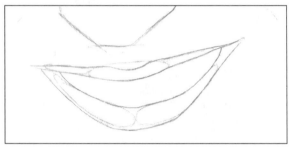

Outlining the long thin oval-shaped forms of lips is very important when sketching a smile.

2. Study the individual shapes of the teeth. The two upper front teeth are generally the largest. As you view the teeth on either side of the front ones, they become gradually smaller the farther they recede into the mouth. Each tooth overlaps the one behind it.

3. Very lightly outline each tooth, paying close attention to their proportions and individual shapes. Keep in mind that each of these lines has to be erased before you add shading, so draw them so light you can barely see them. (I've darkened my lines in a computer program so you can see them.)

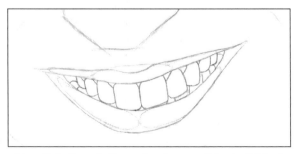

Very light lines indicate the shapes of the individual teeth.

4. Lighten the lines between each tooth until you can barely see them, especially the outlines of the four front teeth. At this point, my lines are so faint I have to look very closely to even see them.

5. Add the darkest shading to the teeth in the back of the mouth. Dark shading makes the back teeth recede into the mouth, giving the illusion of depth to the inside of the mouth.

6. Add shading to the visible gum tissue between each tooth. The darkest sections are next to the outlines of the lips.

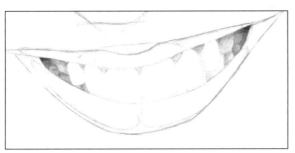

Dark shading of the back teeth gives the smile a sense of depth.

7. Use your lightest pencil and very little pressure to shade in the forms of the teeth. Yes, teeth have forms! Some popular chewing gum pieces look a lot like teeth. Also, keep in mind that even with all the teeth-whitening products available today, teeth are almost never pure white.

? Info Tidbit _____

Brilliant white teeth can look unnatural. A dentist friend once stated that the color (or value) of a person's teeth should match the whites of his or her eyes.

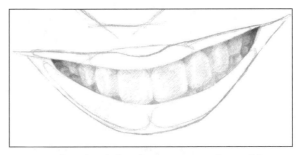

Remember the cliché "less is more" when adding shading to teeth.

8. Add light shading with crosshatching to the lips, nose, and the various facial forms around the mouth.

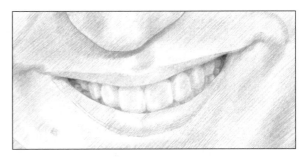

Light shading brings out the facial forms around the smile.

9. Add darker shading to the nose, face, and lips with mostly crosshatching. Take note of the vertical creases in the lower lip.

This is a man's mouth, so be careful not to add too much dark shading to his lips. Smiling lips of a female are generally a little fuller and slightly darker than those of men.

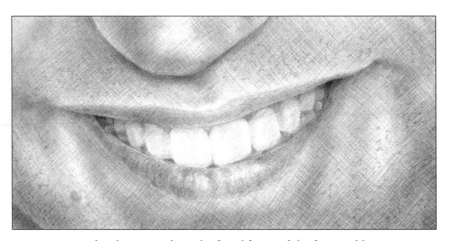

Crosshatching completes the facial forms of the face and lips.

The Least You Need to Know

◆ Ears come in lots of shapes and sizes, but each has five basic easy-to-draw parts.

◆ Children's ears are generally smaller than adults', and the individual forms are softer and more rounded.

◆ The basic shapes of an upper lip can usually be drawn as three rounded forms, and the lower lip as two.

◆ The individual shapes of the perimeters of five ovals determine the overall shape of a mouth.

◆ The less you draw the shapes and forms of teeth, the more natural the mouth will look.

◆ No matter how tempting it may be, outlining teeth with lines is a huge faux pas!

In This Chapter

◆ Comparing dark and light strands of hair

◆ Sketching straight hair with curved lines

◆ Identifying various types of curly hair

◆ Drawing the three-dimensional forms of curly hair

◆ How hairstyles and facial hair can add character to a face

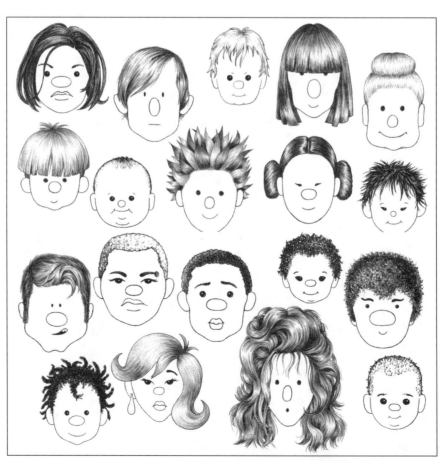

Hairy Heads and Fuzzy Faces

With each new generation, creative individuals exhibit newfangled hair styles. The best part is that no matter how outrageous the style or color was yesterday, tomorrow someone will discover an even more innovative hair design.

Throughout this chapter, I share some of my favorite hair designs from the past three decades. I show you various techniques for drawing diverse hair types and textures. You won't be able to resist some of the fun drawings, so keep your drawing supplies handy!

Strands of Dark and Light Hair

The next time you sit beside someone with longish hair, take note of the variety of widths and swirls of the locks and strands of hair. Hair tends to naturally fall into individual clumps or strands and often seems to have a mind of its own due to the following:

◆ A person's head seems to do more moving than any other part of the body. Consequently, hair frequently moves and groups (and regroups) itself into clumps and strands due to static electricity and gravity.

◆ A human head is a rounded form rather than a flat surface. Hair grows from various places and from differently slanted roots (as in cowlicks) all over the skull.

◆ Whether a person's hair is heavy and oily or light and fluffy affects the way it falls. Hair that is heavy with natural oils or styling products tends to stick together in pronounced strands. Dry, fluffy, or frizzy hair doesn't clump as much, but moves and changes its forms much more easily, especially on a windy day.

Individual strands of dark straight hair are hatched with lines of various values from light to dark. However, more dark lines than light ones are used to create the illusion that hair is

brown or black (or deep purple) rather than blond or gray (or lime green).

In the next illustration, you see close-up views of strands of dark and light hair. While the dark hair has several light sections (integral to creating depth), most of the values are medium to dark. Light hair is rendered with mostly light and medium values, with just a few dark sections to enhance the three-dimensional reality.

Strands of dark hair are rendered with a darker range of values than those of light hair.

Curving Around Straight Hair

Many beginners tend to use long straight lines and a very limited range of values to draw straight hair. Subsequently the hair looks flat and two-dimensional.

Realistic hair is drawn with curved lines of various lengths, which follow the contours and forms of the face, skull, and/or individual strands of hair.

Helpful Hint

Draw straight hair with curved rather than straight lines. Hair naturally falls into individual strands and needs to follow the contours and forms of the person's head and face.

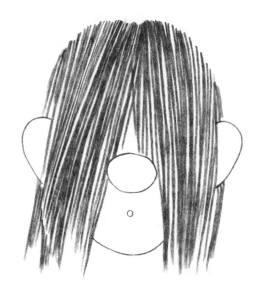

Hair drawn with straight lines and little contrast looks flat.

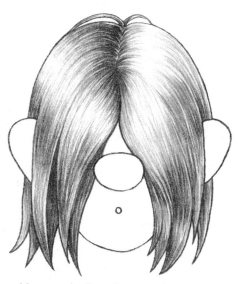

Curved lines and a broad range of values create the illusion of realistic straight hair.

In the next drawing of a little girl, the hatching lines follow the contours of her skull, creating the reality of her head being three-dimensional. Observe the point on the top of her head from which all her hair seems to grow. Her hair looks even more lifelike with a few soft wispy lines (to indicate unruly and untidy hairs) extending from the top and sides of the head and around

the face. Also note that, even though she is fair-haired, the values range from very light to almost black.

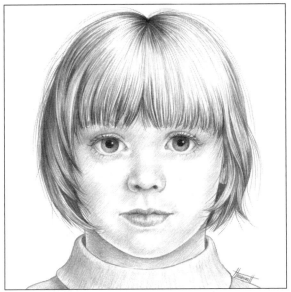

Soft wispy lines around the edges give this little
girl's straight hair a silky, lifelike texture.

Warm Fuzzy

Doing portraits of only bald people
gets boring after a while! So don't
give up on drawing hair. Eventually, with
lots of practice, you will develop the knack
for rendering flowing hatching lines, and
hair will become easy!

Straight Styling

Straight hair styles, from traditional to totally
bizarre, can lie down flat on the head or stick
up and out in all directions. The bangs of
straight hair can be slicked back, fall directly
downward, be pushed to one side; or if they're
very long, be pulled into a big bun on the top
of the head.

The following cartoon faces don realistically
drawn coiffures to show you the diversity
of straight hair. Examine the various curved
hatching lines that define each style.

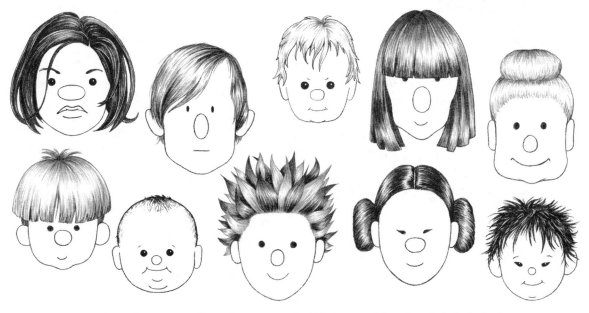

These fun cartoons provide a glimpse into the infinite creativity of straight-hair designs.

Drawing Straight Hair with Curved Lines

In addition to curving from side to side, hair curves outward and inward. Individual sections of hair that are drawn with lighter values appear to curve outward, closer to the viewer. Darker values create the illusion that a section of hair curves inward. The more contrast in values, the more three-dimensional the hair will appear to be.

Put the cat out, let the dog in, and have some fun now drawing a cartoon with realistic long straight hair. (And speaking of dogs and cats, these techniques also work well for drawing long fur and hair on animals!)

1. Outline a vertical drawing space.

2. Draw a wide egg shape (the head) in the upper section. The goal is to draw the hair in such a way as to make the head look three-dimensional.

3. Mark a dot in the center of and slightly above the head. This is the point from which the hair will "grow."

4. Draw two long curved lines from this point outward and downward. Each line follows the contours of the head, then curves slightly inward, and finally curves out again at the bottom.

5. Sketch several short lines from the center point downward (as in the second sketch). Note that the line in the center is almost straight. As the lines get closer to the outside edges, they become progressively more curved.

6. Draw a circle (as the nose) on the lower half of the head.

 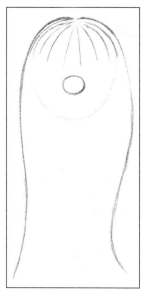

Simple curved lines identify the flow of long straight hair.

Helpful Hint

Hair can be fine, coarse, or somewhere in between. Use a very sharp pencil and thin lines to render fine hair. The thicker you make the individual lines, the coarser the texture becomes.

7. Add two slightly curved lines from the top of the head downward slightly inside the outer edges of the nose. (Refer to the first drawing on the next page.) The goal is to create the illusion that small sections of the hair are behind the edge of the nose on each side.

8. Draw a tiny section of the chin below the nose.

9. Erase the original drawing of the egg shape (except for the chin).

10. Add more curved lines from the top of the head all the way down to the bottom of your drawing space. The lines that are close to the outer edges curve in the same directions as your first outline of the hair. The closer the lines are to the center, the less they curve. The line in the very center is almost completely straight.

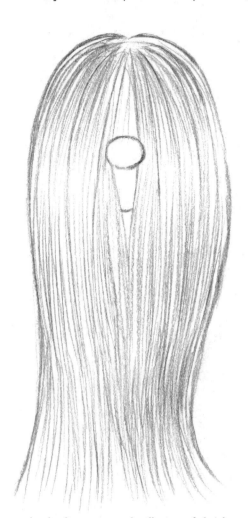

Light shading creates the illusion of depth.

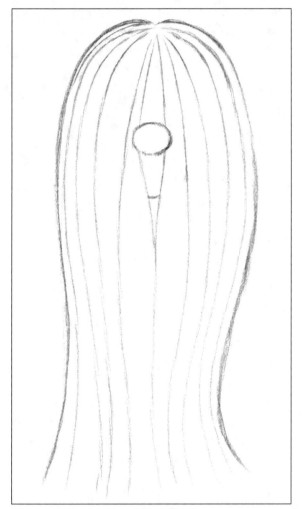

Curved hatching lines follow the forms of the head.

11. Use your 2H and HB pencils to draw the lightest values. The hatching lines are several different lengths and values. The edges are not abrupt stops, but rather feathered (or ragged) to give a more realistic appearance.

12. Add some darker values to the hair (with your 2B pencil) by drawing more curved hatching lines where you need them.

13. Use a 4B pencil to add the darkest shading at the very top and in a small section toward the bottom. Refer to the drawing on the next page.

14. Add shading to the simple face and nose with a 2B pencil. The light source is from the left front, so the lighter values for the nose are on the left and the shadows are on the right.

15. Use a 4B pencil to shade in an oval-shaped mouth and the tiny triangular shape under the chin.

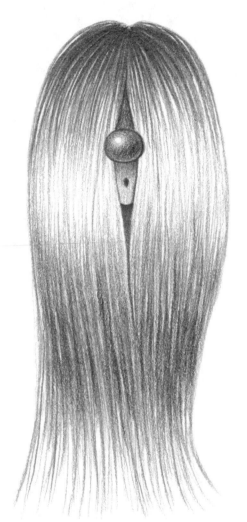

A fun cartoon face adds personality to a drawing of long straight hair.

Following the Curves of Curly Hair

When hair curves in many different directions, curls are created. Realistically drawn curly hair is rendered with a broad range of values and either hatching or squirkling graduations.

Slightly curled hair takes longer to draw and commands a lot more patience than either

straight or very curly hair. You can't draw lifelike wavy hair by simply drawing a bunch of curved lines. Realistic wavy hair requires special attention to its individual strands.

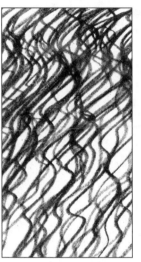 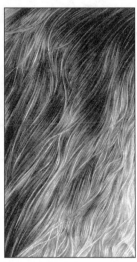

Compare cartoonlike wavy hair on the left to realistic, lifelike strands of wavy hair.

In the drawing of my friend Claudette (on the next page), note each of the following:

◆ The dominant light source is from the right.

◆ Strands of hair are lighter closer to the light source.

◆ The hair is darker further from the light source.

◆ The hatching lines are of various lengths rather than long continuous lines.

◆ The values range, from almost white in the shiny areas, to almost black in the shadows.

◆ Some sections of hair overlap others, helping enhance the illusion of depth and three-dimensional reality.

◆ Numerous soft wispy lines extend from the individual strands of hair.

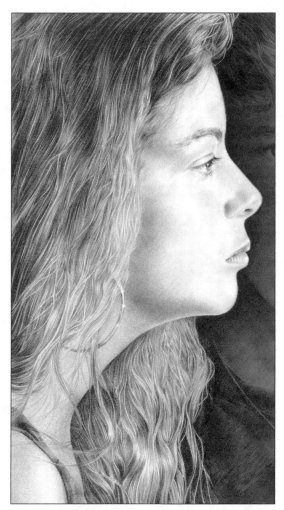

Claudette's long wavy hair is completely rendered with curved hatching lines.

Simply drawing a mass of squirkles doesn't define the forms of tightly curled hair. The texture of tiny curls is best rendered with a full range of values in a squirkle graduation.

Compare the texture of curly hair drawn with random squirkle lines on the left to one with a full range of squirkle values.

In the next drawing, the adorable little child with gorgeous curls tied up in bows is done from my memory. A full range of values, from very light to almost black, illustrates the soft texture and three-dimensional forms of her curls.

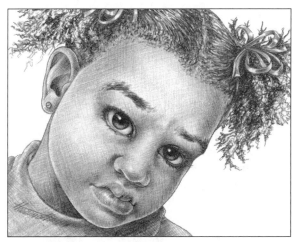

This little girl's curly ponytails are drawn with squirkle graduations.

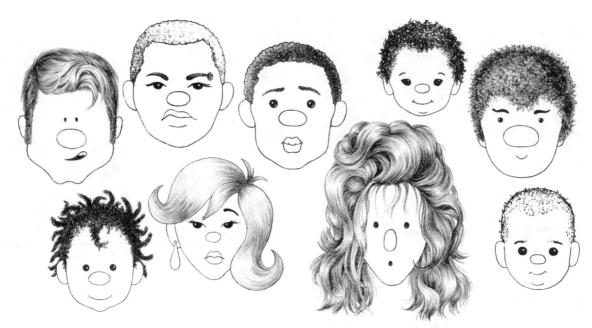

Cartoons exhibit a few fun options for styling wavy and curly hair.

Curvy Coiffures

From sassy to sophisticated, curly and wavy hair lends itself perfectly to numerous creative styling options. Check out the previous drawing to see hair that is big and wavy, nappy and soft, and flipped upward on its ends.

Sketching Curly Hair

The multidimensional curving lines of squirkling lend themselves beautifully to drawing a tight mass of tiny curls. You can use either hatching or squirkling for larger curls. Hair that is slightly wavy is best represented with hatching lines. (Check out Chapter 8 for a project on rendering curly hair with squirkles.)

Creating the illusion of three dimensions is integral to drawing realistic hair. In addition to texture, you need to identify the various levels of depth of the individual sections of hair. In this exercise you draw loose curls by first outlining individual strands and then adding values with hatching graduations:

1. Outline several strands of hair. Follow along with the drawings on the next page. Don't worry about drawing them the same shape and size as mine. The important thing is that you have some sections overlapping others.

2. Identify and number the sections according to which ones are in the foreground and middle ground (see the second sketch). The higher the numbers (from 1 to 4), the farther back (closer to the scalp) the strands of hair will appear. Those sections not numbered will be very close to the scalp.

3. Add shading with graduated hatching lines to the strands of hair in the very front (numbered 1). Use HB and 2B pencils. Note the one thin hair I've outlined from the upper right down to the lower right. Stray hairs add an element of realism to hair.

 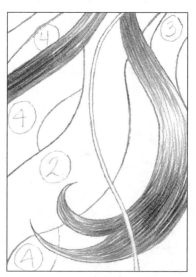

Simple curved lines create a blueprint for adding shading to wavy hair.

Info Tidbit

When you draw hair, you need to identify and outline the larger sections before you add shading. The larger strands are usually the ones on the outside (farther away from the scalp) and tend to be closer to the light source. You need to draw them with lighter values than the hair closer to the scalp.

4. Add shading to the section numbered 2, which is behind section 1.

5. Add shading to sections 3 and 4.

6. Shade in the darker sections of hair closer to the scalp with 4B and 6B pencils. Note that I've added a couple of extra lighter sections. Feel free to add more strands of hair in the background wherever you wish. The more layers you have, the more depth is created.

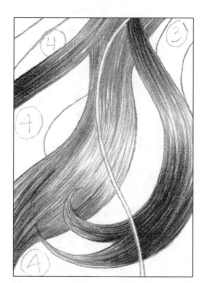

Darker shading is used for the strands of hair closer to the scalp.

7. Make any final adjustments you wish. Use your kneaded eraser, shaped to a thin wedge, to bring out the stray hair in the very front. Add more hatching lines to make sections darker and use your kneaded eraser to lighten sections.

The magic of shading and overlapping makes strands of hair look lifelike.

Helpful Hint

Draw individual strands of hair from the forefront back toward the scalp. This not only clearly defines overlapping, but also allows you to plan to draw the strands darker as you progress.

Hairy Disguises on Heads and Faces

There seems to be no limit to the ways humans choose to style their hair. A person's entire persona can change drastically with modifications to hair, and these illusions become even more radical when you throw facial hair into the equation. My friend Rob loaned me his face to experiment with various creative masquerades. In reality he's never sported any of these four looks, but it sure was fun doing the drawings!

The next drawing shows a hair design I created based on the ingenious artistic styles I have often seen on young adults. To draw such a style, you first need to be aware of the sections of a person's face and head that have hair growth. From there, you can add, take away, and make the hair longer or shorter, however your creativity inspires you!

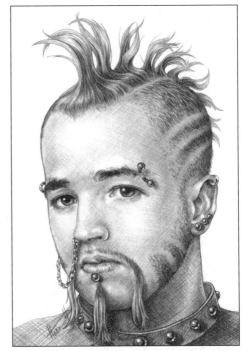

To maintain this hairdo and beard, this man will need to spend half of every day in front of a mirror!

When short hair parted in the middle and a thin mustache are combined with a polka-dot bow tie and thick glasses, the resulting character looks like he just stepped out of a secret agent movie.

A distinctive hair style and thin mustache enhance this fun persona.

The relaxed-looking personality in the next drawing is created by a casual hairstyle and a natural-looking beard.

Our fashion show of facial disguises continues with this casual hair style and beard.

In the next drawing, long blond hair and a full thick beard identify a young man who seems to have time-traveled here from Woodstock in his flower-power van.

This traditional hair and beard style has survived the test of time and remains a contemporary classic.

The Least You Need to Know

◆ You render light hair with more light and medium values than dark. Draw dark hair with mostly medium and dark values.

◆ You create realistic straight hair with curved lines of various lengths and values.

◆ Curly hair can be drawn with either hatching or squirkling graduations.

◆ Shading can create the three-dimensional illusion that hair is curving in any direction, including outward and inward.

◆ Various hairstyles and facial hair can drastically alter how a person looks.

In This Chapter

◆ A look at the facial muscles of expression

◆ Fun drawings of faces exhibit a vast range of emotions

◆ From sad to happy, and everything in between: How to draw expressive faces

◆ An exercise to draw an endearing expression on a face

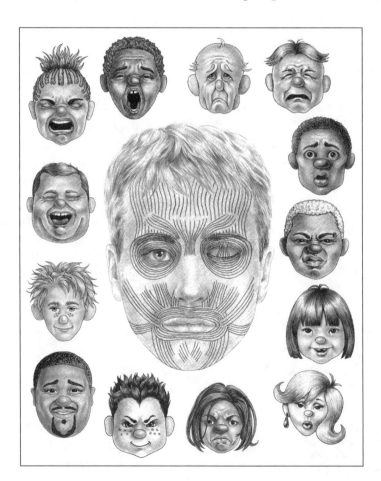

Identifying and Drawing Facial Expressions

When you draw human faces, you have an opportunity to illustrate how the person feels through his or her facial expressions. In this chapter, I tell you about a few important facial muscles that create various expressions. But don't worry! I won't bore you with a bunch of long names of stuff I can't even pronounce. I give them easy names and briefly tell you how they work.

You can then examine a fun collection of facial expressions, and identify their visual characteristics as defined by facial muscles. Finally, I take you step by step through a drawing of a charming caricature with an endearing facial expression.

The Anatomy of Expression

The different expressions of various emotions are created by the movements of facial muscles in response to how a person is feeling. In this section, I introduce you to a few important muscles around the forehead, eyes, and mouth. In the interest of simplicity, I've given each an easy name based on its function. However, I also provide shortened versions of their anatomical names.

Several of the facial expressions discussed are illustrated later in this chapter. You may even want to peek ahead and see them as I describe the various facial muscles used to create each.

Sit in front of a mirror (or use a hand-held mirror) and examine your own face as you read this chapter. Experiment with moving various parts of your face to get a realistic sense of how the muscles work. Try to locate each of the muscles shown in the next illustration.

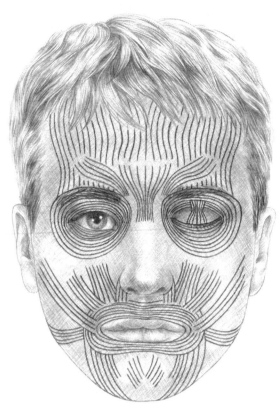

Ten major facial muscles can create an infinite range of facial expressions.

> **Helpful Hint**
>
> Drawing facial expressions is easier when you are familiar with the muscles of the face. To draw a specific expression, simply make the expression yourself, use your fingertips to feel the directions in which the muscles move, and draw the expression accordingly.

Identifying the Movers of the Forehead

Two key muscles control the movements of the brow and eyebrows, resulting in wrinkles on the upper section of the face.

An eyebrow-lifter muscle (also called frontalis), marked number 1 in the first drawing on the next page, is a wide flat muscle, with two independent halves, which runs vertically across the forehead. While its claim to fame is the emotion of surprise, it also helps create other expressions, such as sadness and fear. This muscle can …

◆ Lift the eyebrows straight up, resulting in horizontal folds and wrinkles in the forehead.

◆ Pull the skin below the eyebrows taut when the eyebrows are raised, stretching out any wrinkles hiding under there.

> **② Info Tidbit**
>
> Many people can use half an eyebrow-lifter to raise only one eyebrow at a time. Some talented individuals can even coordinate these muscles well enough to do "the worm" with their eyebrows!

The frowner muscles (also known as the corrugator) are between the eyebrows and extend from the bridge of the nose upward and outward in a fan shape (check out number 2 in the following drawing). Their various movements contribute to the facial expressions of sadness, fear, concentration, anxiety, and anger. This muscle group can …

◆ Pull the eyebrows downward and closer together, resulting in vertical wrinkles.

◆ Form crescent shaped forms (and/or dimples) and wrinkles slightly above the inner ends of the eyebrows.

◆ Pull the skin above the upper eyelids inward.

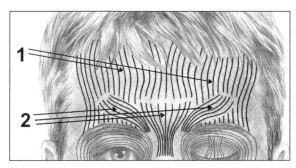

I refer to the forehead muscles as eyebrow-lifters and frowners.

Expressing Feelings from Around the Eyes

Two astute eye muscles are so finely tuned that even the slightest twist, twitch, or lift can dramatically change an entire facial expression.

Great things come in small packages. A tiny muscle called an eyelid-lifter (also called levator palpebrae) is located within each upper eyelid (see number 3 in the adjacent drawing). It controls the up and down movements of the upper eyelid, causing the opening and closing of the eyes.

Info Tidbit

The ability to wink can be credited to one eyelid-lifter's capacity to work independently of the other.

The eye-squeezer muscle (also called orbicularis palpebrae) is a large oval-shaped muscle mass surrounding the eye and extending onto the upper section of the cheek (numbered 4 in the next drawing). The upper and lower halves, and the center section, can work independently or together to show happiness, stress, anger, and pain. The eye-squeezer can ...

◆ Narrow the eye opening to a squint.
◆ Move the lower eyelid upward.

◆ Create a bulge under the eye and a puffy upper cheek.
◆ Form very pronounced wrinkles and folds in the skin that can radiate outward (crow's feet) and inward. (They can even expand and meet across the bridge of the nose.)
◆ Close the eyes so tightly that they look like part of a mass of wrinkles.

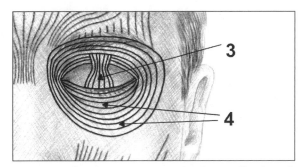

An entire facial expression can be drastically altered by the eye-squeezer and eyelid-lifter muscles.

The Mouth in Motion

Spend a couple of minutes in front of a mirror to see for yourself how you can stretch your mouth into lots of comical directions and shapes. The following six groups of muscles help contort a mouth through its various actions:

◆ The lip-raiser muscles (also known as levator labii superioris), numbered 5 in the next drawing, extend from above the outer mouth area, directly upward on the cheek in a fan shape. The not-so-nice expressions resulting from the movement of the upper lip include disgust, devastation, despair, and sneering.
◆ The smiling muscles (also known as zygomaticus), numbered 6, run from the corners of the mouth back toward the ears. Capable of moving large areas of the lower face, these two small but powerful muscles contribute to the happy expressions of smiling, laughing, giggling, and grinning.

◆ The speaking muscles (also called orbicularis oris), numbered 7, encircle the mouth and work with other muscles to give the mouth its movements when talking (critical for those who are skilled at lip-reading). This versatile muscle can tighten and contort the lips for puckering. (I was tempted to call it the kisser.) It also helps create the expressions of anger, surprise, and sadness.

◆ The sadness muscle (also called triangularis), numbered 8, extend from the corners of the mouth downward. It contributes to such facial expressions as grief, sadness, and frowning.

◆ The pouting muscle (also called mentalis), numbered 9, pushes the center of the mouth upward, resulting in a raised and puckered looking chin.

◆ The lip-stretcher muscles (also called risorius), numbered 10, pull the lips horizontally back on the face in such extreme expressions as devastation, terror, or intense anger.

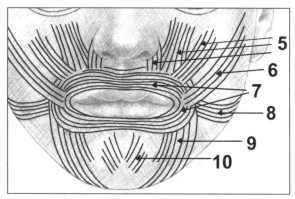

Lots of muscles work together to help put our mouths in motion.

The Range of Facial Expressions

By exaggerating the movements of muscles with cartoon drawings of faces, I can better show you how various expressions are created. Compare each description to its corresponding drawing. Then try to match the various components of each expression with the muscles discussed earlier in this chapter.

Angry

This is not a happy camper! When you see a face like this, you may want to turn around and get as far away as you possibly can.

◆ The eyebrows are lowered in the center down over the upper eyelids. Vertical and horizontal creases appear on the forehead.

◆ The eyes are wide open.

◆ The mouth is closed tightly and the corners are forcefully stretched downward. The chin bulges upward.

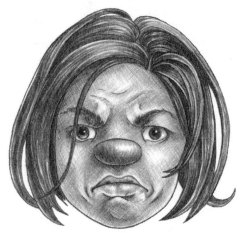

You may be tempted to run for the hills when you see an angry expression like this.

Bored

This expression is highly contagious. Yawning may indicate boredom, sleepiness, or simply a need for another cup of coffee (or two)!

◆ The eyebrows move close together and curve upward in the center. Vertical and horizontal crinkles appear on the forehead.

◆ The eyes are partially closed. Crow's feet and lower-lid creases are pronounced.

◆ The mouth is relaxed and fully open. The upper lip is pulled up and back. The lower jaw is dropped as much as possible, stretching the whole lower face downward. Creases form from the sides of the nose down to the chin.

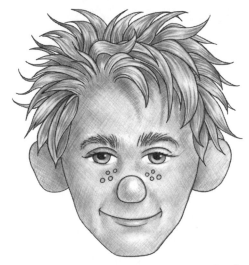

This appealing expression invites interaction from others.

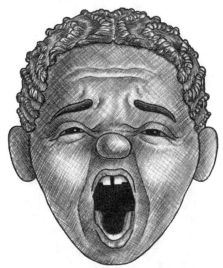

Beware! This expression of boredom is catching!

Contented

Feeling contented, amused, relaxed, and generally pleasant and friendly results in a similar facial expression. In a room full of people, this is a face others are drawn toward.

◆ The eyebrows are relaxed and slightly lifted upward.

◆ The eyes are partially closed and the upper eyelids are drooped downward covering part of the irises.

◆ The mouth is closed, relaxed, and pulled slightly back toward the ears.

Info Tidbit

Some people are so skilled at feigning their facial expressions that huge, internationally televised shows present them with prestigious awards. Of course, I'm referring to television and movie actors!

Devastated

Feeling totally overwhelmed with extreme feelings of grief, devastation, or anguish results in the next facial expression.

◆ The eyebrows are lowered toward the center, and vertical creases form on the lowered brow.

◆ The eyes are very tightly closed with pronounced creases at the outer corners.

◆ The mouth is open, the center is pushed upward, and the lips are stretched horizontally and downward.

◆ The chin is raised and tight.

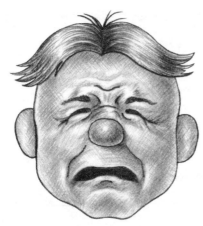

You just want to reach out and give this person a hug.

Disgusted

The expressions of hatred, horror, and disgust are very similar.

◆ The eyes are partially closed with a bulge beneath and pronounced crow's feet.

◆ Deep horizontal creases appear between the eyes extending across the bridge of the nose.

◆ The inner sections of the eyebrows are lowered with vertical folds on the brow.

◆ One (or both) side(s) of the upper lip is raised.

◆ The center of the lower lip and chin are pushed upward.

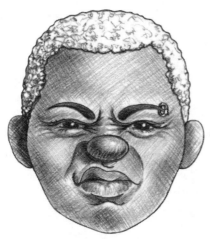

This look of disgust asks, "Fluffy did *what* in my shoe?"

Endearing

Whether you call it endearing, ingratiating, or just plain old adorable, you simply can't resist this face. This young man's pleasant expression is enhanced by his dimpling cheeks, and his upper front teeth resting very slightly on his lower lip.

◆ The eyebrows are raised and curled upward in the center.

◆ Eyes are slightly closed creating crow's feet in the outer corners.

◆ The corners of the mouth are pulled back toward the ears.

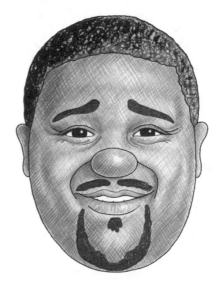

This charming face seems to ask, "Can you do me a favor?"

Happy

It's true! Fewer muscles are used to smile than to frown.

◆ The eyelids and eyebrows are very relaxed.

◆ The mouth widens and the corners curve up and back toward the ears. Sometimes the upper teeth show.

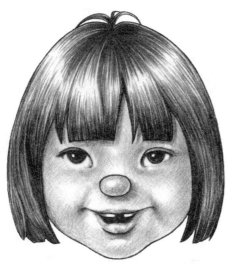

This gentle shy smile involves very few facial muscles.

Gleeful

The facial expressions of laughter, hilarity, and glee are quite catchy.

◆ The eyebrows are relaxed.

◆ The eyes narrow and sometimes close completely.

◆ The mouth opens wide, back toward the ears and lots of teeth are visible, especially the upper ones.

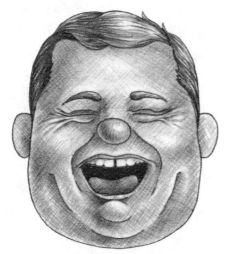

If this book had sound, you'd be hearing laughter.

Mischievous

When you see a devious, impish, or mischievous expression, you begin to wonder what he (or she) is up to.

◆ The brow and eyebrows lower toward the center and partially cover the upper eyelids.

◆ The eyes narrow.

◆ The mouth widens back toward the ears in a grin.

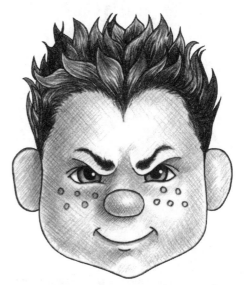

The mischievous grin indicates that something is amiss.

In Extreme Pain

The expression of extreme pain is difficult to watch.

◆ The nostrils are pulled upward and the cheeks are raised.

◆ The eyebrows lower and numerous wrinkles extend from the inside corners of each eye across the bridge of the nose.

◆ The eyes are tightly closed, the lid line is straight, and vertical creases on the upper lid hide the upper lid fold.

- Crows feet extend from the outer corners of the eyes.
- The upper teeth are hidden under the upper lip, and the front lower teeth are showing.
- The mouth is open, and the lips are stretched horizontally and downward.

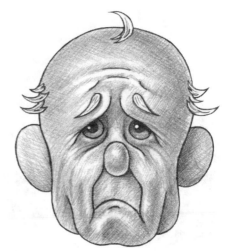

This unhappy individual wears his feelings on his face.

Seductive

The facial expressions of attraction, flirtation, and seduction are simple yet distinctive.

- The eyebrows are raised.
- The upper eyelids are slightly closed.
- The mouth is pushed forward, puckering the lips.

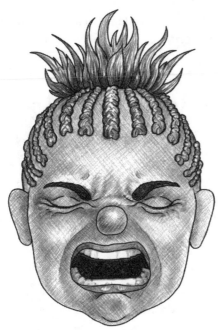

In an expression of extreme pain, much of the face is pulled toward the space between the eyes.

Sad

The emotions of sadness and unhappiness look much the same.

- The brow and eyebrows bend upward and toward the center, forming vertical and horizontal creases on the forehead.
- The upper eyelids fold upward toward the center.
- The corners of the mouth curve downward.

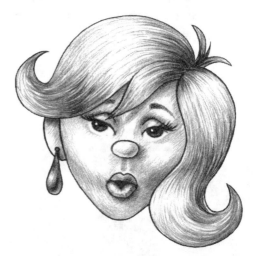

If this drawing could move, those eyelashes would be fluttering.

Terrified

The expressions of terror, surprise, and shock are similar.

◆ The eyebrows lift up and curve upward in the center.

◆ The eyes open very wide with the whites showing all around the irises.

◆ The mouth sometimes falls open.

Imagine this terrified person standing on a chair, watching a mouse run across the floor.

Drawing a Gentle Giant with an Endearing Smile

In this project, you outline and then add shading to a charming cartoon I call Gentle Giant. An endearing smile can result from such feelings as fear, nervousness, ingratiation, and/or anticipation.

Begin by outlining the cartoon's head and face. Don't press too hard with your pencil! You need to erase some of your sketch lines later in this project:

1. Outline a square drawing space (any size you want) and divide it into four equal sections (a simple grid).

2. Sketch an oval shape as his head. Use the grid lines to measure spaces so both sides are symmetrical. (I told you about symmetry in Chapter 3.)

Helpful Hint

When drawing an oval, rotate your paper and look at it from different perspectives. Examine its reflection in a mirror to help locate problem areas.

A simple oval identifies the shape of the head.

3. Erase the center sections of both sides of the oval shape (his head) and sketch in the outlines of his ears. Then redraw the missing section of his face a little narrower.

4. Lighten all your sketch lines with your kneaded eraser, and then redraw the outline of his head with nice neat lines. Check the symmetry of his face as you go. You can even measure with a ruler if you want to be really precise.

5. Add an oval shape for his nose. Note its size and position in relation to the grid lines.

The tops of Gentle's ears stick out a little farther from his head than his earlobes, and his nose is an oval.

6. Outline his eyes slightly above the center horizontal line and add the irises. Observe that the upper and lower section of each iris is hidden under his upper and lower eyelids.

7. Add a curved line as the opening of his mouth. The ends of his mouth are directly below the outside edges of his irises.

8. Draw a wiggly line to mark the perimeter of his hairline.

9. Draw his eyelid creases from the inner corners of his eyes outward beyond his eyes.

10. Outline his eyebrows. They curve upward in the center.

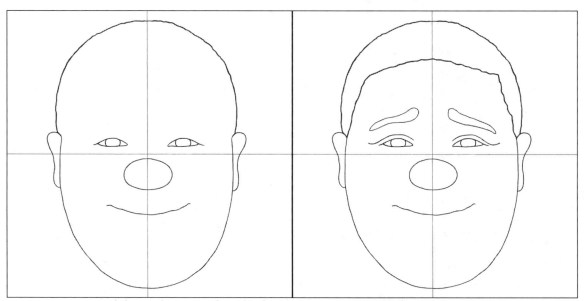

With his eyebrows in place, his facial expression is beginning to take shape.

11. Refer to the drawing on the next page and outline his lips. Leave a space in between so the mouth appears to be slightly open. Two curved lines, above the opening of his mouth, represent his upper lip. The lower lip is created with one curved line, below the opening of his mouth.

12. Draw the curved smile lines, which begin on either side of his nose and then curve outward and downward until they extend slightly past the corners of his mouth.

13. Use wiggly lines to outline his mustache, his goatee (beard), and the little tuff of hair under his lower lip.

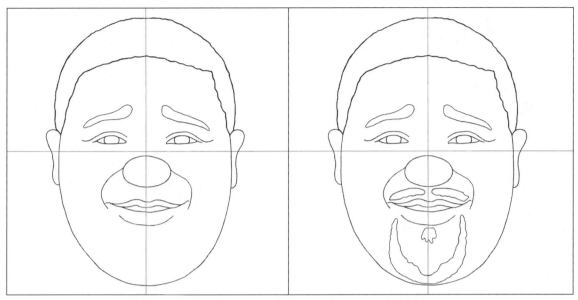

This endearing face patiently awaits the magic of shading.

The light source is from the right, which affects the placement and value of every section of shading. Keep in mind that a full range of values gives contrast between the light and the shadow areas. Before you begin shading, erase your grid lines.

14. Draw a few more smile lines (often called crow's feet or laugh lines) around his eyes to enhance his facial expression.

15. Shade in the hair with graduated squirkles. (Check out shading with squirkles in Chapter 7.) Use a 4B pencil for the darker values on the left and an HB pencil for the lighter sections.

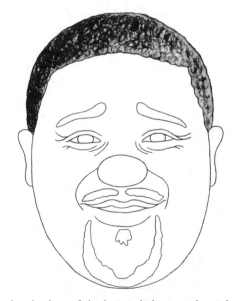

The shading of the hair is lighter on the right.

16. With an HB pencil, lightly shade the entire face with hatching lines.

17. Darken the sections which are in shadow by pressing a little harder with your HB pencil.

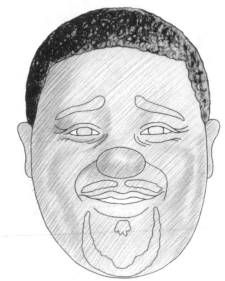

The light source is easy to identify because the shading is lighter on the right.

18. Use crosshatching lines and 2B and 4B pencils to add darker values to Gentle's face.

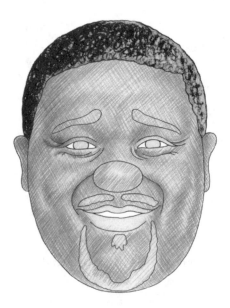

19. Add dark shading to his irises with a 6B pencil. Make sure you leave a small white circle in each eye as the highlight.

20. Shade his lips with a 2B pencil and darken the outer corners of his mouth with a 4B pencil.

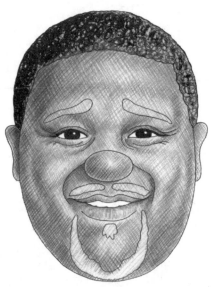

Darker shading makes the three-dimensional forms of his face stand out strongly.

21. Shade in Gentle's eyebrows and facial hair with a 4B pencil.

Adjust anything you're not happy with. You can make an area lighter by patting it with your kneaded eraser. Add more shading lines to make a section darker.

 Warm Fuzzy

Congratulations! You have just completed a very complex facial expression. Sign your name, write today's date on the back of your drawing, and put an endearing smile on your own face!

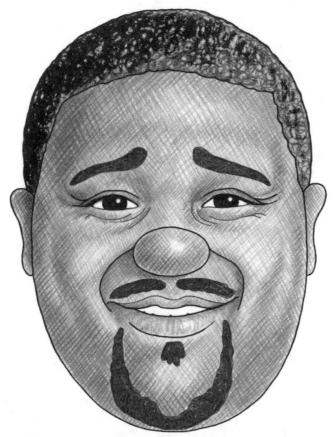

Shading the facial hair and eyebrows completes this caricature of a charming Gentle Giant.

The Least You Need to Know

◆ You don't need to know a bunch of long words to understand how facial muscles work.

◆ A full range of facial expressions are created by the movements of 10 key groups of muscles.

◆ As various muscles do their jobs, different sections of the face move and often create folds and wrinkles in the skin.

◆ When someone is feeling down (sad), the corners of the mouth curve down.

◆ If a person is feeling up (happy), the corners of the mouth curl up.

◆ You can refer back to this chapter whenever you want to portray a specific emotion in the faces you draw.

In This Part

Examining Figures

In this part of the book, various illustrations of human figures respectfully demonstrate forms and proportions as individuals evolve from newborn through old age.

Size is important! Put aside any current notions you have about measurement units. A 6-foot-tall person may actually be 8 heads tall. That's right! Artists measure people in heads instead of feet. In addition to being different heights, humans come in an infinite array of shapes, sizes, and ages. Each and every one of them is uniquely fascinating and individually beautiful.

In these chapters, you won't find drawings of boring bones and a bunch of big long names of all the muscles of the body. Instead, you focus on the more enjoyable aspects of drawing people. I show you how to draw the various shapes and forms of the major sections of a human body. Drawing a complete figure then entails fitting the individual parts together like pieces of a puzzle.

I introduce you to several simple sketching methods so you can draw human figures more quickly and efficiently. I also explain how to draw several different textures of fabrics and how to indicate the forms of a body under the clothing. Keep your drawing supplies handy so you can sketch lots of people (and the individual parts of people).

In This Chapter

◆ Measuring people in "heads" instead of feet

◆ Realistic proportions from newborn to adolescent

◆ Celebrating the diversity of human bodies

◆ Sketching a female figure that is proportionately correct

◆ Explore and draw the proportions of a male figure

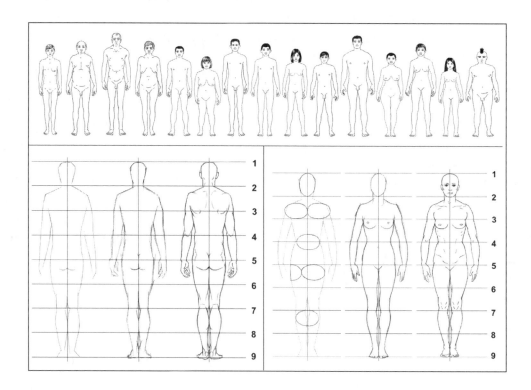

Proportions of the Human Figure

Drawing people's bodies proportionately correct is the foundation of figure drawing. Human beings have an infinite array of magnificently diverse bodies, which can be transformed into wonderful drawings. I cannot possibly say that one specific body type or size is ideal. To do so would be to negate the vast beauty inherent in all human bodies.

Forget measuring people in feet! Artists measure the human figure with heads. This simply means using the length (not the width) of a person's head (excluding his or her hair) as a unit of measurement. For example, the width of an average adult across his or her shoulders can range from 2 heads to 2⅓ heads.

In this chapter, you view both cartoonlike and realistic sketches of diverse individuals of all ages. Respectfully examine the beautiful shapes of their body parts and how they all fit together. Oh, and if one of these figures happens to look like someone you know, keep in mind that they're all from my imagination.

Exploring the Proportions of Children

The bodies of people continuously change throughout their lifetimes. Individual children experience different rates of growth, and their body proportions change at various stages of development. For instance, one-year-olds can be as large as two-year-olds, and three-year-olds can be as tiny as two-year-olds. Hence, there is no way to definitively say that a child of a specific age will be a certain height.

Info Tidbit

While the measurement unit of a foot always has 12 inches, the precise size of a head measurement unit may be different for each person you draw. Human heads become larger as they grow from birth through adulthood. Even fully grown adult heads come in a vast range of assorted sizes.

A Peek at the Petite Proportions of Babies

The most noticeable changes in human bodies occur during the first three years of life. The proportions of infants' bodies are very different from those of adults. Babies' heads are quite large when compared to the rest of their bodies. Between birth and two years, their heads grow more quickly than at any other time in their lives. Therefore, the measuring unit of a head is constantly getting larger as the child gets older.

Refer to the next drawing and note the following:

◆ At birth, most infants are between 3½ and 4 heads tall, and their heads are around 5 to 5½ inches long. (Refer to the first image in the next drawing.) Their abdomens look big because their organs are disproportionately large. Of course, newborns can't stand up, so you have to use your imagination and pretend those tiny little legs are stretched out.

◆ Babies' bodies change drastically during the first year of life. By the time infants reach one year of age (see the second image), they are approximately 4 to 4½ heads tall and their heads are 6 to 6½ inches long. They appear rather chubby, with large abdomens, long torsos, and short bowed legs.

◆ By age two, a toddler is around 4½ to 5 heads tall, and the legs are the fastest growing part of his or her body. The trunk of the body (often called a torso) and the head grow more slowly from this age onward.

◆ During the third year, a toddler reaches a height of 5 to 5½ heads, and the head is approximately 6½ to 6¾ inches long.

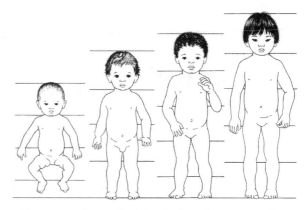

The proportions of babies' bodies change considerably during the first three years of life.

Watching Children Grow

When you observe groups of children of the same age, you see an assortment of body structures, including short, tall, chubby, thin, muscular, and slender.

In the next drawing, you see four children whose stages of development range from a young child (on the far left) to an adolescent (on the far right). Refer to the lines behind each of them to measure their heights in heads. By adolescence, children's body proportions closely resemble those of adults.

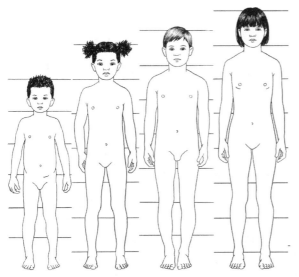

Observe how the proportions of children's bodies change as they grow toward adulthood.

Respecting Beautiful Adult Bodies

Between the ages of 25 and 30, the bone structures of adults have completely formed. The vast array of shapes and sizes of adult bodies is primarily determined by genetics and lifestyles. Remember, leading a healthful lifestyle is much more important to all people than what their bodies look like.

One Size Doesn't Fit All

Imagine if you could randomly select and then compare hundreds of adults of the same age. You'd discover a broad range of various heights, weights, and body structures, each inherently beautiful. In the next illustration, you can appreciate a few diverse adult male and female body types, all of which I consider average.

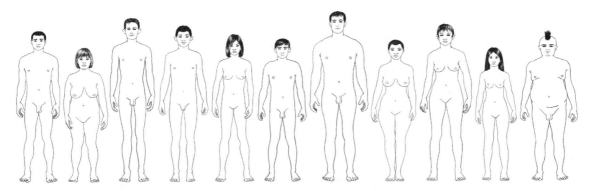

Respectfully observe the inherent beauty of diverse sizes and shapes of adult bodies.

Honoring Time and Age

As athletes proudly wear their medals to show their achievements, so, too, should older people respect their bodies as beautiful trophies of noble lives long lived. Every wrinkle, sag, and scar proudly identifies their victories in overcoming personal adversities and successfully navigating a long life journey.

Examine the next illustration, in which you see four examples of what I consider to be average bodies of mature individuals.

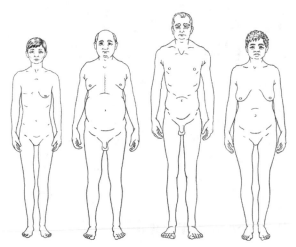

The beautiful bodies of mature individuals are honored by time and age.

Comparing Female and Male Figures

Generally speaking, the external shapes and the proportions of men's bodies are anatomically and visually different than those of women. Overall, men are taller, and their bone structures are larger. Their underforms (such as bones and muscles) are more visible, because they tend to have less body fat than females. Men's muscles are generally well developed, and determine most of the independent forms that are visually defined in drawings.

Each individual man and woman has a unique body, which can differ significantly from those of other persons. Some people's bodies don't even fall within generic proportional guidelines. Keep this in mind as you consider the following general characteristics of a female when compared to a male (refer to the drawings on the next page):

◆ Bone structures are smaller.

◆ Waist is higher and longer.

◆ Muscles tend to be less developed.

◆ Breasts are larger.

◆ More body fat gives a rounder and softer appearance.

◆ Buttocks are fuller and proportionately lower.

◆ Hands are smaller and more delicate.

◆ Hips are wider.

◆ Jaw is smaller.

◆ Neck is more slender.

◆ Ankles and wrists are smaller.

◆ Thighs are wider.

◆ Calves are smaller and less developed.

◆ Feet are proportionately smaller.

Drawing the Proportions of Adult Figures

Again, I'd like to stress that adult bodies are so diverse that no set of proportional guidelines could possibly apply to everyone. However, despite their height, most figures fit within generic principles. Imagine the height of any human figure (such as yourself) being divided into quarters, and compare the proportions to the following:

◆ The armpits are one quarter of the way down from the top of the head.

◆ The wrists and crotch are at the halfway point.

◆ The bottoms of the knees are three quarters of the way down from the top of the head.

◆ The elbows align with the waist.

◆ The tips of the fingers line up with the mid thighs.

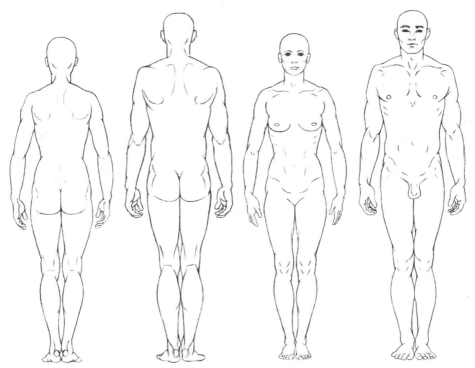

Compare male and female figures and note their differences.

The following two exercises are designed to help you become familiar with the basic proportions of female and male figures. To keep things simple, they are both the same height, 8 heads tall.

Don't worry about drawing the anatomy correctly. Focus on the height and width of the figures, and the relationships of various parts of their bodies proportionate to others.

Female Proportions

In this exercise, your goal is to draw the various parts of a female body in their correct places by using head measurement guidelines. The average height of adult females is between 7 and 8 heads tall. Keep in mind that the distance from the top of the head down to the chin is the measurement unit for all proportions.

In this section, you sketch an outline of a frontal view of a female figure. Follow along with simple instructions and step-by-step sketches on the next page:

1. Draw a vertical line down the center of your paper. This line will help keep both sides of your figure symmetrical.

2. Draw two dots on the center line to mark the placement of the top of the head and the bottom of the feet. These dots identify the height of your figure. (I chose 8 inches to represent a figure that is 8 heads tall, but any length will work. For example, if you choose 6 inches, you simply need to divide this measurement into 8 equal sections to end up with a figure that is 8 heads tall.)

3. Draw a horizontal line through each of the two dots to mark her total height.

4. Measure and divide the total length between these lines into eighths, and mark each point on the center line with a dot.

5. Draw horizontal lines through each dot. The vertical distance between each of the spaces is equal to the length of the person's head.

6. Lightly sketch the outline of the figure. Her head fits into the top section and she is a total of 8 heads tall. Use the vertical line of symmetry and the horizontal lines as guidelines for sketching her body.

This female figure is 8 heads tall.

7. Beginning at the top, number the measurement lines 1 to 9. (Refer to the drawings on the next page.)

8. Lighten your sketch lines with your kneaded eraser.

9. Refer to the first sketch in the next set of three, and adjust the width of your figure

according to the following guidelines (keep in mind that these measurements can vary for thinner or heavier individuals):

◆ The width across the shoulders is approximately 2 heads.

◆ The waist is around 1 head wide.

◆ The width across the hips and thighs is about 1½ heads.

◆ The total width across both calves is approximately 1 head.

Helpful Hint

When you plan to draw a standing figure, make sure you choose a long enough drawing space. If you draw the head first, keep in mind that the length of the head determines the final height of your figure. Measure out the total height of the figure before you begin to sketch the body. There's nothing more frustrating than running out of paper by the time you get to the knees.

10. Modify your sketch with detailed lines. Refer to the second sketch, which shows the correct placement of the different parts of the body, according to the following guidelines:

◆ The top of the head is touching line 1.

◆ The entire head is in between lines 1 and 2.

◆ On line 2 is the lower edge of the chin.

◆ The top of the shoulders is approximately one third of the way down from line 2.

◆ The armpits are along line 3.

◆ The nipples are below line 3.

◆ The waist and elbows rest along line 4.

◆ A female's navel is slightly below line 4.

◆ Line 5 marks the locations of the wrists and crotch, which are halfway down from the top of the head.

◆ Around one third of the way down from line 5 is the bottom of the buttocks.

◆ The tips of the fingers end between lines 5 and 6, about one third of the way up from line 6.

◆ The knees are located in the lower half of the distance between lines 6 and 7.

◆ The bottoms of the knees are either on or slightly above line 7.

◆ Line 9 marks the bottoms of the feet.

11. Add details to your drawing to represent the locations of the prominent forms (see the third drawing), such as the collarbones, ribcage, ankles, and the joints of the knees and elbows.

Helpful Hint

When drawing female figures, keep in mind that extra body fat obscures the surface forms of many of the smaller bones and muscles, and even creates independent forms.

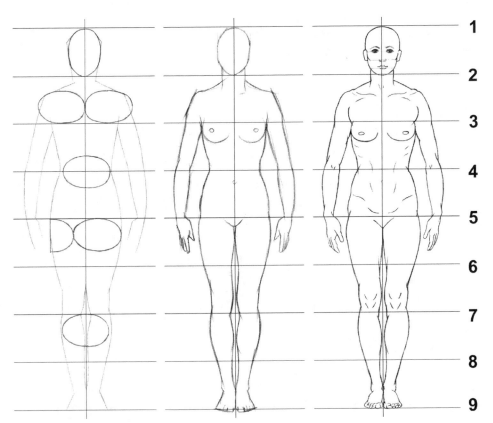

With help from guidelines, you can sketch a female figure that is proportionately correct.

Male Proportions

An average adult male can range in height between 7 and 9 heads. The physical structures of diverse male body types share some similar characteristics with each other, but look different than those of females.

Draw a back view of a male figure that is proportionately correct. Use the same instructions as used to draw a female, but keep the following differences in mind:

◆ Shoulders are wider (around 2⅓ heads).

◆ Waist is shorter.

◆ Ribcage is larger and longer.

◆ Hips are narrower.

◆ The nipples on a male are along line 3.

◆ A male's navel is on or very close to line 4, higher than that of a female.

You have now completed drawings of a front view of a woman and a rear view of a man. For more practice, refer to the illustration in "Comparing Female and Male Figures" earlier in this chapter, and draw a rear view of a woman and a front view of a man.

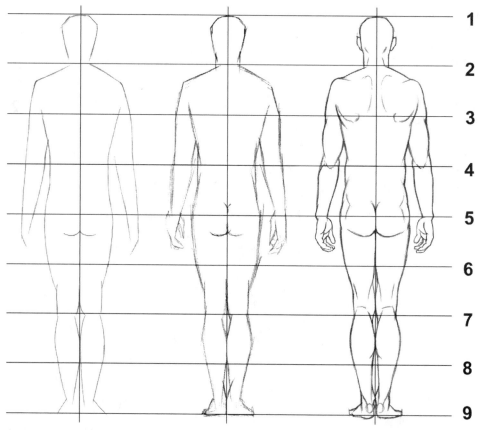

The various components of this male figure are placed according to measurement guidelines.

The Least You Need to Know

- Drawing human bodies proportionately correct is the most important component of figure drawing.

- The distance from the top of the head down to the bottom of the chin is the measurement unit used in figure drawing.

- No single head measurement unit applies to all people because of the vast diversity of sizes of human heads.

- The most noticeable changes in the proportions of human bodies occur during the first three years of life.

- Humans come in a broad range of heights, weights, and body structures, each inherently beautiful.

- The proportions of men's bodies are anatomically and visually different than those of women.

In This Chapter

- ◆ Examining the structures of torsos
- ◆ How to draw realistic arms and hands
- ◆ Rendering the forms of a leg and foot
- ◆ The steps to drawing a seated female figure
- ◆ Sketching from an actual model

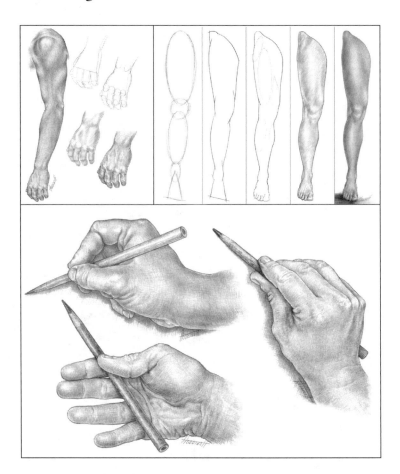

Forming the Shapes of Figures

The human body is the most incredible structure in the universe! The more you become familiar with its infinite abilities, the more awestruck you become. Most human bodies are capable of continuously functioning with an internal power source, constantly regenerating and self-repairing, moving with self-determined flexibility and strength, and performing an unlimited range of movements and tasks.

A human body is also artistically magnificent and presents the most fascinating and rewarding drawing challenges. When you can draw a human figure well, everything else you draw seems like a piece of cake!

Do you remember the old song "The ankle bone's connected to the … bone," because I've completely forgotten it! My point being, you don't need to know the names of all the things under the skin to draw them well. Nonetheless, in order to draw an anatomically correct figure, you need to be able to visually identify the exterior forms of various parts of the body, as defined by bones, fat, and muscles.

Drawing the forms of a human figure from life is the best possible way to develop an understanding of human anatomy. Even though no human models are included in this chapter (sorry!), keep your drawing supplies handy. I show you some simple strategies for drawing an arm, leg, foot, and hands. Then I take you through the entire process of drawing human figures, from the tops of their heads down to their toes.

Connecting the Head to the Body

The primary structure of all human bodies is the trunk (often called a torso). As with branches on a tree, the head, arms, and legs are connected to the trunk. All human torsos share some similar parts, such as a neck, ribcage, pelvis, and spinal column. However, as you already know, the bodies of males and females are innately diverse. Subsequently, the trunk exhibits physical differences according to genetics, lifestyle, and gender.

Warm Fuzzy _____

Mastering figure drawing takes time and lots of practice. Be gentle with yourself. Focus your attention on drawing correct proportions and making the individual forms of the body appear three-dimensional.

Generally speaking, women's waists are smaller and proportionately longer, and their hips are wider than men's. A little extra fat over most of the bones and muscles causes women's torsos to appear softer and more rounded.

Overall, men's torsos are proportionately longer and larger than those of women. Men tend to have larger ribcages, wider shoulders, narrower hips, and the independent forms of their bones and muscles are more pronounced.

In the following set of drawings, I have outlined the primary forms of female and male figures from the front and back. Compare the basic structures of their torsos.

Hardly any of us have bodies as well defined as those in the next drawings. However, in order to clearly show you the various muscles and bones, I chose to exaggerate their forms, which are shaded with curved crosshatching lines.

Choose at least one (preferably all four) of the torsos and draw it in your sketchbook. Sketch the basic proportions and outlines first, and then add shading to accentuate the forms.

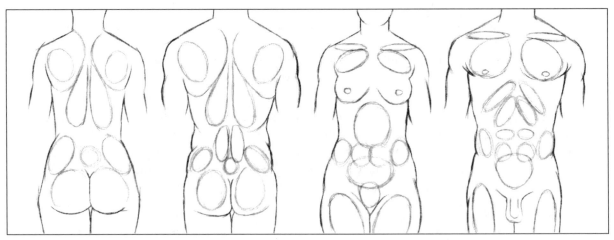

Various shapes outline the locations of the forms of human torsos.

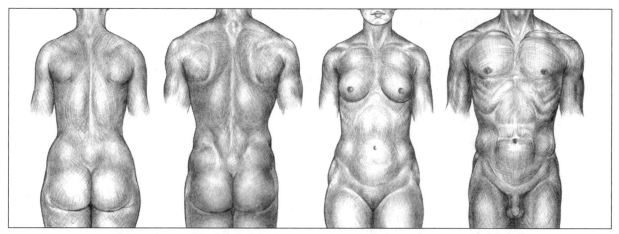

The primary forms of female and male torsos are shaded with crosshatching.

Arms and Hands from Different Perspectives

When drawing people, you find lots of opportunities to include the upper body, including arms and hands. When broken down (not literally, of course) into individual shapes, arms are surprisingly simple to render. On the other hand (excuse the pun), hands are very intricate, and therefore more difficult to draw. However, when you understand how to render the basic proportions and shapes of the various components, the process becomes much easier.

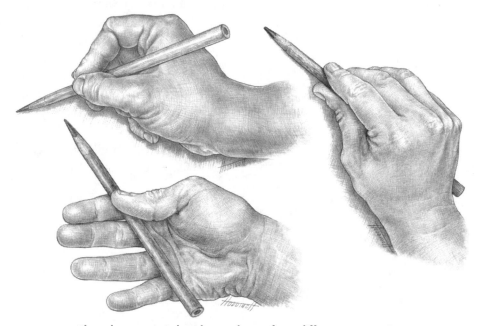

Three busy artistic hands are drawn from different perspectives.

The Process of Drawing Hands

In the previous drawing, you saw three hands in poses very familiar to artists.

When drawing hands, accurate proportions are very important. Find your drawing materials and try your hand (grin) at drawing one of your own hands. I'm right handed, so I drew my left hand. If you're left handed, draw your right. Use whichever pencils you prefer.

1. Draw a vertical rectangle to represent the overall shape of your hand. Divide it in half to mark the point where the base of the fingers meets the main section of the hand.

2. Outline the fingers and thumb. A hand is one of the few parts of the body that I sometimes outline with straight (rather than curved) lines.

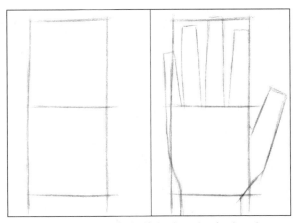

Fingers make up half the length of a hand.

3. Add circular shapes to represent the knuckles and the joints of the fingers and thumb.

4. Use the shapes of the knuckles and joints to complete the outline of the hand with curved lines.

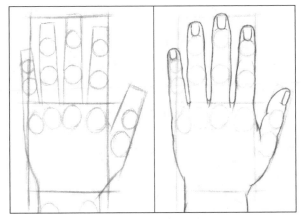

Correct proportions and curved lines complete an outline of a hand.

Don't put your supplies away just yet! In this next exercise, you outline a side view of a hand, and then add shading to define its forms:

1. Outline the basic shapes of a hand (as viewed from the side). The fingers are slightly bent, but are still almost half the total length of the hand. The base of the thumb appears quite prominent from this angle.

2. Refine your drawing. Indicate the rounded shapes that define the various forms.

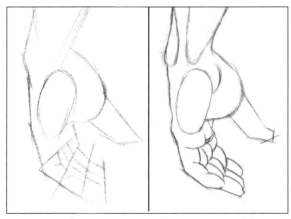

Rounded shapes identify the proportions and forms of a hand.

3. Add light shading with hatching graduations to bring out the three-dimensional forms. Take your time and work on only one small section at a time. Accuracy is more important than speed. Identify the highlights, and the light and dark values.

4. Use crosshatching to add final details, such as darker shading in the shadow sections.

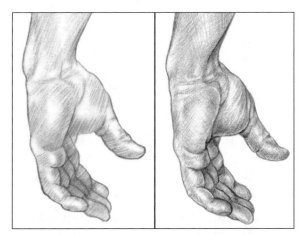

Shading enhances the three-dimensional forms and brings a hand to life.

Helpful Hint

Practice drawing hands every chance you can. Don't worry if your drawings don't look realistic at first. Just do your best and in time, you will get better!

Connecting Hands to Arms to Shoulders

In this exercise you draw a shoulder attached to an arm, which just happens to be connected to a rather familiar-looking hand! Refer to the drawings on the next page.

1. Draw the basic shapes of a shoulder, arm, and hand. The elbow is located approximately at the halfway point between the highest section of the shoulders and the tips of the fingers. As long as the vertical proportions are correct, you can draw an arm longer or shorter than this one. (In a female arm, the muscles are generally less defined.)

2. Outline the shapes of the various rounded forms.

3. Add light shading with hatching to bring out the three-dimensional forms. When viewed from this perspective, the most prominent form is the upside-down heart shape in the upper arm.

4. Use crosshatching to add more details and darker shading in the shadow sections.

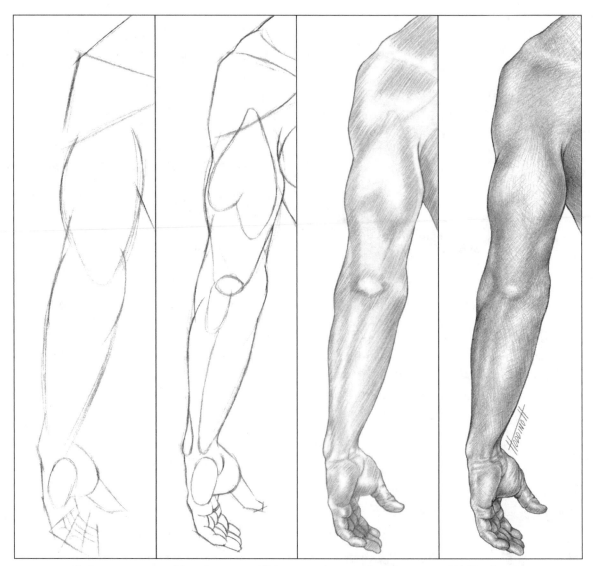

To draw an arm and hand, you establish proportions, outline shapes, and define forms.

In the next drawing, you see a side view of an arm and hand. Notice how the fingers on the hand look disproportionately short. An element of perspective called foreshortening (I explain foreshortening in Chapter 5) creates this illusion, which is integral to drawing the hand correctly from this angle.

Draw this arm and hand using the previous instructions as guidelines.

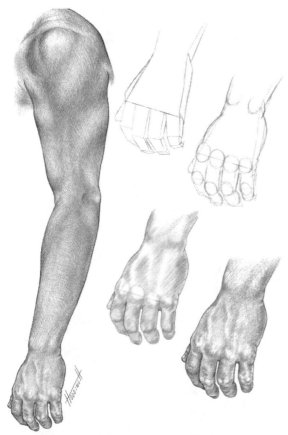

Four close-up, step-by-step views help you render this view of an arm and hand.

The Long and Short of a Leg and Foot

Legs come in many shapes and sizes, from the short chubby legs of a tiny infant to the well-defined, muscular legs of an athletic adult. The forms of women's and children's legs are generally softer and less defined than men's. When adding shading to adult legs, use lots of contrast to help emphasize the intricate forms of the knee, ankle, and foot.

Follow along with the drawings on the next page to draw a leg and foot. Thank you to my son, Ben, for allowing me to borrow one of his legs.

1. Lightly sketch the outline of the individual shapes of the leg and foot as in the first sketch in the next illustration. Visually measure how large or small some parts are when compared to others. Take note of the following:

 ◆ The upper leg is a large, elongated oval shape.

 ◆ A circle encloses the shape of the knee.

 ◆ A smaller long oval defines the shape of the lower leg.

 ◆ The ankle is a very small oval shape.

 ◆ A triangle marks the shape of the foot. The bottom side of this triangle is lower on the right.

2. Lighten your rough sketch lines with your kneaded eraser, and outline the shapes of the leg with neat lines (the second drawing). Check your proportions and make adjustments if necessary.

3. Add more details to your drawing, such as on the foot and ankle (the third sketch). Logic dictates that a human foot is actually longer than it appears in this drawing. However, keep in mind that this foot is being viewed from an extreme frontal perspective, which makes it appear shorter. (I tell you about perspective in Chapter 5.)

4. Use hatching lines to shade the light and medium values of the leg and foot (the fourth drawing). The dominant light source is from the right.

5. With darker values of crosshatching, accentuate the forms of the leg and foot. Use hatching to indicate the cast shadow.

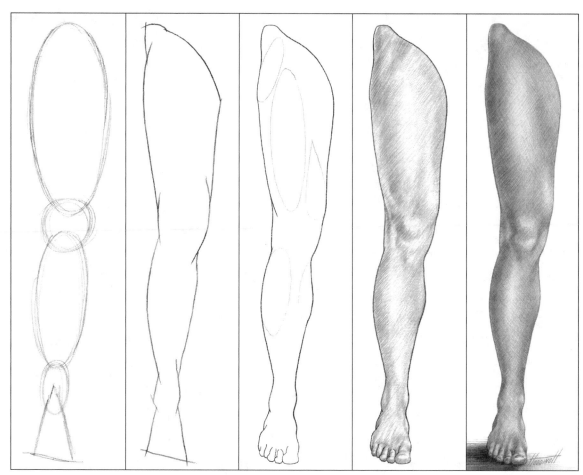

A rough sketch of a bunch of rounded shapes becomes a muscular adult leg and foot.

Drawing a Seated Female Figure

Meet Claudette, my former student and current friend, an incredibly creative artist in both visual and literary arts! Find your drawing supplies and draw along with me as I take you step by step through this project.

First you need to establish the proportions of the seated figure. When you work from an actual model, working with a grid becomes complicated. When models see you about to draw lines all over them with a thick black marker, they may run for the hills!

Warm Fuzzy _____

You can draw a human figure in oodles of different ways. I like outlining with detailed lines and then adding shading, but what's right for me may not be right for you. Take time to experiment with different ways of drawing, until you find the

After I did my initial rough sketch, though, I decided to add a simple grid to help guide you through the process of setting up proportions. (For more information, on working with a grid,

refer to Chapter 23.) If you prefer to draw freehand without a grid, skip Step 1, and go for it!

1. Draw a simple grid of six squares, two across by three down. Keep in mind that the size you choose for each square determines the final size of your drawing:

 ◆ 2 inch squares = 4×6-inch drawing

 ◆ 3 inch squares = 6×9-inch drawing

 ◆ 4 inch squares = 8×12-inch drawing

2. Draw a light sketch of the overall proportions of the figure. (Use the grid squares as guidelines, if you like.) I consider this to be the most important step. With a figure drawing, if your proportions are wrong, your drawing just won't look right no matter how wonderful your shading is. Note the following:

 ◆ The shoulder on the right is lower than on the left.

 ◆ The head is tilted downward and turned a little to the left.

 ◆ Her hands and the lower section of her right leg and foot are drawn slightly larger, disproportionate to the rest of her body, because they are closer to you.

Art Alert!

Don't press too hard with your pencils. Not only do these areas become impossible to touch up, but they also leave dents in your paper. When you try to draw over dents in the paper with a soft pencil (such as a 2B or 6B), they show up as light lines, spoiling the overall appearance of your drawing.

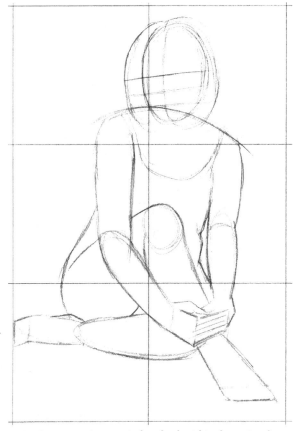

Basic proportions are sketched within four simple grid squares.

During the next stage of the drawing (refer to the first illustration on the next page), you indicate the basic shapes and forms of her face, hands, and feet.

3. Erase your grid lines. Some areas may need to be lightly sketched back in if they are accidentally erased.

4. Use your kneaded eraser to gently pat your entire sketch until the lines are very light.

5. Refine your drawing by adding more details, such as the outlines of some of the forms. Take note of the additional details I've added to the face, hands, and feet.

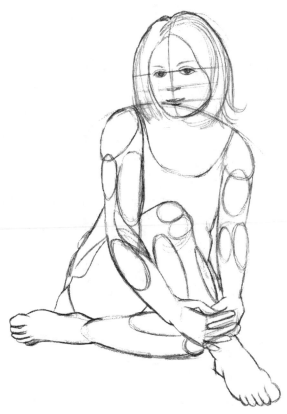

Rounded shapes of various sizes identify the locations of forms.

6. Use your kneaded eraser to lighten your sketch lines again.

7. Outline the hair, body, and clothing. Closely examine the upper right drawing and notice some of the adjustments I made, such as shortening the foot on the left, and making her head, face, and right shoulder smaller.

8. Draw the outlines of the details for her face, feet, and hands. Before you get into the really fun stuff (the shading), you have one last chance to make changes. First, take a nice long break; then come back and look at your drawing with fresh eyes.

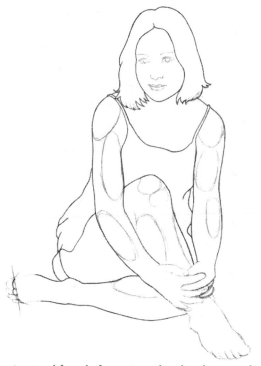

A seated female figure is outlined with neater lines.

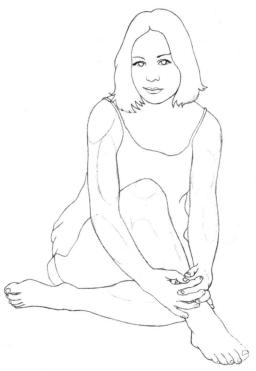

The contour drawing is complete and awaiting shading to bring the figure to life.

As you may recall from Chapter 6, the most important phase of drawing is seeing. Peek ahead a page to the final drawing. Carefully observe how the light source (from the upper left) identifies the light and shadow areas of the various forms. The highlights are white, and the cast shadow has the darkest shading. A full range of middle values falls somewhere in between these two extremes.

For this subject, I plan to add shading to the light and dark areas first. I'll then add the medium values to link them together. Feel free to use any other shading method you prefer.

9. Draw the lightest shading around the highlights and in the areas closest to the light source with hatching lines.

10. Shade in the light to medium sections by gradually adding more lines (closer together and darker), until you achieve the intended values. Remember to keep a sheet of clean paper under your drawing hand so you don't smudge your drawing.

11. Use hatching lines of various lengths and values to draw her hair.

12. Shade in the sections of her body and clothing that are in shadow, with darker values of crosshatching. Taper off the dark shading as you approach any light areas.

13. Use horizontal, parallel hatching lines and a dark pencil to draw the cast shadows below the figure.

14. Complete the shading of her face, arms, legs, torso, feet, hands, and clothing. The medium values are between the lightest and darkest values. If you want, you can add a few stronger lines to outline some contours in dark areas.

15. Step back from your drawing and have a look at the overall values. You may need to make some areas lighter (by patting with your kneaded eraser) and others darker (by drawing more hatching and crosshatching lines).

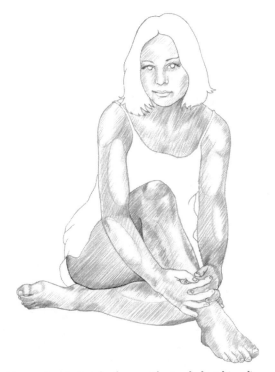

Shapes begin to take form with simple hatching lines.

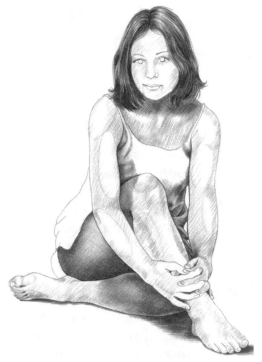

Dark values contrast beautifully against the lighter sections of the figure.

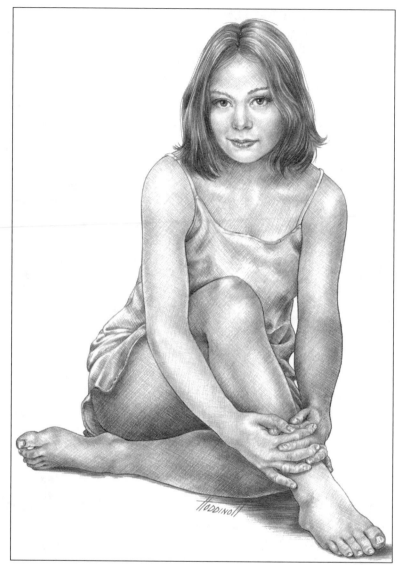

Final details and enhanced forms provide the final touches to this drawing of Claudette.

Sign your name, write today's date on the back of your drawing, and put a smile on your face!

Drawing from a Live Model

Practice drawing individual parts of human anatomy every chance you can. If your friends and family begin running away when you approach them with your drawing stuff, you can always draw your own body parts! You need only one hand to draw, so the other one is just begging to be a model. Take off your shoes and you find two wonderful foot models.

Put on your bathing suit (or birthday suit), set up your drawing materials in front of a large mirror, and draw your own face, legs, arms, hands, feet, and torso.

With the cooperation of a model, you can draw standing, sitting, and laying down poses from several different perspectives. Choose poses that are expressive, artistically pleasing, and comfortable for your model.

Helpful Hint

Use tape or chalk to mark the placement of the model's body on the surface on which he or she is sitting, standing, or lying. For example, by marking the outline of the model's feet in a standing pose, he or she can easily find the correct pose

Experiment with different drawing media such as conté (a drawing medium made from graphite and clay), charcoal, or graphite sticks and use large sheets of paper. Decide on a pose and plan your drawing format.

1. Study your model (or your own reflection in a mirror).

 ◆ Examine the contours of the body as defined by the understructures.

 ◆ Carefully inspect the positive and negative spaces.

 ◆ Observe how all the body parts interact with one another.

 ◆ Visually measure the vertical and horizontal proportions.

 ◆ Determine which parts are close to you, and which are farther away.

 ◆ Take note of where some body parts overlap others.

2. Decide where on the drawing paper your model is to be positioned.

3. Look at your drawing paper and imagine this figure on its surface.

4. Use loose sketch lines to draw the basic pose. Constantly refer to your model. Don't forget the hands and feet!

5. Lightly sketch the shapes of the various forms of the body.

6. Confirm that objects, spaces, and perspective elements are drawn correctly.

7. Continue adjusting your drawing until you are happy.

8. Indicate the joints of the limbs.

9. Identify the light source, and take note of the light and shadow sections of the body.

10. When you're happy with your sketch, add shading to the various forms.

Modeling can be difficult. Have snacks and beverages on hand and assure your model that he or she can take a break at any time. Most people can only hold certain poses for a few minutes at a time before they become uncomfortable. Deciding on a timeframe for holding a specific pose is best left to the model. You may want to continue drawing from memory while your model takes occasional breaks before resuming the same pose.

The Least You Need to Know

◆ Drawing from life is the best possible way to develop an understanding of human anatomy.

◆ Beyond careful observation of your model, focus on drawing correct proportions.

◆ Practice drawing hands every chance you can.

◆ An element of perspective called foreshortening is integral to drawing the human figure correctly.

◆ Experiment with lots of different methods of drawing human figures to find one you're comfortable with.

In This Chapter

- So what's the purpose of a sketch?
- Tips for improving your sketching skills
- Turn a wooden manikin into a sketch of a man
- Sketch expressions, actions, and movements
- Exploring different methods of sketching
- Making quick sketches of a child in motion

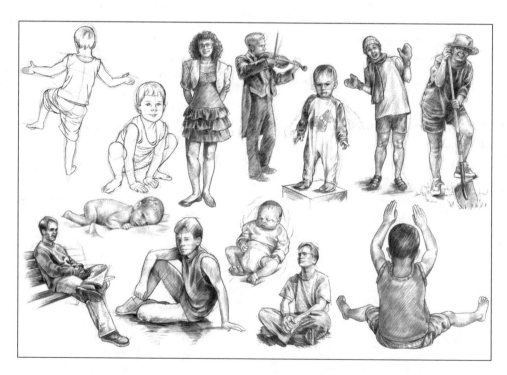

Chapter **19**

Sketching Expressive Figures

As the old saying goes, a picture is worth a thousand words. A rough sketch can quickly and efficiently illustrate the important shapes and forms of people with very few details. Sketching can be a fun warm-up exercise or the creation of a blueprint for a more detailed drawing. Some sketches are complete artworks that stand strong all by themselves.

Rocks and vases may stay quiet and still, but when you're looking for drawing subjects, they're not nearly as fascinating as people. However, in that people inevitably become fidgety and move, you usually need to be able to draw them more quickly than still-life subjects.

Sketching people from your own unique perspective allows you to emphasize the visual information that is important to you. In this chapter, I demonstrate different sketching methods and show you how to capture your visual memories as sketches. Keep your supplies handy so you can sketch figures in various poses.

The Art of Sketching Quickly

A rough sketch is quickly rendered and illustrates the important elements of your drawing subject with very few details. A gesture sketch uses simple sketching methods to capture the past, present, or potential movements of living beings. An action sketch is rapidly rendered with simple lines and/or shading to define an individual's actions or movements.

Working competently is generally more important than working fast. However, sometimes sketches need to be done quickly, such as when a person is moving. Also, when drawing a figure from life, some poses become uncomfortable for the model after only a couple of minutes.

The Goals of Sketches

Sketching frequently strengthens your visual skills and drastically improves your overall drawing abilities. A sketchbook filled with sketches of people helps refresh your visual memories of life's precious moments. Sketches can capture any moment in time—from the introspective and peaceful mood of a still figure, to the quick actions of a basketball player, to the graceful movements of a dancer.

In the next rough sketch of my friend Rob, a few simple lines indicate the forms of his clothing and the contours of his arms, head, feet, and hands.

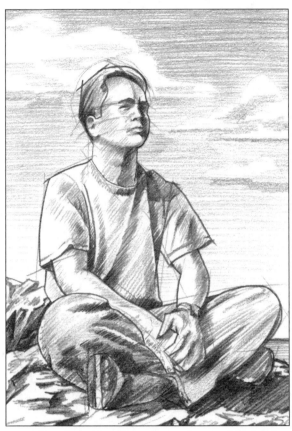

Hatching lines identify various values in this sketch of my friend Rob.

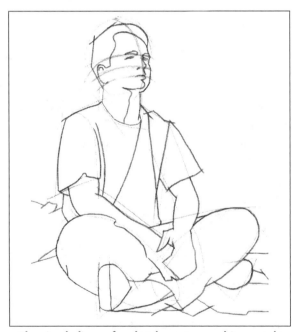

The simple lines of a sketch capture and immortalize a peaceful moment in time.

In the next sketch, shading identifies the light and shadow areas of various forms. Simple sets of hatching lines define his hair, face, arms, and hands, as well as the folds in his clothing, and the jagged rocky surface on which he is sitting.

Sketches serve as fantastic references when you want to later create a detailed drawing. Rob's sense of humor provided the fun pose for the next illustration. The gesture sketch (on the left) captures his pose, facial expression, the forms of his body and clothing, and the light and shadowed areas. The second drawing took considerably more time to render, and shows a more detailed drawing of the same pose.

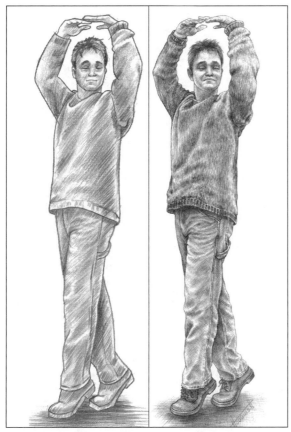

A fun sketch of a dancing man is transformed into a more detailed drawing.

Sixteen Super Suggestions for Successful Sketching

Can you say that quickly 16 times?

The essence of gesture sketching is in the process itself, rather than the creation of works of art. Your goal is not to simply replicate what you see, but rather to capture a mood, expression, or gesture. Keep the following list of suggestions in mind when you prepare to render sketches:

1. Relax for a couple of seconds before you begin each sketch.

2. Study the overall proportions of your figure carefully (but quickly) before you begin.

3. Press lightly with your pencil at first, until you feel more confident in your sketching abilities.

4. Feel free to sketch several loose lines to denote one solid line, such as the curve of a back.

5. Don't worry about drawing fine details.

6. Sketch lots of lines for sections that are moving (or show potential movement) until you are happy that you have successfully captured the curves of the motion.

7. Don't erase any of your initial sketch lines. Simply make your final lines darker so they stand out more.

8. Practice some sketches with a pen so you won't be tempted to erase any lines as you go.

9. Pay close attention to proportions and continuously adjust them as needed throughout the sketching process.

10. Spend more time looking at the model than your sketch.

11. To keep your lines nice and loose, sketch from your shoulder rather than just your wrist whenever possible.

12. Focus on capturing the essence of your model and his or her expressive gestures beyond the physical body.

13. Don't overdraw. If you find yourself focusing on details or begin feeling frustrated, stop and begin a new sketch.

14. Watch for sections of the body that are at an angle, such as one shoulder or hip that is higher than the other.

15. Accentuate even the slightest bend in the spine for a more expressive gesture. Don't miss the many curves, twists, and tilts of the arms, shoulders, hips, and legs.

16. Don't expect to like all your sketches. If 1 sketch in 20 turns out the way you want, you are doing exceptionally well. With practice you will get better!

Improving Accuracy and Speed

Consider sketching nonliving models until your skills become strong and your speed increases. Then, you can enjoy the benefits of both speed and accuracy!

In the next drawing, meet my little friends, Woody and Woodette. As models, they are incredibly cooperative, maintain the desired pose for indefinite spans of time, are available at any time, and don't require union-negotiated coffee breaks.

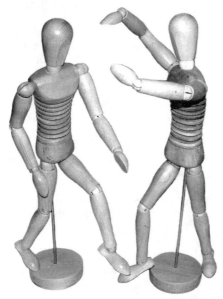

Woody and Woodette love to model for figure drawings.

Info Tidbit

You can purchase male or female (or both) manikins (known to some as womankins) at most art supply stores. They are relatively inexpensive and will come in very handy if you plan on doing a lot of figure drawing.

With lots of practice and patience, sketches become quick and easy. Seeing your subject well is integral to sketching. Practicing rough sketches with a timer increases your speed, improves the fluidity of your lines, and strengthens your observation skills.

For the next exercise, you need some sort of timer, a big pile of paper, several freshly sharpened pencils, and any nonliving object to serve as a model! Wooden manikins, dolls, or figurines work well. Find a quiet place with minimal distractions. Put your sketching subject in front of you, set up your drawing supplies, and get comfortable. Then follow these steps:

1. Set your timer for one minute.
2. Look closely at your model. Identify specific shapes and visually measure the proportions.
3. Start sketching the lines and shapes you see. Remember to look at your model often.
4. When the timer goes off, stop sketching.
5. Turn your model to a different angle (front, back, or side), or rearrange it into a new pose.
6. Grab another sheet of paper, or turn to a new page in your sketchbook, reset the timer, and do another sketch.

Start with several one-minute (or less) sketches, and slowly work your way up to five minutes.

Bringing a Wooden Manikin to Life

In this project, I demonstrate the process of transforming a sketch of a wooden manikin into a sketch of a human figure. You first break the manikin down into simple shapes (not literally, of course), then visually measure and sketch the proportions, and finally outline a human figure around its shape:

1. Set up your manikin in an interesting pose.
2. Lightly sketch the various shapes. Take note of the areas where parts of the body bend, twist, or are extended or outstretched. Don't press too hard with your pencil.
3. Check your proportions and adjust your sketch if necessary.

Info Tidbit _____

Before you begin changing Woody into a man, take a moment and review the guidelines for human proportions in Chapter 17.

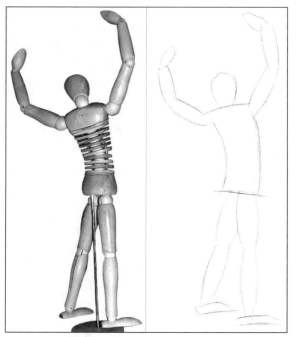

A quick sketch captures proper proportions and the essence of Woody's pose.

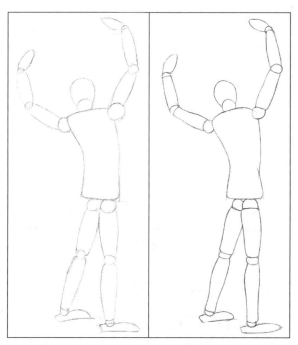

Woody's various shapes are neatly outlined, and he is waiting to be brought to life.

4. Sketch the various rounded forms that represent the movable sections of his body, such as his neck, shoulders, elbows, wrists, hips, knees, and ankles.
5. Study your manikin carefully, and then add more refined lines.

6. Sketch the forms of a man (or woman) around the basic structure of the manikin.
7. Adjust your drawing until you are happy with the shapes of each part of the body. You can even try adding some shading if you want!

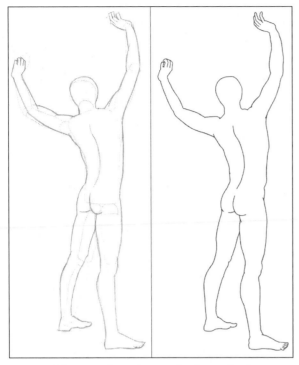

A wooden manikin takes on the form of a human figure.

Exploring Expression, Gesture, and Movement

Gesture sketches utilize your personal choices of simple sketching methods. Some artists prefer lines, some prefer only shading, and others (like me) prefer a combination of values and lines. Throughout this section, I show you various ways of sketching. Take time to experiment with each method to see what you feel most comfortable with.

Expressing Motion with Lines

Try your hand at using only a few strategically placed lines to sketch a figure (or a manikin):

1. Set up your drawing materials and get comfortable.

2. Examine your subject, and note the sections you consider most interesting.

3. Use simple lines to outline the shapes you see.

4. Double-check the proportions and adjust your sketch accordingly. Resist the urge to erase. Simply draw corrected lines right over or beside the initial sketch lines.

In the next drawing, take a peek at figurative poses using only lines. Some body parts simply bend in various directions; others can bend, rotate, or curve.

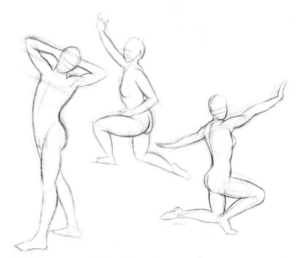

Various types of sketching lines capture gestures and expressions.

Sketching Gestures with Shading

Some artists like to sketch with only values and find sticks of charcoal or conté faster to work with than pencils. The wide ends and sides can define a lot of information with a single stroke.

Helpful Hint

Sketching on large sheets of paper enhances your sketching skills by allowing you the freedom of drawing from your shoulder rather than your wrist. Keep your wrist still and move your entire arm from your shoulder to sketch long flowing marks in one continuous movement.

Find an interesting subject with a strong light source so you can see various light and dark values. Remember, squint your eyes to help see the different values. Use a stick of charcoal (or conté) to try your hand at sketching with shading. Focus on the shapes of each different section of values. Stay away from lines as much as possible.

1. Block in the shapes of the middle to dark values with the side of your charcoal. This shading defines the shape and size of your subject within your drawing space.

2. Eyeball the shapes of the forms close to the light source.

3. Add light values to the edges of the light sections, or shade in the negative space behind the figure (or do both).

4. Find the dark shadow sections and define them boldly with the end of your charcoal stick.

5. Use your kneaded eraser to gently pull out a few highlights.

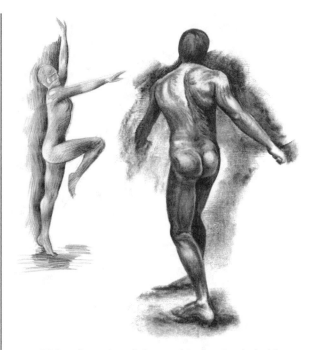

Sticks of conté and charcoal make simple bold marks in sketches of figures.

Capturing Movement with Lines and Shading

By experimenting with different sketching methods, you eventually find those that work best for you. My favorite sketches include both lines and shading. I generally set up the proportions with lines and then add shading with hatching. (In Chapter 18, I take you step by step through the entire process of drawing from a live model.)

Wherever you go, take time to explore your surroundings in search of interesting people for sketching. Try some sketches using both lines and shading. Refer to the following illustrations for ideas.

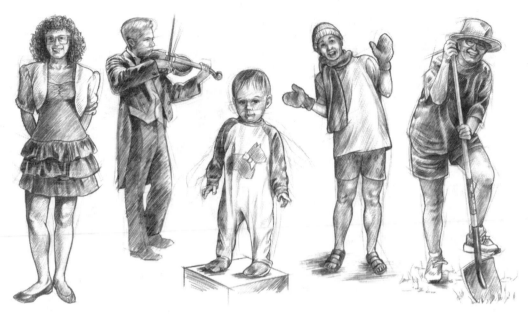

Lots of visual information can be sketched with lines and shading.

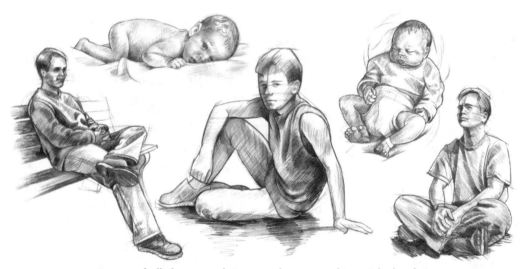

Figures of all shapes and sizes can be captured in quick sketches.

Sketching Moods, Stories, and Memories

Sketches of people can make powerful visual memories. Consider sketching Grandpa Don as he snoozes in his chair in front of the TV. Do a sketch of baby Alora who has fallen fast asleep on the floor while cuddling her favorite teddy bear. Sketch Grandma Carole as she peacefully knits in front of the fireplace. Another fun sketch could be of little Audra, sitting on the floor with her tongue stuck out to one side in deep concentration as she plays a video game.

When you work from a naturally relaxed person (or a photo), you tend to feel more calm and comfortable in your sketching approaches. In the second illustration on the previous page you see several sketches of peaceful poses.

Do oodles of sketches of many different people. When you have no model, sketch yourself in a mirror. When you get bored of drawing yourself, sketch a wooden manikin, doll, stuffed toy, or even the family pet. With each sketch you do, your drawing skills improve!

Catching Up with a Child in Motion

The movements and gestures of children tend to be very natural and their bodies are surprisingly flexible. However, most children are incredibly challenging to sketch from life. They are not fond of staying still, tend to be easily distracted, ask gazillions of questions, and love to clown around.

What's faster than a speeding meteorite and busier than a hive of bees? That's easy—a six-year-old named Brandon (my grandson)! I decided to follow Brandon around with my digital camera for an hour to capture a few quick poses for sketching.

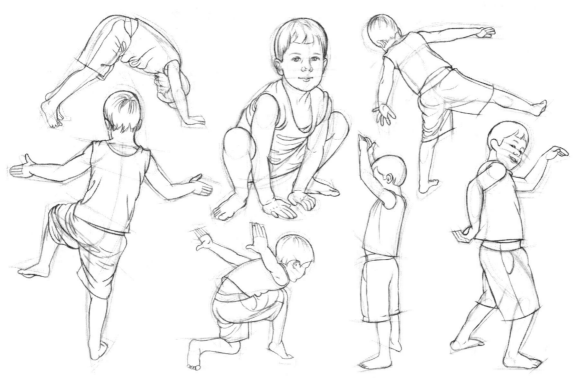

A busy child makes for some very active sketches.

In the previous illustration, I shared a few recent sketches of Brandon throughout his daily routines.

Sketching children is well worth the effort. If you have a young child in your family or can borrow one from a friend, the resulting sketches are a lot of fun. In the following sketches, Brandon has finally wound down a little.

Helpful Hint

Try taking photos of your potential models. Many people, especially children, are quite comfortable simply being themselves in front of a camera. After a few moments of being followed, they often lose interest in the camera and simply go about their busy lives. Be patient, enjoy yourself, and be quick about clicking that camera button!

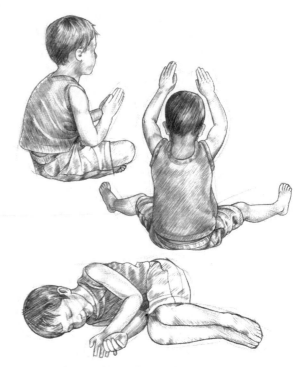

According to these sketches, Brandon has finally begun to run out of steam!

The Least You Need to Know

- The purpose of a sketch is to quickly and efficiently illustrate your drawing subject.

- Sketch nonliving models until your skills become strong and your speed increases.

- Sketching strengthens your visual skills and drastically improves your overall drawing abilities.

- Patience and practice are the basic ingredients for successfully rendering sketches.

- Sketches can be successfully rendered with only lines, only shading, or a combination of both lines and shading.

- Children in motion are hard subjects to sketch; try capturing the moment on film and sketching from the photos.

In This Chapter

- ◆ A patchwork of fabric textures
- ◆ Planning and rendering textures
- ◆ Comparing texture with pattern
- ◆ How to draw different textures of a pattern
- ◆ Draping an arm with fabric

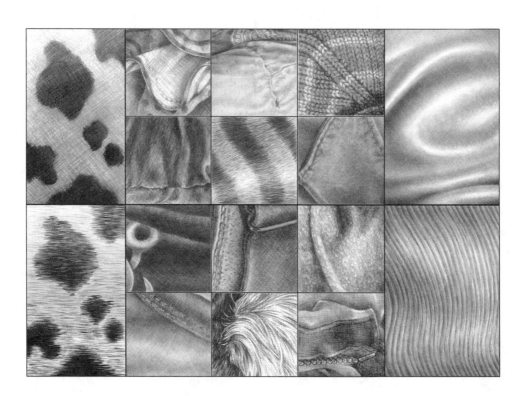

Clothing the Figure

Fashions may come and go, but the basic forms of human figures remain constant. Drawing believable fabrics, textures, and patterns is integral to accurately rendering the clothed figure. The folds, creases, puckers, and wrinkles of clothing reveal the unseen figure. Textures identify the surface details of clothing such as whether it is soft, coarse, shiny, matte, or fuzzy.

In this chapter, I illustrate and discuss examples of the endless possibilities for drawing the textures of fabrics. I also show you how to draw fabrics that drape naturally over human forms. Keep your drawing supplies close by and try your hand at drawing diverse textures, fabrics, and clothing.

Exploring Textures of Fabric

Your general knowledge of your subject can help you identify the properties of a texture. You can also visually examine it or touch it. However, if the texture is crocodile skin, being worn by a big mean crocodile, you may prefer to use only your vision and knowledge!

Designers have an infinite range of textures and patterns to choose from when creating fabrics. In essence, whatever can be imagined can end up as clothing! Lots of words describe the textures of fabrics including soft, coarse, shiny, matte, smooth, bumpy, woven, or fuzzy.

Shiny Fabrics

Many fashions are shiny, made from such synthetic and natural fabrics as silk, polyester, vinyl, plastic, and leather. Check out the next four fabric swatches, and identify the following characteristics, which help you draw shiny fabrics:

◆ Bright highlights reflect off the surface areas closest to the light sources.

◆ The transition of values from light to dark is compacted into very short distances.

◆ Extremes in values, such as dark shadows and pronounced highlights, are often right beside one another.

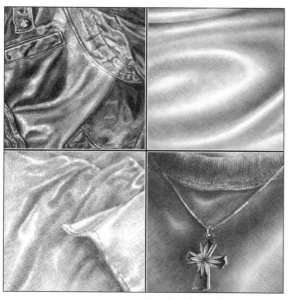

Shiny fabrics have bright highlights and high-contrast shading.

Matte Materials

Matte fabrics aren't shiny, but can include a wide range of different textures, including soft, smooth, rough, bumpy, fuzzy, furry, and coarse. Both natural and manmade fabrics, such as cotton, synthetic, faux fur, fleece, denim, knits, and others, have a matte texture.

The patchwork of 12 swatches of matte textured clothing featured on the next page shows a diversity of shading techniques. Generally speaking, drawings of matte fabrics share the following characteristics:

◆ The transition of values from light to dark is gradual.

◆ There are no distinctive highlights.

◆ Low-contrast shading with values that flow smoothly into one another.

Shading Different Textures

Fabrics are lots of fun to draw because of their infinite array of values, textures, and patterns. With careful observation, patience, and practice, you can draw any fabric. Implement the KISS (Keep Its Shading Simple!) principle as you explore translating textures into drawings.

Warm Fuzzy

Whatever shading technique gets the results you want is correct. Have fun experimenting with drawing different fabric textures. You may even discover fantastic techniques completely by accident. So if denim ends up looking more like corduroy, be happy! You now know how to draw the texture of corduroy!

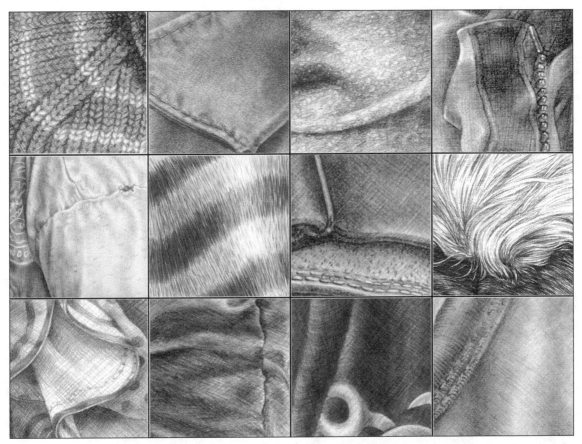

This patchwork of clothing demonstrates a variety of fabric textures.

Making Material Matte

The following technique works well for drawing the textures of matte, ribbed fabrics such as corduroy or knits:

1. Indicate the gentle pucker in the fabric with curved hatching lines.

2. Darken the shading and add bolder lines. (Examine the first drawing on the next page.) Both the shading and the lines need to graduate from dark (on the left) to light, then back to light, and finally dark again on the far right. The bolder lines identify the creases in the fabric.

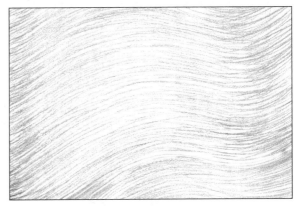

Curved hatching lines define the pucker of a swatch of fabric.

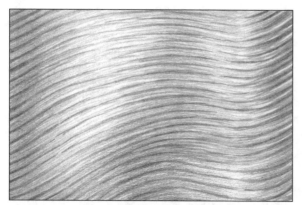

The shading lines and dark creases flow in the same directions.

3. Make the shadow areas and the creases in the fabric more pronounced.

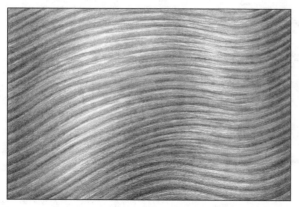

A stronger contrast in values enhances the texture of the fabric.

Shading Shiny Fabric

Drawing a smooth shiny texture is somewhat more challenging than drawing matte fabrics. The values graduate from white to dark over very short distances.

1. Draw three simple curved lines to indicate the folds in the fabric.

Three curved lines mark the folds in the fabric.

2. Add light shading with fine crosshatching lines.

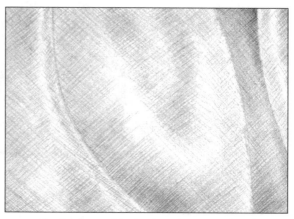

Light shading adds depth to the fabric's folds.

3. Shade the shadow areas with middle values. Make sure you leave very light areas to contrast with the darker values.

At this point, the texture of the fabric is closer to matte than shiny. If your goal was to draw a matte textured fabric, this drawing would be finished.

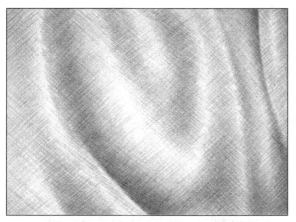

Middle values create a matte textured fabric.

4. Slightly blend the lighter values. (I tell you about blending in Chapter 9.)

5. Use your kneaded eraser to pull out highlights in the light areas.

6. Add more dark values (use a 2B or 4B pencil) very sparingly to give more contrast.

The high contrast of light and dark values makes this fabric look shiny.

Combining Pattern with Texture

When you draw a patterned texture, you need to define both the pattern and the texture. Any

pattern, such as flowers, stripes, or plaid, can be on any texture of clothing. For example, both a shiny, smooth silk shirt and a bumpy, thick wool sweater can have an identical striped pattern.

Compare two identical striped patterns on two different textures. Both the texture and pattern of the smooth fabric (the first drawing) are rendered with various values of fine cross-hatching lines. Short hatching lines define the texture and pattern of the fuzzy fabric (the second drawing).

A smooth shiny texture and a fuzzy matte texture have identical striped patterns.

Warm Fuzzy

When drawing complex clothing, it's perfectly okay to leave out either the pattern or texture (or both). Indicating the form of the figure under the clothing is much more important than drawing patterns and textures. Drawing both texture and pattern at the same time can be very overwhelming for a beginner.

You can draw patterned textures by shading either the background or the pattern first. You may even decide to try drawing both at the same time. Whichever method gives you the results you want is best for you.

If you like Dalmatians or cows, you'll love the pattern of the fabrics in the next two exercises. You can draw two different textures with the same spotted pattern. The base of each is mostly light values and the spots are dark. The first will be shaded with crosshatching and the second with hatching.

Draw two identical (or very similar) shading maps (one for each texture). Note that the spots are various shapes and sizes. Some are partial spots and seem to disappear beyond the edges of the drawing format.

Draw two spotted shading maps, similar to this one, before you begin the next two exercises.

Shading Pattern Before Background

In this exercise, you shade the dark spots of the pattern first, and then the background. The light source is from the left on this smoothly textured fabric. Hence, the crosshatching graduates from light on the left, to dark on the right.

1. Lighten your mapping lines with your kneaded eraser and add shading to the spots with crosshatching. Graduate the values of the spots from dark on the left to almost black on the right. Leave the background white for now.

The dark spots of the pattern graduate from dark to almost black.

2. Add a crosshatched graduation of light values to the unspotted sections. These light values graduate from light on the left to medium on the right.

Light values added to the background complete the spotted fabric.

Shading from Background to Pattern

In this exercise, you use graduated values with hatching to draw a spotted fuzzy fabric. The light values of the background are shaded before the dark spots. The light is coming from the left, so the values are darker on the right.

1. Draw a bunch of hatching lines of different lengths in all the areas without spots. Don't forget to lighten your mapping lines before you begin. Extend some hatching lines beyond the mapped outlines of the spots to create a jagged, natural-looking, furlike texture.

2. Graduate the values from light on the left to medium on the right. Leave the spots white for now.

Vertical hatching lines graduate from light to medium in unspotted sections.

3. Use darker hatching lines to graduate the shading of the spots from medium (on the left) to dark.

Dark fuzzy spots are created with medium to dark hatching lines.

Drawing Pattern and Texture

Find an article of clothing or a swatch of fabric (or anything else) with a simple pattern. Draw both its pattern and texture, using the following process:

1. Arrange the fabric in front of you with a dominant light source (such as a bright window or lamp) on one side.

2. Outline a shading map of the pattern.

3. Examine the texture and decide which shading technique (hatching, crosshatching, or squirkling) best defines its texture.

4. Decide whether you want to shade the background or pattern first (or work on both together).

5. Use whichever pencils you prefer and add shading to the fabric. Pay close attention to the different values that define the pattern. Observe how the light source makes some areas of the fabric look darker than others.

Helpful Hint

When combining patterns with textures, experiment with different techniques and work out potential problems before you begin the final drawing. Make a few preliminary sketches of the pattern and texture individually.

Drawing Believable Folds of Fabrics

Clothing provides viewers with vital information about the forms of various parts of a person's body beneath the fabrics. Fabric draped over a human form tends to overhang from the most prominent forms, such as shoulders, elbows, and knees. To indicate the pose of a figure under the clothing, you need to pay close attention to the way the fabric clings to, or falls away from, the various forms.

In the first drawing on the next page of a seated male figure, my friend Gordon Forbes, the numerous folds in the fabric of his shirt indicate the forms of his shoulders and arms. While this is obviously a white (or light-colored) shirt, a broad range of values is used to realistically illustrate the fabric.

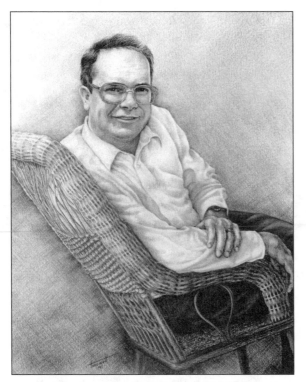

A broad range of values illustrates the folds in the fabric of this gentleman's light-colored shirt.

In this project, you draw the folds and creases of a sleeve to indicate the forms of an arm.

1. Lightly outline an arm bent at the elbow and indicate the shapes of the ribcage, breast, and waist. See the first drawing below.

2. Sketch the outlines of the folds of the fabric. Observe how the bent form of the arm bunches up the fabric in some places. Note how the fabric at the opening to the sleeve falls downward from the wrist.

3. Refine your outline of the clothing, paying close attention to the forms, folds, and creases.

4. Add light shading with hatching graduations, to indicate the forms of the fabric and the arm underneath. See the first drawing on the next page.

5. Graduate the light shading into the shadow sections with medium values.

6. Add dark shading to accentuate the darkest shadow sections of the fabric.

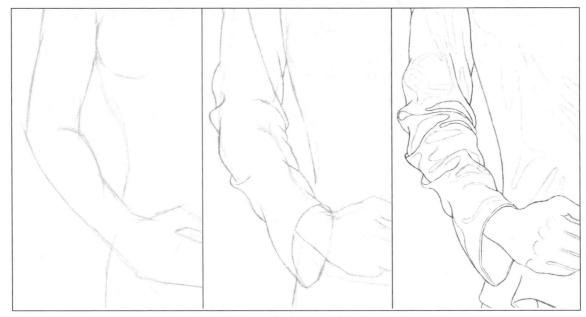

Soft fabric gently drapes itself around the forms of an arm.

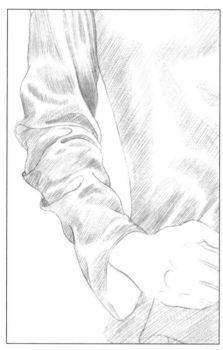

Light shading brings out the forms of the fabric.

Dark shading and final touches complete the forms and folds of the sleeve.

Borrow your friends and family and practice drawing their clothing (or draw from your own reflection in a mirror). With an understanding of the forms of a person's body under the clothing, drawing fabrics becomes easier. (Refer to Chapters 17, 18, and 19 to find out more about the forms of figures.)

The Least You Need to Know

◆ You can identify the properties of a texture with a visual examination, your sense of touch, and your general knowledge of your subject.

◆ You can render the surface details of clothing, such as whether it is soft, coarse, shiny, matte, or fuzzy, by using various shading techniques.

◆ When drawing a patterned fabric, you need to define both the pattern and the texture.

◆ The forms of figures can be implied by drawing the folds, creases, puckers, and wrinkles of their clothing.

◆ Pay close attention to the way fabrics cling to, or fall away from, the various forms of the figure.

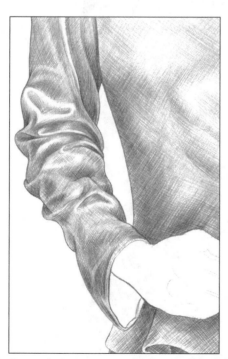

Medium values accentuate the forms of the folds of the clothing.

In This Part

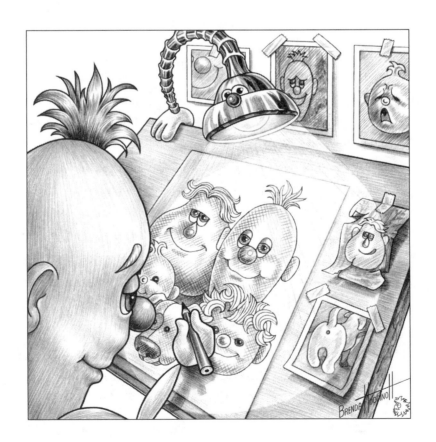

Enjoying Eclectic Facets of Drawing People

In this part of the book, you focus more on the creative aspects of drawing people rather than the technical nature of artistry. You examine various artistic approaches to drawing people, such as contrast, key, backgrounds, and body language.

I discuss eclectic approaches for creating natural-looking drawings from photos. Grids assist in rendering precise proportions and correct perspective. I encourage you to use your imagination when you translate photos into drawings by investigating possible creative goals, approaches, and techniques.

You and I work together to create two major projects. The first drawing of a young man is drawn freehand. The second is based on a photo of a little girl and is rendered with help from a grid and viewfinder frame.

While this part of the book represents the end of our journey together, your individual quest—to become the very best artist you can possibly be—is only beginning. As you continue your journey, remember that learning is an infinite quest. With each future artistic path you choose comes new insights, challenges, and successes. Each skill that you have gained in our journey together represents a tiny section of a road map toward your ultimate destination: a lifelong love of drawing.

In This Chapter

- ◆ Exploring key and contrast in drawings
- ◆ Observing visual ambiance in backgrounds
- ◆ The visual language of the body
- ◆ Implementing different drawing approaches

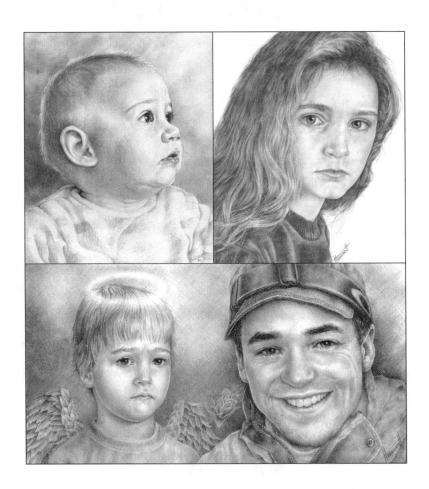

Chapter 21

Artistic Approaches to Diversity

People are all different, and so too are artistic approaches to drawing them. Capturing the essence of an individual necessitates careful attention to his or her personality and personal characteristics. You may even have specific commentaries or messages you want to visually portray in your drawings.

Throughout this chapter, I show you various approaches to drawing diverse peoples, with a focus on contrast, key, backgrounds, and body language. I discuss my initial goals for each drawing and share the creative approaches and drawing techniques I used to illustrate my original vision. An exercise in drawing a young man takes you step by step through the process of using a combination of techniques.

Creating Character with Contrast and Key

Contrast is an invaluable tool for heightening the visual effects of drawings. High-contrast shading includes a full range of values between very light to almost black. Low-contrast shading has a more limited range of values. (Review Chapter 4 for more on contrast.)

Key refers to the overall amounts of light and dark values in a drawing. High-key (also known as high-value) drawings, or some sections within drawings, tend to be bright with mostly light and medium values rather than dark, deep values. Even most of the shadows and dark areas are shaded with medium values, rather than extreme darks.

High key is a close cousin of low contrast. Low-contrast shading has an overall limited range of values, and high key has a limited range of values that are mostly light. Think of a drawing of a polar bear in a snowstorm as a fun example of high key.

Low-key (sometimes called low-value) drawings, or sections of drawings, have ranges of predominately dark values and tend to be ominous or moody. Think of a drawing of a black horse at night. Low-key drawings can also have sections of high contrast, which entails putting the darkest darks next to the lightest lights. Consider the addition of a bright full moon to the scene with the black horse.

Throughout this section, I discuss the rationale for choosing either high or low contrast, high or low key, or a combination of any or all of them to enhance the mood in your drawings.

Comparing the Highs and Lows

The diptych (the next set of two artworks) is titled *Yin and Yang*. My goal was to illustrate two completely different facets of my friend Ben Fong from the exact same photo reference.

Successfully creating two dissimilar drawings was completely dependent on how I chose to draw them. High contrast and low contrast each have unique abilities to communicate completely different visual messages. By combining high and low key, with contrast, I ended up with two very different drawings.

Two drawings demonstrate different uses for contrast and key.

The first drawing, *Yin*, is dark and rather ominous. Note the following:

◆ The chaotic background is high contrast, with very strong dark and light values.

◆ His hair is rendered with low-key values, which make the texture of the hair look coarse, heavy, and dull.

◆ The facial forms and clothing are shaded with dark shadows and bright highlights (high contrast).

◆ The shading techniques give the slightly tilted head an unnerving and piercing quality.

Yang, the second drawing, is gentle and endearing and uses the following shading techniques:

◆ A limited range of light and middle values (low contrast) creates a peaceful and calm background.

◆ High-contrast values from very light to very dark result in a fine, soft, shiny hair texture.

◆ High-key shading (with mostly light values) makes his clothing look soft and gives his face a gorgeous gentle appearance.

◆ The slightly tilted head, combined with the shading techniques, communicates an introspective and inquisitive persona.

High Key and Low Contrast

An ideal opportunity to combine high key and low contrast is in a drawing of a light-haired, fair-skinned person wearing light-colored clothing.

The next drawing, titled *Into the Light*, shows a traditional approach to drawing a baby's portrait. Meet my nephew, Colin, when he was around the age of one. My goal was to capture both the innocent facial expression typical of young children and a gentle ambiance.

The soft light from the right illuminates his facial profile and accentuates his angelic facial expression. Most of the values range from light to medium. However, I make his eyes the focal point by rendering them with very dark values.

Soft lighting enhances Colin's introspective facial expression.

Helpful Hint

Portraits depicting gentleness, such as those of young children, generally work best with soft lighting and low-contrast and high-key shading.

In the next drawing, meet Jaclyn, the daughter of my photographer friend Bruce Poole. My goal was to use shading to enhance her look of innocence while accentuating her eyes.

With the exception of her eyes, all aspects of the drawing incorporate low-contrast and high-key shading. Her hair, face, and clothing are shaded with a limited range of values, mostly between light and medium.

Again, I use the power of shading to accentuate my focal point. Her eyes become the most powerful aspect of this drawing by using the darkest darks and the lightest lights beside one another (high contrast).

By combining high key with high and low contrast, a gentle ambiance enhances the persona of a young girl.

Low Key and High Contrast

A detail section of a drawing of my friend Ben (the next illustration) demonstrates low-key shading. My goal was to capture a dark and ominous atmosphere. Most of the values range from medium to dark. However, bright highlights in his dark eyes contrast sharply with the overall darkness of the drawing (high contrast).

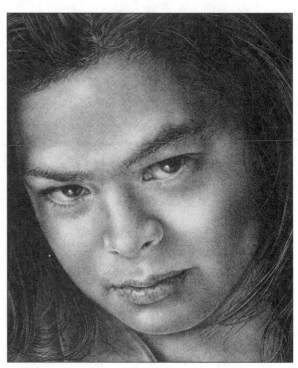

The low-key shading of this man's face creates a menacing atmosphere.

In the next drawing, an engaging adolescent named Mike personifies a rebellious attitude. My goal was to find a shading technique to enhance a complex persona of vulnerability and strength.

High-contrast shading was the ideal approach. His hair and clothing are shaded with a full range of values from very light to almost black. His facial expression is enhanced by using dark shading for his individual features and softer shading for the skin tones. In doing this, the elements of facial expression are exaggerated, further emphasizing the independent attitude.

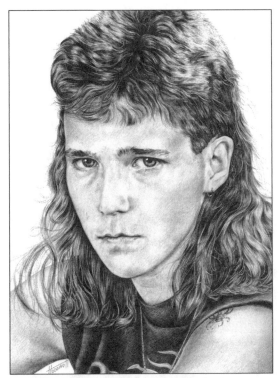

High-contrast shading accentuates a defiant and independent facial expression.

Expressing Individuality with Different Approaches

In addition to contrast and key, other approaches can help bring specific moods or individual characteristics into the visual arena of a drawing.

Info Tidbit

Different approaches to rendering the individual lines within values can affect the final ambiance of your drawings of people. Shading with big bold lines can give a drawing a mood of strength, attitude, and roughness. On the other hand, smoothly blended, soft shading can evoke such characteristics as gentleness, innocence, and sensitivity.

Bringing Backgrounds into Play

Many drawings stand strong without a background. Others need at least a little shading in the background to help make light sections stand out or to soften the contrast between dark areas and the white paper. How you choose to render a background can project a powerful visual message about your drawing subject. To give you a better idea of what I mean, take a look at the drawings in this section.

Meet my grandson, Brandon, when he was only one day old. This drawing was inspired by his grumpy expression. He doesn't look very impressed with the new world he has come into! My goal was to portray his facial expression, along with a visual message of chaos and confusion.

A motley combination of patterns and textures in the background exhibits both chaos and confusion. However, the mostly light and medium values provide a gentle, soft feeling.

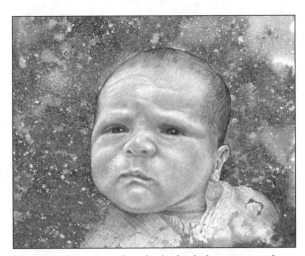

My grandson, Brandon, looked a little grumpy when he was one day old.

The next drawing is of my friend Mike, another of my former students. To improve the composition, I needed to find a way to make his skin tones stand out from the background. From a philosophical standpoint, I also wanted to create a dark ambiance to complement his contemplative facial expression.

I finally decided that a low-key background would allow me to accomplish both my initial goals. Compare the dark background in this drawing to the lighter values in the previous one.

Info Tidbit

It's easier to obtain a likeness to someone with a profile rather than frontal view. Even the overall drawing process is simpler because you're only dealing with one eye, one ear, and half a face, nose, and mouth.

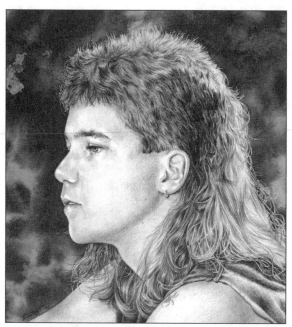

A dark background contrasts sharply against the facial profile of an adolescent male.

Combining two or more people into a unified drawing can be rather challenging. However, a creative background can cohesively tie two individual personas together.

A background can also hold secondary images that contribute to the moods and messages you want your drawings to portray. Background images need to be subtle so as not to compete with the focal points. By using either low- or high-key shading, background images enhance rather than take away from your primary subjects.

My goal in the next drawing was to portray the indelible strength of the human spirit through the quintessential, innocent spirit of the inner child. My friend Rob is both the child and the adult.

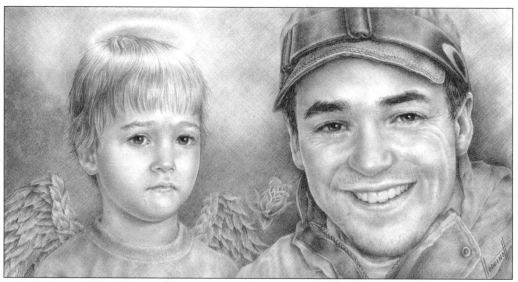

The angelic inner child of a young man is behind his right shoulder.

The background, rendered with high-key and low-contrast shading, pulls both people together and unifies the drawing. The image of a rosebud (in between the two figures) has been subtlety imbedded into the background to further exemplify the philosophy of personal growth.

Communication Through Body Language

Most experts and researchers agree that visual communications are much more reliable and informative than verbal. Facial expressions provide universal, easy-to-interpret exhibitions of emotions. (I tell you all about facial expressions throughout Chapter 16.) Body language can also communicate a vast array of visual messages.

The way a person's body is posed can identify feelings and provide insights into the personality of an individual. Consider the following when choosing poses for your drawing subjects:

◆ A tilted head can imply concentration, introspection, or attentiveness to an object or another individual.

◆ Shoulders can exhibit fear or anxiety when raised. When one shoulder is higher than the other, a general feeling of unbalance is projected. When pulled back, shoulders can portray confidence; when slumped forward, a person may appear tired, nervous, or insecure.

◆ Arms exhibit relaxation when loosely folded or resting. When arms are folded tightly across the chest, individuals may appear isolated or insecure and may be unconsciously using their arms as shields of self-protection.

◆ Hands that are open and relaxed generally portray calmness and tranquility. When formed into a fist, hands can represent anger, anxiety, or aggression. If

someone comfortably rests his or her head or face in or on a hand, that person is usually relaxed or contemplative. However, a hand (or hands) holding the head can also be interpreted as the person feeling stress, fatigue, or sadness.

◆ Legs that are crossed or twisted around one another (when seated) can be a sign of anxiety or general discomfort. On the other hand, legs that are casually spread apart generally imply that this person is feeling comfortable, safe, and confident.

In the next drawing, meet Phil, my friend and former student. A partial background helps separate his face and arm from the background.

His facial expression clearly conveys sensitivity. By drawing his arms tightly folded I have enhanced the impressions of both strength and vulnerability. He seems to be unconsciously using his folded arms as a shield of self-protection.

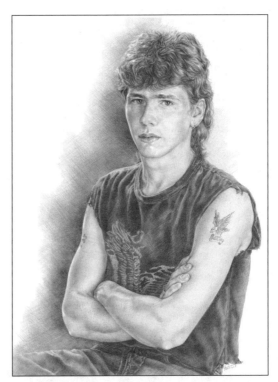

Folded arms contribute to an atmosphere of vulnerability.

Emphasizing Mood with Different Approaches

With a focus on key and contrast, this exercise walks you through the process of using diverse drawing approaches within one drawing. In addition to enhancing composition, key and contrast can contribute to the mood of a drawing.

You can visually follow along with me, or grab your art supplies and do your own drawing based on my drawing process. Use whichever pencils you prefer.

The first step is to plan your shading approach. Many artists do a small preliminary sketch (often called a thumbnail sketch) to work through potential problems before they begin a drawing. A thumbnail sketch for the next drawing of my longtime friend Joel will also provide me with a guide for the actual shading.

The rough sketch in the next illustration places Joel within the drawing space.

1. Sketch the basic pose including the up-turned face, ear, neck, hand, hair, and clothing. Having his chin casually resting on his hand contributes to the relaxed and contemplative mood I want to project.

A rough sketch captures the essence of the basic pose and composition.

2. Use contrast and key to create a thumb-nail sketch. With high-contrast and high-key shading, his face stands out strongly as the focal point. The dark shading of the background serves as a sharp contrast to his brightly lit facial profile. Low contrast helps to underplay less-important areas such as his hand, clothing, and the background.

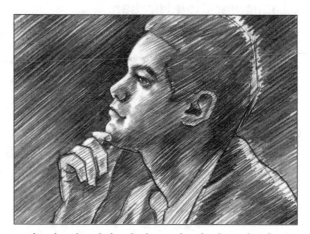

This thumbnail sketch shows the shading plan for the drawing of Joel.

Art Alert!

Save yourself the frustration of poten-tial problems by carefully planning your drawings. Take as much time as neces-sary to work out your shading and composi-tion strategies until you are happy with the results. If the plan of action doesn't come together quickly, put your preliminary thumb-nail sketches away for a few days. A fresh look at a later time may offer insights into problem areas that you can then work out before you begin the actual drawing.

A contour drawing can outline composition and accurate proportions and identify the over-all pose of a person. With the thumbnail com-pleted and taped to the top of my drafting desk, it's time to begin the actual drawing.

3. On a fresh sheet of drawing paper, outline the face, clothing, hair, and hand.

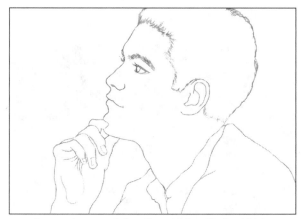

Proportions and details are identified within a contour drawing.

To help make the face stand out against the dark background, the shading is mostly light values (high key). However, with high-contrast shading for the eyes, they become the strongest facial feature.

4. Add light values to the face and hand. The goal is to identify the highlights and leave them white. The light values then graduate from the highlights toward the sections that are in shadow.

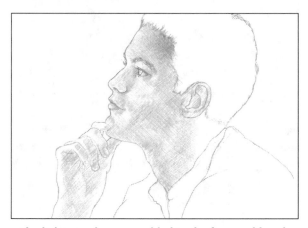

The lightest values are added to the face and hand.

The primary light source is from the left. A diffused secondary light source from the right serves to separate the back of the hair and clothing from the background.

5. Add medium values to the face and hand to accentuate the various forms. I've enlarged this section so you can better see the shading.

6. Use slightly darker values to emphasize the corners of the mouth, the nostril, the pupil of the eye, and the upper eyelid crease.

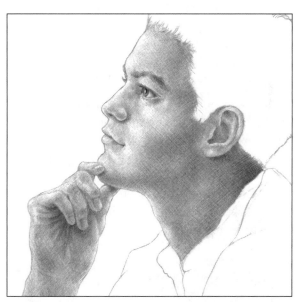

Mostly medium values, with a few dark details, give form and character to the face.

7. Use hatching to begin shading the dark values of the background next to the facial profile. (Refer to the first drawing on the next page.)

8. Add crosshatching lines to make the shading darker closer to his face. The extreme high contrast between the facial profile and the background make this section of the drawing very powerful.

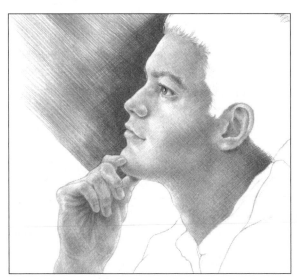

Dark background shading beside a light facial pro-
file becomes high contrast shading.

Low-key and low-contrast shading keeps the
background, hair, and vest subdued so as to not
overpower the focal point.

9. Complete the rest of the shading of the
 background with crosshatching and
 mostly medium and dark values. The
 darkest background shading continues
 to be next to the face.

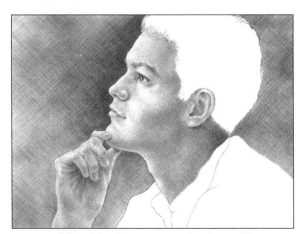

An overall low-key, low-contrast background accen-
tuates the bright facial profile.

10. Use mostly medium and dark hatching
 graduations to shade in his hair. The only
 sections that are light are around the
 edges of his head.

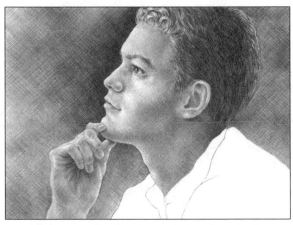

His hair is rendered with mostly low-key shading.

11. Use squirkles and low-key, low-contrast
 values to add textured shading to his vest.

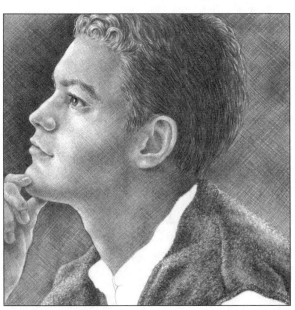

Low-key shading with squirkles provides texture to
his vest.

12. Use low-contrast shading to complete his
 shirt.

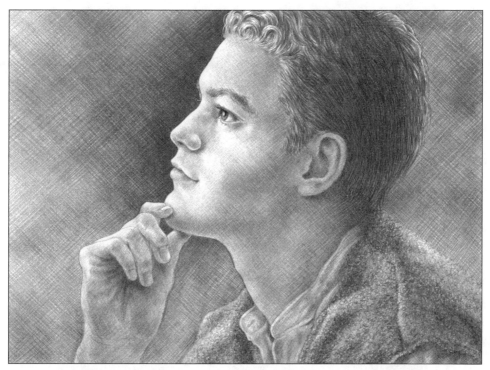

With the addition of a few final touches, the drawing of Joel is finished.

As this drawing approaches completion, I examine the overall shading. I adjust the values in some places:

◆ I add darker shading to his ear, the perimeter of his clothing, and the shadow sections of his hair.

◆ With my kneaded eraser, I make the lightest shading on his face even lighter.

◆ With a 2B pencil, I darken the shading slightly around the entire perimeter of my drawing space to help bring more attention to the facial area.

The Least You Need to Know

◆ With a basic understanding of diverse shading approaches, you can add elements of a person's personality to your drawings.

◆ The techniques you use for adding shading to your drawing can strongly affect the overall ambiance of the drawing.

◆ A background can project powerful visual messages and contribute to the mood of your drawing.

◆ You can add messages to your backgrounds by drawing faint imagery.

◆ A background can be used to tie together a drawing of two or more people.

◆ With an understanding of body language, you can use people's bodies to visually communicate information about them.

In This Chapter

- ◆ Taking and choosing ideal photos for drawing
- ◆ Organize your photos into a resource library
- ◆ Modifying photos to suit your artistic vision
- ◆ How to draw a lifelike portrait from a photo
- ◆ Combining multiple subjects into one drawing

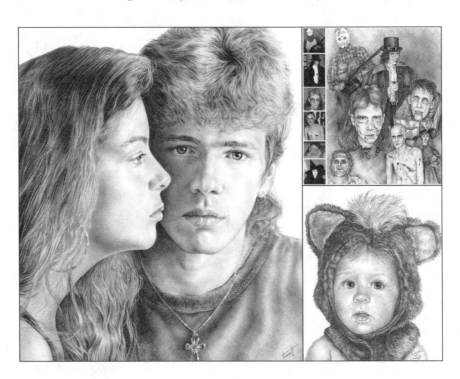

Sketching People from Photos

Photos are great models. They don't need to be fed, have infinite patience, and best of all they stay perfectly still as you draw. When I work from a photo reference, my goal is to create an original drawing based on my photo. Not only would I be bored copying a photo exactly as I see it, but I'd feel like a photocopying machine rather than an artist.

In this chapter, I discuss various methods of working from photos, so as to end up with natural-looking drawings. I encourage you to use your artistic license to make any modifications you want when translating photos into drawings. You and I then work together to create an original artwork from a photo reference. Finally, I show you how to create a harmonious composition when combining two or more people in the same drawing.

Preparing to Draw from Photo References

Lots of photos from my old photo albums have found their way into my studio to be transformed into drawings. However, when I have a special project in mind, I find a model and take (or have someone else take) the photos I need.

Putting Together a Resource Library

Most of us already have tons of photos of people that would make fantastic drawings. My photos are sorted into inexpensive, brightly colored boxes, which I purchased at a local photo supply store.

My photos are organized into easily accessed photo boxes.

Plan some time to dig through those 20 boxes of old photos under your bed and in the closet. Find (or purchase) some file folders, plastic containers, or photo boxes. Label your photo boxes into various categories, according to the subjects you plan to draw. Mine are marked with such names as Babies Faces, Children's Figures, Hands and Feet, and Adult Clothing.

Sort through your photos and select those that look like they might be fun to work with. When trying to decide which photos will make good drawings, consider the following:

◆ When you want to draw a close-up of a face, examine the photo very closely. If you can't clearly distinguish the white of an eye from the iris or pupil, chances are you won't be able to do a detailed drawing.

◆ If the photo is of an individual's full body, make sure you can clearly see fine details such as fingernails and eyes. Drawing a close-up of just a face from a full-body pose is incredibly challenging because

there may not be enough detail in the facial section.

◆ Make sure the subject of your photo isn't fuzzy, out of focus, or in really bright light or dark shadows. It's difficult to draw something you can't see. You need photos that are sharp, well lighted, and highly detailed.

> **Helpful Hint**
>
> If you have a friend who is handy with a camera, you may want to ask that individual to share some of his or her photography tips, or even take some photos for you.

Taking Reference Photos

A concept for a new drawing usually bounces around inside my head for a few weeks before I even think about taking photos. Even though I'm an amateur photographer, I often get lucky and end up with some good photos for drawing. I tend to take lots of photos of the same pose. I'm happy if I end up with one good photo from a session of 20 to 30 shots.

I've picked up a few tips, which may help you when taking your own photo references:

◆ Before you begin, make a few preliminary sketches of how you envision your completed drawing. Share these with your model so he or she has some idea of what you need.

◆ Make sure you have good lighting. Photos taken with just a flash and no other light source tend to look flat.

◆ After you take the photos of the body and the basic poses you want to draw, take several others of close-up areas, such as the face, hands, and/or feet. Take some from various angles so you have a good idea of the person's forms.

◆ Many people have an automatic photo facial expression that they don as soon as they see a camera pointed their way. The key to taking a photo with a more natural expression is patience. Casually chat with your models (with the camera ready to go) until they seem more relaxed.

> **Helpful Hint**
>
> If you plan to draw just a facial portrait, take lots of close-up photos of the head and individual features, from various perspectives. It's better to have too much visual information than not enough.

The following photo is of my grandson Brandon as he modeled the hood of his Halloween costume (a little skunk) that his mom was making for him. Notice how tiny his shoulders are compared to the size of his face. The huge hood of his costume further emphasizes his petite body.

Brandon models the hood of his first Halloween costume.

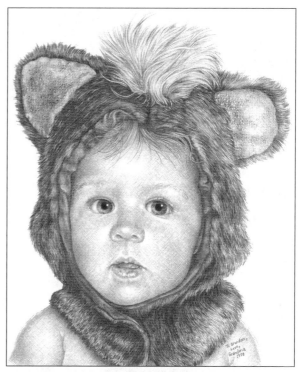

A creative skunk hat provides a fun approach to drawing a baby's portrait.

My photo was a great reference tool, and I had both the child and skunk hood handy when I needed additional information. Compare the photo to the above illustration. Take note of the following modifications I made as I translated the photo into a drawing:

◆ His hood looks solid black in the photo. In the drawing, I made the hood much lighter to show the furry texture of the fabric.

◆ The photo made his face rather flat, quite typical with flash photography. To combat this problem, I enhanced the forms of his face with a greater contrast in values.

◆ In the photo, his eyes look dark. To make his eyes stand out more, I drew the pupil as the darkest value (with a 7B pencil) and drew the irises a little lighter to provide more contrast.

◆ I lowered his eyebrows a little, and made his eyes and mouth less round. This took away the "startled deer caught in the headlights" facial expression that was in the photo.

◆ I just loved the long fur between the ears, so I drew it longer and fluffier than it was in the photo.

Taking Advantage of Your Artistic License

The coolest part of being an artist is having an artistic license. In that you are reading this book, you have qualified for yours. Your artistic license entitles you to exercise your creativity and modify a photo any way you wish.

In the next illustration, you see four drawings all done from the exact same photo. This fun exercise can be done from a photo of anyone. Imagine drawing your stuffy Aunt Ethyl with spiffy spiked hair and a big nose ring. Or a drawing of Grandpa Granville (who's been bald as an egg since forever) now sporting long curly hair down past his shoulders.

There's absolutely nothing wrong with using photos as drawing references. However, photos can sometimes be distorted, underexposed, overexposed, or have a weak composition. This doesn't necessarily mean you can't draw from them. However, you may need to make modifications to successfully transform a less-than-ideal photo into a drawing.

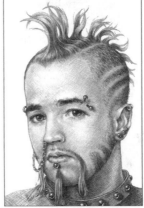

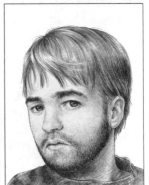

Four very different drawings of my friend Rob are all based on the exact same photo.

Consider the following:

◆ A weak composition can be enhanced by creatively cropping unnecessary and distracting stuff. Use a viewfinder frame to play with various compositions until you find something you're happy with. (I show you how to build and use a viewfinder frame in Chapter 23.)

◆ The dilemma of insufficient information in the photo can be resolved with some creative research. Let's assume you're drawing a person wearing a specific uniform and the details in the photo are in dark shadows. By looking for better images of this type of uniform on the Internet or at the library, you're back in business.

◆ If a photo is overexposed or underexposed, scan it (or have someone scan it for you) into a computer imaging program and adjust the values.

◆ Sometimes you have an excellent photo with the subject wearing the ugliest clothing you ever saw. Of course, you can simply draw the clothing as it is, or you can create another outfit (or find a photo of your subject wearing another outfit).

◆ Hairstyles present numerous challenges. If you don't like the way the hair is styled (or not styled) in a photo, locate a better photo, or draw the hair from the actual person.

A Word About Copyright

Copyright is a type of protection that provides artists with the exclusive right to publish, sell, reproduce, or exhibit their original drawings. A drawing is considered an original when it has been created in its entirety, from conception to completion, by the artist. A drawing is not deemed original if any aspect of it is copied from an image that is already copyrighted (such as photographs or drawings in books, magazines, or on the Internet). However, you can draw from a copyrighted image if you first obtain permission from the person who owns the copyright.

Art Alert!

Before you draw from a copyrighted image, you should obtain permission from the person who owns the copyright. For example, I own the copyright to all the drawings in this book. However, you have my permission to draw from any of my drawings (actually, I'd be honored). But, unfortunately, you can't claim copyright ownership of any of your drawings that are based on my drawings. This would be considered plagiarism.

Drawing a Portrait from a Photo

I sometimes ask my friend Bruce Poole, who just happens to be the world's best hobby photographer (I may be just a tad biased), to share his photography expertise and help me with photo shoots. When I go to his studio, I bring the model, any special props or clothing to be used, and a few conceptual sketches of the lighting, facial expressions, and poses I need. As I work with the model, Bruce takes photos based on my sketches and any other creative ideas we devise. Even though Bruce and I co-own the copyright to photo concepts we work on together, I still ask for his permission and ensure that he receives photo credits for his work.

When working from a photo, you almost always need to make your drawing either smaller or larger. The next two charts are especially helpful when you work with grids. Refer to the following chart when you want to convert a large photo or sketch into a smaller, proportionately correct drawing.

Most photos are small and you'll often want your drawings to be larger. To set up a proportionately correct drawing format larger than your photo, refer to the following guidelines:

Photo Size	Some Options for Converting to a Smaller Drawing			
5×7	4×5.6	3.5×4.9	3×4.2	2.5×3.5
8×10	6.4×8	5.6×7	4.8×6	4×5
9×12	7.2×9.6	6.3×8.4	5.4×7.2	4.5×6
10×12	8×9.6	7×8.4	6×7.2	5×6
11×14	8.8×11.2	7.7×9.8	6.6×8.4	5.5×7
12×16	9.6×12.8	8.4×11.2	7.2×9.6	6×8
16×20	12.8×16	11.2×14	9.6×12	8×10

Photo Size	Some Options for Converting to a Larger Drawing			
2×3	3×4.5	4×6	5×7.5	6×9
3×3	4.5×4.5	6×6	7.5×7.5	9×9
3×4	4.5×6	6×8	7.5×10	9×12
3×5	4.5×7.5	6×10	7.5×12.5	9×15
4×5	6×7.5	8×10	10×12.5	12×15
4×6	6×9	8×12	10×15	12×18
5×7	7.5×10.5	10×14	15×17.5	15×21
5×8	7.5×12	10×16	12.5×20	15×24
5×9	7.5×13.5	10×18	15×22.5	15×27
6×8	9×12	12×16	15×20	18×24
6×9	9×13.5	12×18	15×22.5	18×27
8×10	12×15	16×20	24×25	24×30
9×12	13.5×18	18×24	22.5×30	27×36
10×12	15×18	20×24	25×30	30×36
11×14	16.5×21	22×28	27.5×35	33×42

When Bruce showed me the following photo he had taken of my daughter, Heidi, I saw a lot of potential for a great portrait.

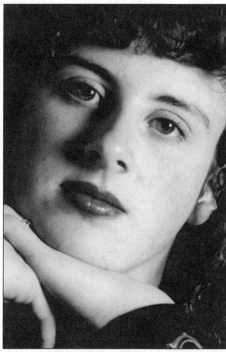

This photo of my daughter, taken by a friend, inspired me to do a drawing. (Photo © Bruce Poole, 1999)

Now dig out your drawing materials and follow along with me as we draw a lifelike drawing based on a photo of my daughter, Heidi. If you prefer, find one of your photos that is similar and use it to create your own original artwork.

1. Outline a drawing format proportionate to your photo.

2. Lightly sketch your subject proportionately correct.

3. Carefully observe the values in the photo (Chapter 6 is all about seeing values) and draw a shading map (as discussed in Chapter 8).

4. Lighten your mapping lines and refine your drawing.

5. Use light pencils and crosshatching to add the light values.

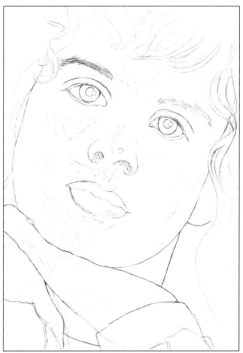

A lightly rendered drawing outlines the basic proportions.

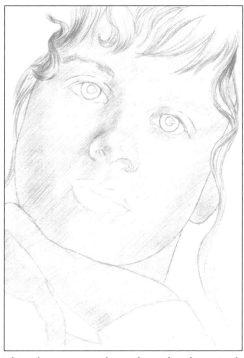

Light values are mostly on the right, closer to the light source.

The step-by-step illustrations speak for themselves in this section. However, if you run into problems with the shading, refer to Chapters 6 through 9.

6. Add medium values that graduate from the lights toward the dark sections.

7. Begin sketching the shapes of the individual strands of hair with hatching. (I show you how to draw hair in Chapter 15.)

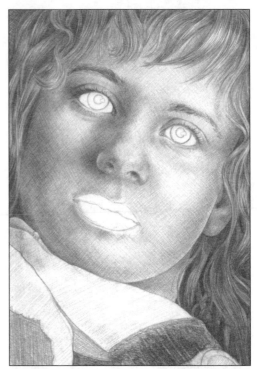

Dark values accentuate the facial forms by providing strong contrast.

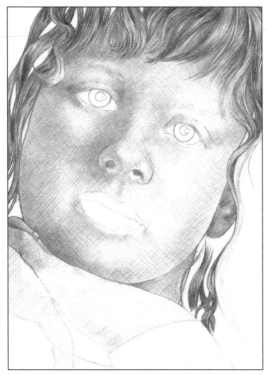

The forms of the face, hand, and hair begin to take shape.

8. Add the dark shading in the shadow sections of the face, hands, and hair.

9. Complete your drawing by finishing the eyes, lips, clothing, and the tiny section of her watch.

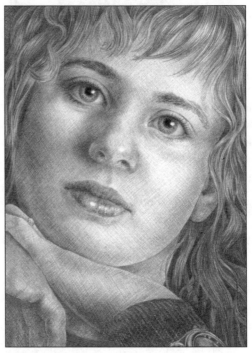

Powerful contrasting values personify Heidi's strength of character.

Portraits with More Than One Person

Including two or more people in one drawing is lots of fun, but somewhat more challenging than drawing only one person. While exploring creative ideas for illustrating each unique individual, you also need to find a way to unify the drawing.

Art Alert!

The most common problem in drawings of two or more people is a lack of unity. If you randomly draw faces or figures on your paper without finding a way to connect them together, you end up with a weak and disjointed composition.

Consider the following suggestions for unifying a drawing of multiple subjects:

◆ A creative background can serve to unify any number of subjects. (Refer to Chapter 21 to see what I mean.)

◆ By overlapping some sections of your subjects, you unify your composition and create a sense of depth. (I tell you about overlapping in Chapter 4.)

◆ A drawing of a group of people becomes connected by varying the presentation of each individual. Consider combining close-ups of faces with full figures. For example, larger presentations of the heads and shoulders of parents can partially overlap, and complement, smaller full-figure views of children.

Double Portraits

When drawing two people in the same drawing, plan to use an unusual composition or lighting option to create strong contrast and exaggerate their independence.

The next photo of my former students and current friends, Claudette and Philip, was taken in a well-equipped photographic studio. As my friend Bruce handled all the technical stuff, I focused on arranging the models, adjusting hair and clothing, making sure the tilt of their heads was what I wanted, and that their facial expressions portrayed what I needed.

Many aspects of this photo are fantastic for drawing without modifications. The dominant light source creates a full range of values from white to black. I just love the way both faces are presented. The fun composition brings them together, yet a feeling of separation is created by the high-contrasting values. Claudette's facial profile is soft and gentle. Half of Phil's face is in shadow, and these powerful shadows enhance his eyes, as well as the forms of his nose, mouth, and chin.

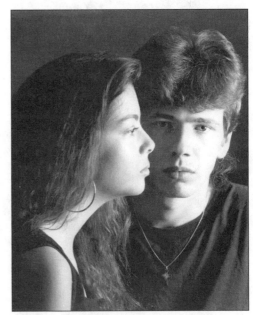

This high-contrast photo inspired me to do a drawing.
(Photo © Bruce Poole, 1999)

Follow along with my thought processes as I translated the previous photo into the next drawing:

◆ The two faces are very close together. The strong lighting provided an opportunity for an even more powerful visual separation of the two individuals. I accentuated the bright light along the edge of her facial profile and darkened the shadow section of his face. High-contrast shading makes this section of the drawing the center of interest.

◆ To provide a sense of intimacy, the drawing is more tightly cropped than the photo.

◆ The shading in the rest of the drawing has been modified so as to not compete with the strong contrast of the center of interest. Their clothing and hair are shaded with lighter values than in the photo.

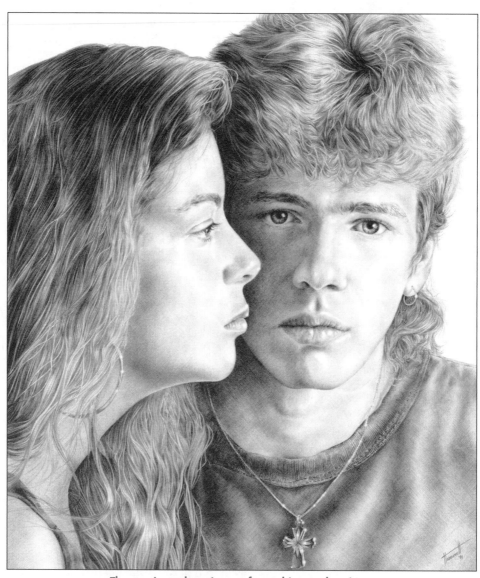

The previous photo is transformed into a drawing.

Creating a Collage of Faces

If you are a fan of Halloween or live theater, or love artistic costumes and special-effects makeup, I suspect you'll enjoy the next drawing. A few years ago, I was asked to organize a group of my students and friends to paint the sets and backdrops, and play some of the characters, in a haunted house production.

Imagine how complicated everything becomes when you choose to combine seven people into one portrait! I decided to do a collage-type composition, loosely based on several of my photographs. Here's how I tackled this drawing:

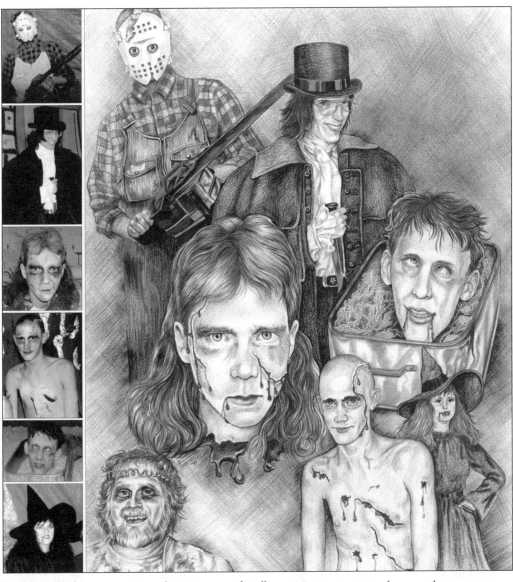

Shudder with fear as you view these images of Halloween in gruesome makeup and scary costumes!

◆ To make the overall subject interesting, I chose to draw close-up views of some characters and full-figure presentations of others from various perspectives.

◆ My goal of a unified composition was enhanced by drawing a motley background.

◆ By randomly overlapping figures of different shapes and sizes, the figures meld together into one abstract silhouette.

◆ The composition is anchored on three sides by cropping parts of some of the figures at the edges of my drawing space. On the fourth side (on the right), the shading of the background seems to extend beyond the perimeter of the drawing.

◆ The light, dark, and textured areas are intermingled throughout the composition, resulting in a sense of balance.

◆ Some of my photos were poor, necessitating some additional research. For example, I had to look for other photos of some of the clothing and the chainsaw.

 Info Tidbit

The haunted house drawing resulted from my acceptance of a challenge. One of my former students (and long-time friend), Jason, in the top hat, had teased me for several years that everything I drew was "cute." This drawing was my response. I fully expect you to be shaking in your boots with fear right about now!

The Least You Need to Know

- There's absolutely nothing wrong with using photos as drawing references.
- You can sort through your collection of photos and organize them into a personal photo reference library for drawing.
- Your artistic license entitles you to exercise your creativity and modify a photo any way you wish.

- Including two or more people in one drawing is lots of fun, but more challenging than drawing only one person.
- You can unify a drawing with multiple subjects by using a creative background and/or by overlapping some sections of your subjects.

In This Chapter

- ◆ Planning a drawing from a photograph
- ◆ Gridding the photo and drawing space
- ◆ Transferring a photo image onto drawing paper
- ◆ How to shade a drawing from a photo

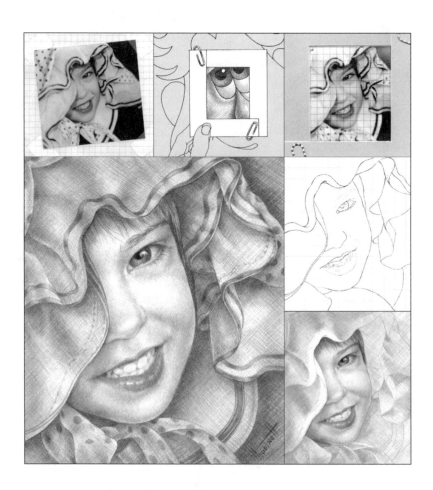

Transforming a Photo into a Drawing

If you were an artist during the time of Leonardo da Vinci, you'd feel highly honored to be privy to the secret tool of his artistic trade: the grid. Grids help with numerous challenges encountered by artists who draw people, such as rendering precise proportions and correct perspective.

In this chapter, I walk you through the entire process of drawing a little girl from a photo. I share lots of helpful tips and time-saving methods that I've learned from many years of drawing with grids. You begin by setting up a grid on the photo and working out a pleasing composition. From there, you outline your drawing with simple lines and then add realistic shading.

You can follow along with me and draw a portrait of my adorable little friend Karin, or you can use one of your own favorite photos. If you want to work from your own photo, pick one with only one person. (Refer to Chapter 22 for tips on selecting photos to draw from.) A family portrait of 13 people, 6 dogs, and a parrot may be a little over the head of a beginner!

Planning and Composing the Drawing

If you want to use your creative license and modify some aspects of your photo, make your changes in the planning stages, before you actually start to draw.

When working from a cherished photo, consider the following alternatives to drawing directly on the photograph:

◆ Draw the grid on a photocopy (or a scanned and printed image) of the photo.

◆ With a fine-tip permanent black marker, draw a grid on a clear sheet of acetate, or draw a grid in a computer photo imaging program, and print it on clear acetate (available at many business and art supply stores). Place the acetate over the photo and tape it in place.

Setting Up a Grid on a Photo

A very simple little trick allows you to avoid the tedious and time-consuming measuring process of drawing a grid. Find a sheet of graph paper, a pencil, and a ruler, and follow along with me:

1. Tape your photo to your graph paper. If you like, you can tilt it slightly as in the following illustration.

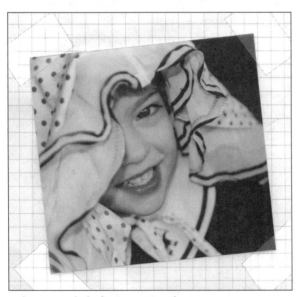

This sweet little face seems to become more expressive by simply tilting the photo.

2. With a fine-tip ballpoint pen, draw the horizontal and vertical grid lines, using the lines of the graph paper as guidelines. My graph paper has one-quarter-inch squares.

Check out this super simple method of drawing accurate grid lines on a photo.

Your grid is accurately rendered and you are ready to plan your composition.

Building Your Own Viewfinder Frame

A viewfinder frame is an adjustable, see-through drawing format that allows you to view a potential drawing subject from various viewpoints. It's an invaluable tool for planning a composition and can be used for portraits, figures, or any other drawing subjects.

Through its adjustable opening, you can examine and evaluate the relationships between the lines, values, and shapes of your subject.

You can easily make a viewfinder frame with some heavy paper (or cardboard), a utility knife, a ruler, and two large paper clips. Follow these steps:

1. Use a ruler and a utility knife to cut two identical L-shaped pieces of cardboard. The wider your frame, the more distracting unwanted objects are blocked from view.

Two pieces of cardboard (or heavy paper) are the primary ingredients for a viewfinder frame.

2. Use two large paperclips to join the two pieces of cardboard together to form a frame.

Framing someone inside a viewfinder is a fun way to plan your composition.

Finding and Framing Your View

An entertaining aspect of being an artist is that you can make any changes you wish to a photo before you draw. Changing the composition is easy with help from a viewfinder frame:

1. Place your viewfinder frame on your photo.

2. Continuously adjust both sections until you find a composition you like.

3. When you choose an ideal composition, mark the corners of the photo so you know its location after the frame is removed.

Thanks to my viewfinder frame, I've found a composition that works well.

Transferring the Image

Setting up an accurate grid on both the photo and drawing surface is essential to achieving a proportionally correct portrait. Letters and numbers identifying each square help you keep track of where you are as you draw. I know from personal experience how frustrating it is to accidentally draw the wrong image in a grid square.

Preparing the Photo

When you are happy with your composition, you need to prepare your photo for its transformation into a drawing.

1. Tape off the perimeter of your chosen composition.

2. Number the squares across the top and bottom.

3. Add letters down both sides of the photo.

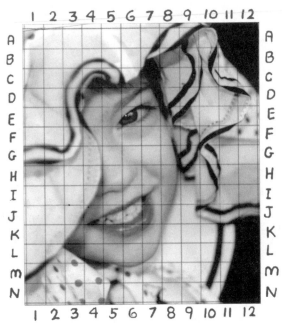

Add letters and numbers to all four sides of the grid.

Setting Up the Drawing Format

Choose a drawing format size that is proportionate to the size of your photo. Use a larger drawing format for a larger drawing and a smaller one for a smaller drawing. To help choose a size, refer to the grid conversion guideline charts in Chapter 22.

1. Draw the outline of your drawing format.

2. Press *very* gently with a 2H or HB pencil to divide your rectangle into 168 squares, 12 across and 14 down.

Helpful Hint

Tape the corners of your drawing paper to a large sheet of graph paper to help draw the grid lines. Adjust the size of each square proportionate to the size you want the drawing to be. For example, if you want your drawing to be twice the size of the photo, use four (2 by 2) of the one-quarter-inch graph squares, to represent one, quarter-inch grid square on the photo.

3. Starting from the left, number the vertical squares along the top and bottom with numbers 1 through 12.

4. Starting from the top, letter the horizontal squares down both sides with letters "A" through "N."

This completed grid is patiently awaiting a drawing.

Practice Drawing Square by Square

Rendering accurate proportions with a grid depends on your skills at correctly drawing what's inside each individual square. You can identify where to draw the lines inside each grid square by visually measuring proportions and observing the relationships between the lines, shapes, and spaces.

The following short exercise offers some tips to help make drawing with a grid easier:

1. Draw a rectangle 2 inches wide by 1 inch long and divide it into two 1-inch squares.

Two squares become a mini grid.

The next drawing shows you what you'll draw in the left grid square (in the next step). Beside it are its positive and negative spaces.

The shapes of spaces provide clues for accurately drawing lines within a grid square.

2. Visually locate the place where the line meets the left side of the square (close to the center). Mark it with a tiny dot.

3. Find the spot where the line meets the right side (near the top). Add another dot here.

4. Draw the line inside the grid square. Start with the dot you made on the left and end with the dot on the right. In between the two dots, the line curves in different directions. Note the lengths of different sections of the line in relation to the sides of the grid square. Pay close attention to the spaces and shapes on either side of the line.

The line inside this grid square curves in many directions.

5. Draw the two lines in the second square. Use the same technique of drawing dots. One dot is already identified by the spot where your first line ended.

If you can draw these two challenging grid squares accurately, you can draw anything!

Accuracy Counts: Outlining the Drawing Subject

Drawing with a grid takes a lot of the guess-work out of rendering correct proportions. As you draw, don't think about what the subject is. Concentrate on only one square at a time. Focus on the shapes and the negative and positive spaces that define the actual lines. (I tell you about negative and positive spaces in Chapter 3.)

1. Draw the outline of Karin's face. Constantly check that your proportions are as close as possible to the photo (or in this case, my drawing).

Art Alert! _____

Don't press too hard with your pencils! No matter how careful you are, when you draw with a grid, accidents do happen. If you draw some lines in the wrong grid squares, simply erase that section, redraw the grid lines, and keep on going. Lightly drawn lines are easy to erase!

2. With your HB pencil, very lightly draw the outline of the various sections of her clothing and hat.

When drawing a portrait, it doesn't matter if the proportions of the clothing are slightly off. But accurate placement of facial features is crucial to achieving a likeness. Until your eye is well trained, a grid is an invaluable drawing tool.

3. With your 2H or HB pencil, very lightly draw the outlines of the eyes, nose, and mouth. Use the same drawing techniques you used in the last step. Work on only one feature at a time. Carefully observe the location of her nostrils, eyes, corners of her mouth, and the outline of her lips within the grid squares. Take your time. Patience is a virtue!

The basic outline is beginning to take shape.

This step is the most important toward completing a facial likeness you'll be happy with. Note that the entire face and all its features are at an angle.

Karin's features are tilted toward the upper-right corner of the drawing space.

Adding Shading to the Drawing

Before you get into the really fun stuff (the shading), you have one last chance to make changes. First, take a nice long break, and then come back and have a fresh look at your drawing. Closely examine the placement of the individual features and correct any areas you're not happy with.

To create a smooth transition of values, you need to layer your shading from light to dark. Draw the light values first, layer medium shading on top of the light, and then build up the darkest values on top of the medium.

The Face Comes to Life

The soft light source in my photo is from the front and right of Karin's face. Large areas of her face are shaded with light and middle values or are left white. Dark values are used very sparingly.

1. Map out where you plan to draw the light and dark values. (I show you how to map values in Chapter 8.) Draw the mapping shapes lightly. (I adjusted my scanner settings so you could see mine.)

2. Erase the grid lines in the facial area and use your kneaded eraser to gently pat all your mapping lines until you can barely see them.

3. Use 2H and HB pencils to add light and medium values.

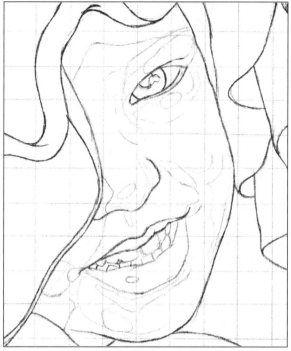

Lightly drawn shapes map out where the shading needs to be added.

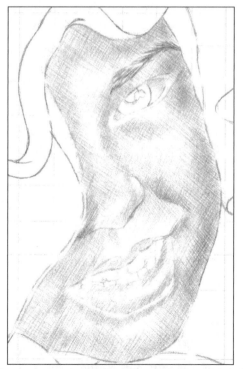

The mapping shapes have been filled in with light and medium values.

A foundation of shading has identified the forms of Karin's face. Beginning at the top of her face, you now work down toward the chin and neck to complete the facial shading.

4. Draw Karin's hair. The hatching lines need to be many different lengths and values. A few wispy hairs extending onto her face give a soft, natural look to her hair. A freshly sharpened HB pencil is great for lighter values, and a 2B or 4B pencil works well for the darker shading in shadow areas.

5. Add darker shading with crosshatching to the shadowed sections of her upper face around her eyes.

6. Draw her eyebrow. These short hatching lines are curved and grow in many different directions.

7. Complete the shading of her eye, while noting the following:

 ◆ The shading of the iris is darker under the upper eyelid and on the side where the highlight is drawn.

 ◆ The darkest shading (use an 8B pencil) is in the pupil of her eye.

 ◆ The shadow sections of the white of the eye (under the upper eyelids) are a little darker.

8. Add her upper and lower eyelashes with your 2H and HB pencils. Eyelashes are curved, various lengths and thicknesses, and appear thicker closer to the eyelids. Draw only half as many as you think there should be. (See Chapter 12 for more on drawing realistic eyelashes.)

9. With your HB and 2B pencils, add a little darker shading to the nose, lips, forms of the lower face, and the opening of her mouth.

10. Take your time and draw the inside sections of her mouth around her teeth. Don't actually outline the teeth.

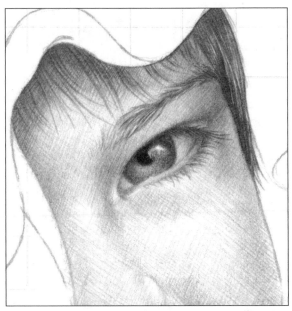

Thanks to the shading of her upper face, Karin's eye appears to be smiling.

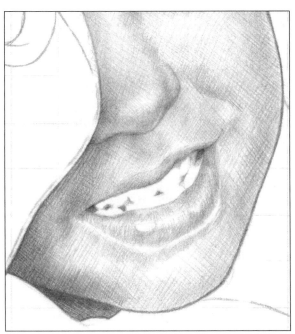

A little dark shading brings out Karin's sweet smile.

11. Add shading to the teeth. (I show you how to draw teeth in Chapter 14.)

12. With your 2B pencil, add darker shading in the shadow areas on and around her lips. Note the vertical creases on her lower lip. Leave a lighter area on her face surrounding the perimeter of the mouth.

Softly shaded teeth add character to her wonderful smile.

13. Darken the shading on the neck.

14. Have a final look at Karin's face and touch up any areas you're not happy with. If an area is too light, add some more shading with hatching lines. If you want to make a section lighter, pull and stretch your kneaded eraser until it becomes soft and then gently pat the shading that is too dark.

 Warm Fuzzy _____

With lots of practice drawing from live models, you will become more comfortable and skilled at drawing people from photos.

A few final touches complete the facial shading.

Shading Clothing and Adding Final Touches

Let's exercise a little more artistic license! In the photo, I find the sharp contrast between the white and black of Karin's clothing detracts attention from her face. Therefore, my goal is to use shading to make Karin's face the focal point of this drawing. Karin's hat and clothing will be shaded with less contrast than in the photo. The pupil of her eye will stand out from all the other values because it will be the darkest (shaded with an 8B pencil).

1. Use light values to define the forms of her clothing. Keep the graduations (transitions) between these values smooth. Don't forget to erase your grid lines with either your vinyl or kneaded eraser before you begin each section of shading.

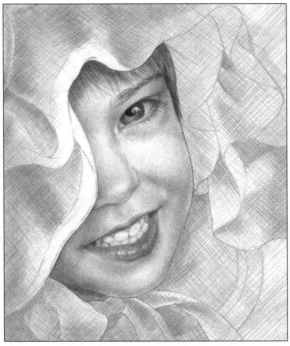

Forms of the hat and clothing begin to emerge with light shading.

2. Add darker shading to the shadowed areas of her clothing and hat. Taper off the darkness of the crosshatching lines as you approach any light areas and darken your lines as you move toward the darkest shadow areas.

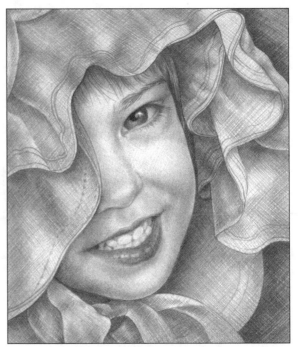

Darker shading creates depth by bringing the face forward.

3. Shade in some polka dots and ribbons on her clothing where indicated. (Refer to the final drawing on the next page.)

Step back from your drawing and take a look at the overall values. You may need to make some areas lighter (by patting with your kneaded eraser) and others darker (by drawing more crosshatching lines).

As a grand finale to this chapter, take a moment and compare your drawing to the original photo. (Karin's photo is in the beginning of this chapter.) Put today's date on the back of your drawing, sign your name, and pat yourself on the back!

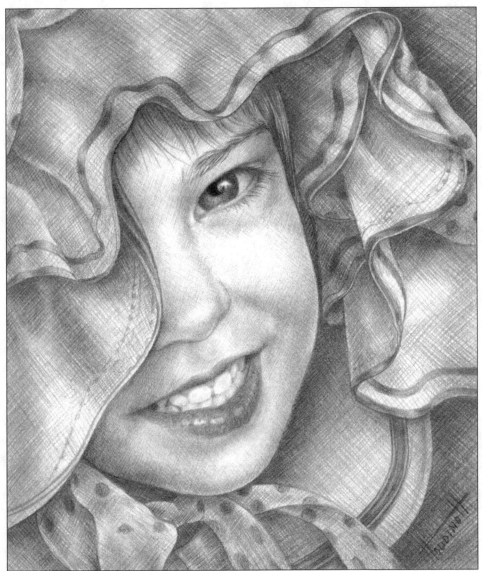

Today, Karin is a teenager; when I took the photo for this drawing, however, she was barely 5 years old.

The Least You Need to Know

- Using a grid helps render precise facial and figurative proportions and correct perspective.
- Changing the composition of a photo is easy with help from a viewfinder frame.
- You can easily make a viewfinder frame with heavy paper and two large paper clips.
- You can modify the values in your drawing either lighter or darker than the photo to enhance the sections you consider most important.

Appendix A

Drawing Glossary

acid-free A high-quality, long-lasting, and pH-balanced paper that has had the acid removed from the pulp in the paper-making process. Drawings can be ruined when papers with acid deteriorate and turn yellow.

aerial perspective Sometimes called atmospheric perspective, refers to the visual depth created by various particles in the atmosphere. The farther people recede into the distance, the lighter in value they seem to become, and their edges and forms appear more blurred.

age progression The art of rendering individuals older than they really are.

age regression The art of rendering individuals younger than they really are.

angle lines What occurs when two straight lines meet (or join together). Angle lines are used to draw such shapes as squares, rectangles, and triangles.

balance A stable arrangement of subjects within a drawing composition.

ball of the nose Also called the tip, refers to the largest, central, rounded form on the lower half of the nose.

base of a nose Also called a septum, the lower section in between the nostrils, which connects with the lower face above the upper lip.

blending The process of rubbing shading lines with a blending tool (such as tissue or paper towel) to evenly distribute the drawing medium over the surface of the paper, thereby achieving a silky smooth graduation of values.

bridge of the nose Sometimes referred to as the nasal bone, the section of the nose where the upper bony section joins the cartilage. The contoured shape of the bridge is most obvious when the nose is viewed in profile.

bull's eye The center portion of a drawing space (or format). A drawing composition usually becomes weak when the primary subject is drawn within the bull's eye.

cast shadow A dark section on a surface that receives little or no light. The values of a cast shadow are darkest right next to the object and become gradually lighter farther away.

composition The arrangement of the various facets of your drawing subject within the borders of a drawing space. A strong composition brings the eyes of the viewer to what you consider to be the most important elements in your drawing.

compound curve What is created when a curved line changes direction (think of the letter "S").

contour drawing A drawing comprised of lines that follow the contours of the edges of various components of a drawing subject and define the outlines of its forms.

contour lines Lines that are formed when the shared edges of spaces and/or objects meet.

contrast The comparison of different values when put beside one another, and an invaluable tool for heightening the effects of composition.

cranial mass Often referred to as the cranium or skull, the large upper section of the head.

crosshatching A shading technique in which one set of lines crosses over (overlaps) another set.

curved line What is formed when a straight line curves or bends (as in the letters "C" and "U"). The most common type of line used for drawing people. A curved line becomes a circular shape (as in the letter "O") when the ends meet.

down-turned nose A nose shape that angles downward, with the ball lower than the wings.

drawing The application of an art medium to a surface so as to produce an image that visually defines an artist's choice of drawing subjects from his or her own unique perspectives.

drawing space Also called the drawing surface or a drawing format, the area in which you render a drawing within a specific perimeter. It can be the shape of your paper or outlined by any shape you draw, such as a square, rectangle, or circle.

ear canal The opening to the inner ear.

earlobe The soft, fleshy, lower section of the ear.

eye-squeezer muscles Also called *orbicularis oculi*, the large oval-shaped muscle mass surrounding the eye and extending onto the upper section of the cheek. The upper and lower halves, and the center section, can work independently or together, to show happiness, stress, anger, and pain.

eyeball Commonly referred to as the white of an eye, the fragile sphere nestled safely inside a protective bone cavity of the face.

eyebrow An arch-shaped group of hairs above the eye.

eyelashes Fine hairs that grow from the outer edges of the upper and lower eyelids.

eyebrow-lifter muscle Also called *frontalis*, the wide flat muscle, with two independent halves, which runs vertically across the forehead. It helps create the facial expressions of surprise, sadness, and fear.

eyelid-lifter muscle Also called *levator palpebrae*, the tiny muscle located within each upper eyelid that controls the up and down movements.

facial guidelines Sometimes called proportional guidelines, these identify the placements of all aspects of diverse human faces within generic spaces.

facial mass Also called the face or facial area, it refers to the frontal lower section of a human head.

foreshortening The visual distortion of a person or object when viewed at extreme angles. As the angle of viewing becomes more extreme, the level of distortion becomes more pronounced.

forms The three-dimensional structures of shapes. Rounded and spherical forms are the primary ingredients for drawing almost every part of a human body.

frowner muscles Also known as the corrugator, these muscles are between the eyebrows and extend from the bridge of the nose upward and outward in a fan shape. Their various movements contribute to the facial expressions of sadness, fear, concentration, anxiety, and anger.

gesture sketch A drawing that uses simple sketching methods to capture the past, present, or potential movements of living beings.

golden mean A classic type of precise composition devised by the ancient Greeks, and based on the division of what they deemed as a perfect rectangle into three triangular shapes.

graduated shading Also known as a graduation or graduated values, a continuous progression of values from dark to light or from light to dark. The goal of graduated shading is to keep the transitions between the different values flowing smoothly into one another.

grid A precise arrangement of a specific number of squares, of exact sizes, proportionately drawn on both a photo and drawing surface. Grids help artists with numerous challenges, such as rendering precise proportions and correct perspective.

hatching A series of lines (called a set) drawn closely together to give the illusion of values. Depending on the shading effects you want, you can make the individual lines in hatching sets far apart or close together.

high contrast Shading that is created by drawing the darkest values, close to the highlights and lightest values.

high-key drawings Drawings that have a limited range of values that are mostly light. Even most of the shadows and dark areas are often shaded with medium values rather than extreme darks.

highlight The brightest area of a form where light bounces off its surface and is usually the section closest to the light source.

horizon line Also known as eye level, refers to an imaginary horizontal line that divides your line of vision when you look straight ahead. Your eye level always stays with you wherever you move. You always draw the horizon line parallel to the upper and lower sides of a square or rectangular drawing space.

inner corner of the eye A small, reddish, triangular shape in the inside corner of the eye, close to the nose.

inner rim of the ear The smaller long form inside the ear that circles the rear of the opening to the ear canal.

iris of an eye The colored circular section of the eyeball surrounding the pupil.

in-home studio A personal drawing place within an artist's home that has adequate space for the artist and his or her art supplies. It can range from a corner of the kitchen table to a large professional fully equipped art studio.

key The overall amount of light and dark values in a drawing.

kneaded eraser A versatile, soft, pliable eraser. You can use it to erase parts of your drawing or pat or gently rub the surface of your paper to make a section lighter. Its tip can be molded to a point (or wedge) to draw fine lines on a surface, covered with a drawing medium, such as graphite.

left brain The left hemisphere of the brain, which controls analytical, mathematical, and verbal thinking.

life drawing The process of drawing from an actual person rather than from a two-dimensional photo or sketch.

lines Specific to drawing, lines visually separate and/or define the forms of the various components of a drawing subject. Lines can be categorized into three types: straight, angle, or curved.

lip-raiser muscles Also known as *levator labii*, these muscles extend from the outer mouth area, upward on the cheek in a fan shape, and help create the facial expressions of disgust, devastation, despair, and sneering.

lip-stretcher muscles Also called *risorius* and *platysma*, these muscles pull the lips horizontally back on the face in such extreme expressions as devastation, terror, or intense anger.

light source The direction from which a dominant light originates. A light source identifies the light and shadow areas of a drawing subject, so you know where to draw shading.

low contrast Shading that has a limited range of values.

low-key drawings Drawings that have a range of mostly dark values and tend to be dark, ominous, or moody. Low-key drawings often have high contrast, which entails drawing the darkest darks next to the lightest lights.

lower eyelid A fold of skin protecting the lower section of the eyeball.

nasal wings Two small, soft, rounded (often triangular shaped) forms extending from the sides of the ball of the nose.

negative space The background around and/or behind an object, person, or another space.

nostril The opening on the lower section of each side of a nose.

one point perspective The process of rendering the perception of a three-dimensional space in a drawing when the front, rear, or one side of an object (or person) is closest to the viewer. The edges of its contours recede into space as lines which converge at a single vanishing point.

orbital socket Also called the orbital cavity, the bone cavity of the face that protects the eyeball.

outer rim of the ear The long form along the outside edge of the ear that meets up with the earlobe at the lower section.

overlapping A technique that gives the illusion of depth in a drawing and refers to the position of subjects in a composition, when one visually appears to be in front of another (or others). A drawing space can be separated into foreground, middle ground, and distant space by overlapping (or layering) objects in front of one another.

perspective A visual illusion in a drawing in which people and objects appear to become smaller and recede into distant space the farther they are away from the viewer.

perspective lines Straight, usually angular lines invisible in real life that extend from the edges of objects or people back to a vanishing point(s) on the horizon line.

positive space The space occupied by an object or person or its (or his or her) various parts.

pouting muscle Also called *mentalis*, the muscle that pushes the center of the mouth upward, resulting in a raised, puckered-looking chin.

primary focal point The most important center of interest (or focus) in a drawing. In a drawing of a person, it may be the eyes, the entire face, or a whole section of the body that is especially fascinating.

proportion The relationship in size of one component of a drawing to another or others.

pupil of an eye The darkest circular shape within the iris, which adjusts its size under different lighting conditions.

reflected light A faint light reflected or bounced back on an object from the surfaces close to and around it.

right brain The right hemisphere of the brain, which controls visual and perceptive functions. Your creative and insightful right brain sees abstract connections between lines, shapes, and spaces in a non-narrative context by instinctively seeing proportions.

rough sketch A quickly rendered drawing that illustrates the important elements of your drawing subject with very few details.

rule of thirds A simplified variation of an old traditional compositional formula known as the golden mean, which identifies four ideal locations within a drawing space for the most important components of your composition.

sadness muscle Also called *triangularis*, this muscle extends from the corner of the mouth downward and contributes to such facial expressions as grief, sadness, and frowning.

secondary focal point A center of interest in a drawing composition that is significant but not as important as the primary focal point.

sets of lines Lines that are created when several individual lines are grouped together to create shading.

shading The process of adding values to a drawing to create the illusion of form and/or three-dimensional space.

shading map Also called a value map, a plan (or blueprint) for adding shading to a drawing, in which the shapes of various values are identified and lightly outlined.

sketch A simple drawing that captures the integral aspects of your subject quickly and efficiently.

small lobe The small, round form over the frontal section of the opening to the ear canal, which joins the earlobe at the front of the ear (where the ear joins the face).

smiling muscle Also known as *zygomatic major*; the muscle that runs from the corners of the mouth back toward the ears and contributes to the happy expressions of smiling, laughing, giggling, and grinning.

speaking muscle Also called *orbicularis oris*, the muscle that encircles the mouth and works with other muscles to give the mouth its movements when talking. This versatile muscle can tighten and contort the lips and helps with the facial expressions of anger, surprise, and sadness.

squirkling My own term for an easy method of shading in which randomly drawn curved lines (called squirkles) combine squiggles and scribbles with circles to create textured values.

straight lines These lines can be thick or thin, long or short, and they can be drawn in any direction. Each can be classified as either horizontal (level and at a right angle to vertical lines), vertical (straight up and down and at a right angle to a horizontal lines), or diagonal (slanting or sloping at an angle).

straight nose A nose shape in which the ball and nostrils line up horizontally with the wings. This term can also apply to the shape of a nose when viewed in profile.

symmetry A balanced arrangement (sometimes referred to as a mirror image) of lines and shapes on opposite sides of an often-imaginary centerline.

talent A process of self-discovery, throughout which you acknowledge and embrace your ability to become exceptional. With personal commitment, patience, and dedication, you can develop your talent for drawing.

thumbnail sketch A preliminary sketch rendered before an artist begins a drawing; designed to work through potential problems with composition, values, perspective, and proportions.

tooth The surface texture of paper, which can range from silky smooth to very course. The more tooth a paper has, the rougher it feels to the touch.

torso Also called the trunk, the primary structure of a human body to which is connected the head, arms, and legs.

upper eyelid A movable fold of skin that opens and closes to protect the eyeball.

upper-eyelid crease A fold in the skin above the eye, defining the location of the top of the eyeball.

upturned nose A nose shape that angles upward, and the ball is higher than the wings.

value scale A range of different values from light to dark or from dark to light.

values Different shades of gray created in a drawing by various means, such as varying the density of the shading lines and/or the pressure used in holding a pencil.

vanishing point The imaginary point on the horizon line where perspective lines seem to converge.

viewfinder frame Two adjustable L-shaped pieces of paper, cardboard, or matte board, held together with paper clips and used for planning the compositions of drawings.

vinyl eraser An artistic tool used for erasing sections of your drawings and/or drawing crisp light lines and fine details on a surface covered with a drawing medium, such as graphite.

warm fuzzies Words of encouragement or affirmations either given or received. They represent something unique to everyone and live wherever kindheartedness dwells. I also use the term "warm fuzzy" to describe an adorable little critter you can draw to help you learn basic skills for drawing people.

white of the eye A section of the eyeball that is light, but not really white.

wrinkle A three-dimensional form on human skin that develops when the skin begins to lose its elasticity, becomes thinner, and loses fat. Gravity also plays a role in creating wrinkles by pulling the skin downward.

Resources for Drawing People

Art Books

Albert, Greg. *Basic Figure Drawing Techniques.* North Light Books, 1994.

Angrill, Muntsa Calbo I. *The Big Book of Drawing and Painting the Figure.* Watson-Guptill Publications, 1995.

Barcsay, Jeno. *Anatomy for the Artist.* Metro Books, 2001.

Brookes, Mona. *Drawing with Children: A Creative Method for Adult Beginners, Too.* Jeremy P. Tarcher/Putnam Inc., 1996.

Cameron, Julia. *The Artist's Way: A Spiritual Path to Higher Creativity.* Jeremy P. Tarcher/Putnam Inc., 1992.

Edwards, Betty. *The New Drawing on the Right Side of the Brain.* Jeremy P. Tarcher/Putnam Inc., 1999.

Faigin, Gary. *The Artist's Complete Guide to Facial Expression.* Watson-Guptill Publications, 1990.

Graves, Douglas R. *Drawing Portraits.* Watson-Guptill Publications, 1983.

———. *Figure Painting in Oil.* Watson-Guptill Publications, 1983.

———. *Drawing a Likeness.* Watson-Guptill Publications, 1984.

Gray, Henry. *Gray's Anatomy.* Grange Books, 2001 (first published in 1858).

Hillberry, J. D. *Drawing Realistic Textures in Pencil.* North Light Books, 1999.

Hogarth, Burne. *Drawing the Human Head.* Watson-Guptill Publications, 1989.

———. *Dynamic Figure Drawing.* Watson-Guptill Publications, 1996.

Jarrett, Lauren, and Lisa Lenard. *The Complete Idiot's Guide to Drawing.* Alpha Books, 2000.

Kinstler, Everett Raymond. *Painting Faces, Figures, and Landscapes.* Watson-Guptill Publications, 1981.

Loomis, Andrew J. *Figure Drawing for All It Is Worth.* Viking Press, 1943. (Out of print, but worth searching for!)

Nicolaides, Kimon. *The Natural Way to Draw.* Mariner Books, 1990.

Parramon, Jose Maria. *How to Draw Heads and Portraits.* Watson-Guptill Publications, 1989.

———. *How to Draw the Human Figure.* Watson-Guptill Publications, 1990.

Ryder, Anthony. *The Artist's Complete Guide to Figure Drawing: A Contemporary Perspective on the Classical Tradition.* Watson-Guptill Publications, 2000.

Rubins, David K. *The Human Figure: An Anatomy for Artists.* The Viking Press, 1953.

Sheppard, Joseph. *Drawing the Figure.* Watson-Guptill Publications, 1984.

Simblet, Sarah. *Anatomy for the Artist.* Dorling Kindersley Publishing, 2001.

Art Websites

Hoddinott, Brenda.
Fine Art Education
www.finearteducation.com

Hoddinott, Brenda.
Paintings and Drawings of People
www.hoddinott.com

Pendleton, Elin.
Painting People and Horses
www.elinart.com/pages/stupage.html

The Figure Drawing Lab
www2.evansville.edu/drawinglab

What You Need to Know About Drawing and Sketching
drawsketch.about.com

Online Art Supplies

Dick Blick Art Materials
www.dickblick.com

Loomis Art Store—Art Materials
www.loomisartstore.com/engl/promo/index.asp

Jerry's Artarama
www.jerrysartarama.com

Mister Art
www.misterart.com

Index

F

G

H

T

U